joanna hardy

edited by malcolm cossons

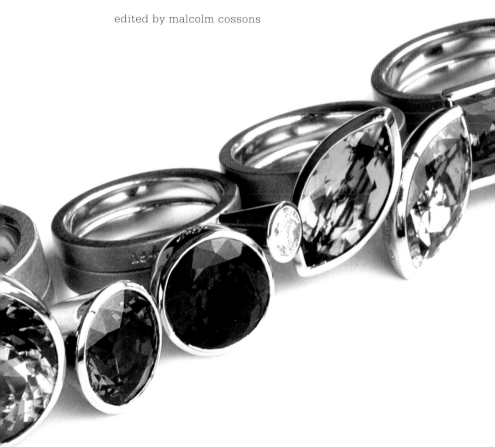

COLLECT
contemporary | **jewelry**

with 226 colour illustrations

Thames & Hudson

First published in the United Kingdom in 2012 by
Thames & Hudson Ltd,
181A High Holborn,
London WC1V 7QX

British Library Cataloguing-in-Publication Data
A catalogue record for this book is available from the
British Library

ISBN 978-0-500-28855-9

Printed and bound in China by C&C Offset Printing Co. Ltd

To find out about all our publications, please visit
www.thamesandhudson.com. There you can subscribe to
our e-newsletter, browse or download our current catalogue,
and buy any titles that are in print.

City Council

Newcastle Libraries and Information Service

☎ 0191 277 4100

Please return this item to any of Newcastle's Libraries by the last date shown above. If not requested by another customer the loan can be renewed, you can do this by phone, post or in person.

Charges may be made for late returns.

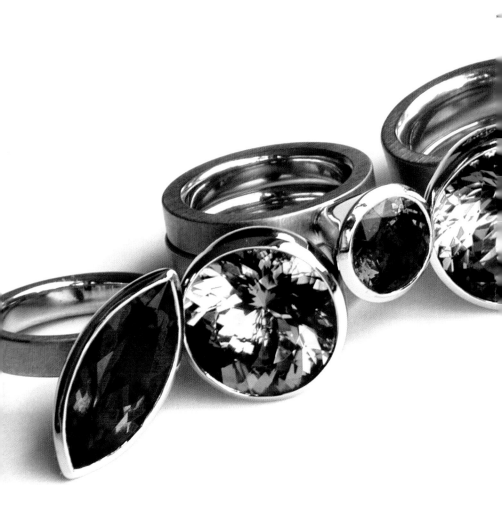

contents

the makers

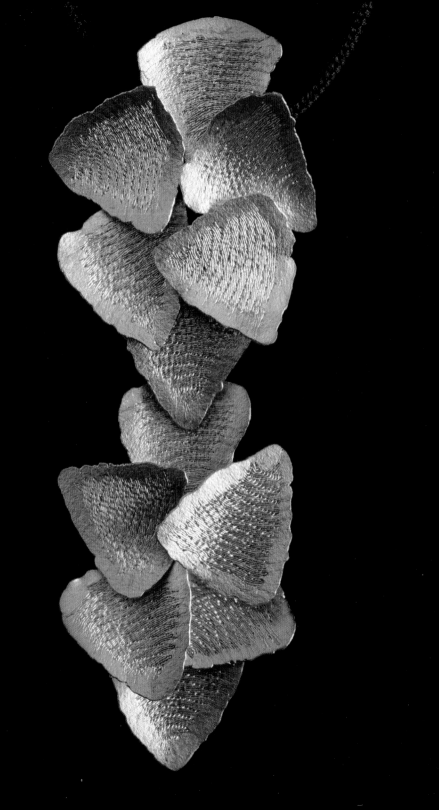

introduction

These are exciting times for contemporary jewelry. More than ever, makers, designers and collectors are coming together to create imaginative pieces through a mixture of craftsmanship, creativity and patronage that challenges traditional notions. It is fascinating to watch how, over time, this highly portable and visible art form manages both to reflect an individual's artistic temperament and to serve as a response to what is taking place in wider society. Wearing a work of art that has an emotional meaning and is at the same time unique in its design, beautifully unites concept and creation. Collecting jewels of good design, manufacture and craftsmanship has now entered a new era of vast potential and diversity.

Jewelry has been a part of my professional life for nearly three decades. Having worked in a variety of roles, including fourteen years as a senior jewelry expert and auctioneer at Sotheby's, I now have a jewelry consultancy business that includes the 'Jewellery School of Excellence', where I conduct masterclasses to teach people what to look for in a piece of jewelry and how to appreciate craftsmanship and design, be it antique or contemporary. It is inspiring to witness people who know little of the field reacting with enthusiasm when confronted with the work of a talented craftsman, and it has been interesting to see how attitudes towards jewelry have altered and how it is now no longer viewed as simply a commodity or subject of study. Jewelry-making has developed a sophistication that aligns it much more closely with the world of fine art. Talented goldsmiths and jewelry designers and makers are creating individual pieces that are cherished as artworks far beyond the intrinsic value of the materials used.

Jewelry is both personal and theatrical, and the importance of craftsmanship is paramount for discerning buyers in search of originality that amplifies the powerful emotional resonance of a piece. Designer/makers see their relationship with those who own their work as vital, and pieces rapidly develop a personal significance for both wearer and creator. I wear rings by three different makers, which gives me both a sense of affinity with their creativity and the far more mundane relief that I will never attend a party where someone else is wearing the exact same rings. Indeed, in such situations they often act as a conversation starter.

Contemporary jewelry is truly international, with designers and makers from across the world stretching the boundaries of the field. With practitioners from the United States to Japan, Germany and the United Kingdom, jewelry is finally assuming its rightful position as an art form. In my own small way I have assisted in this, having curated a selling exhibition at Sotheby's, London, entitled 'London Rocks' in 2006, where designer/makers were invited to showcase their work. I believe it is important not to dissociate jewelry from its maker, and the show was enhanced by the presence of the artists themselves. Even in the relatively brief period since the last 'London Rocks' in 2007, jewelry has moved on again, with an increasing number of artists looking to it as a means of expression.

This book focuses exclusively on designer/makers – individuals who create both the concept and the finished work. It includes jewellers working in a wide range of materials, from diamonds to nylon, and demonstrates both that craftsmanship is paramount and that contemporary jewelry is accessible to all. It brings together forty key names – both established and emerging – that anyone new to this field will need to be aware of and anyone already immersed in it would expect to see. These are names to watch, for they are creating what will become the antiques of the future.

There still remains a need to help artists and goldsmiths achieve the recognition they deserve and to bring their creations to the widest possible audience. This book reveals the huge creativity in jewelry-making today and will help new buyers feel comfortable in exploring this art genre. It is also an opportunity to share my passion and belief that jewelry is 'wearable art'.

jacqueline ryan
brooch, 2008
vitreous enamel
and 18-carat gold

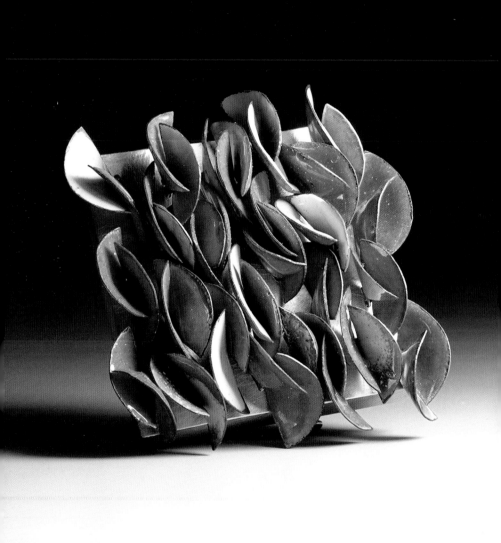

buying jewelry

Buying jewelry is one of life's pleasures, but people often think you have to be wealthy in order to collect it. This is certainly not the case – you can spend as little or as much as you like, depending on your budget – but there are three main things to keep in mind: jewelry should be appreciated for its originality, its craftsmanship and its wearability. Wearing jewelry is a form of self-expression and should make you feel good, so choose a jewel that reflects your personality and, whatever style you prefer, always buy the best you can afford. Do not be scared to mix styles – antique pieces can be worn with modern ones – just ensure that the quality of craftsmanship is consistent. If the jewelry looks fantastic, so will you.

Jewelry comes to life when it is worn. If you are just beginning your collection or buying a single special item, it is a good idea to try on as many different pieces as possible to get a feel for what suits you. Auction houses and jewelry fairs are a great introduction, allowing you to study pieces from the past and present. Jewelry shops and makers will also be delighted for you to try things on – how else will you know if you like them? Take time to study and handle the jewel; it should feel good

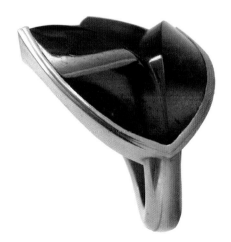

charlotte de syllas
'tulip' ring, 2003
tourmaline and
22-carat red gold

to the touch. It should be possible to feel the quality of a piece: rough or smooth, light or heavy? Explore the reverse to see if it is well finished. If a piece looks good from the back, this is usually an indication that it is well made.

Buying a jewel is an important decision, so take your time, ask questions and explore all the options available. Building a collection is challenging but does bring a huge amount of pleasure. Do not buy with the intention of making a quick profit: jewelry is not first and foremost about investment, it is about passion. It can be difficult to ignore intrinsic value, but the best collections are the ones that reflect the taste and style of the collector, while the worst are those that have been assembled in the hope that money will be recouped or value increased over time. As with any art form, jewelry can fall prey to fashion and style – my advice is to buy the best you can afford and buy it because you want to wear and treasure it. In terms of contemporary jewelry, collecting works of art by young talent is always interesting, while being able to commission pieces from and become friends with the artist is a remarkable opportunity. There is something immensely rewarding

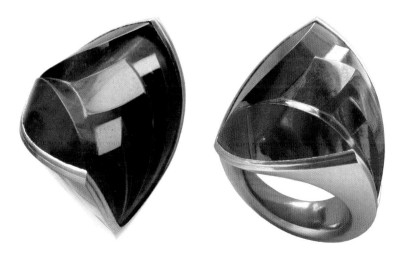

about discovering a young, talented designer and being able to give support and encourage them by buying their work. So be bold and enjoy the experience. Be careful, though – it can become addictive.

designers and designer/makers

I strongly believe in collecting jewelry made by designers who also have an understanding of how to make their pieces. Some of the most sought-after antique jewels today are those from the workshops of master craftsmen who designed their pieces themselves or worked extremely closely with a designer.

There are many today who only design jewelry and then have it made up in other workshops. For this book I have sought out designers who are able to make jewelry as well, even if it is only fashioning the prototype before instructing other craftspeople on creating the finished product. This level of involvement gives a crucial understanding and insight into the discipline of creating jewels. Technological advances, in particular computer-aided design, have changed the way jewelry is created, yet the challenge is still to combine these 21st-century possibilities with skills that have existed for generations. The technical knowledge of how to make a piece is vital to create truly great jewelry.

the artists' materials

For some collectors, gemstones are very important, and everyone is familiar with the big five: diamond, emerald, ruby, sapphire and pearl. When buying jewelry that includes these stones bear in mind that they can be expensive and that there are other varieties of gemstone that can be equally, if not more, exciting. There are three key qualities to look out for in a gemstone: beauty, rarity and durability. In my view – shared by many contemporary makers – the division of stones into precious and semi-precious is arbitrary. If a stone possesses these three qualities it is automatically precious.

Gemstones are normally valued by their intensity, richness and evenness of colour, but stones of a subtle shade can still qualify as 'vibrant', referring to their sparkle and life. Colour can indicate the

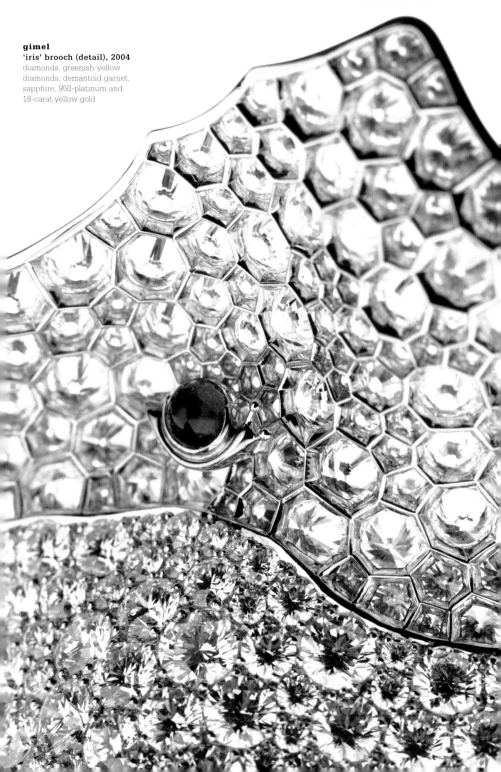

gimel
'iris' brooch (detail), 2004
diamonds, greenish-yellow
diamonds, demantoid garnet,
sapphire, 950-platinum and
18-carat yellow gold

origin of a gemstone; a blue stone could be either sapphire, blue diamond, aquamarine or topaz, to name but a few, but each hue of blue is unique to a particular variety, and a discerning eye will be able to ascertain the difference. Colour in gemstones has not been standard-ized as with diamonds, so the desirability of a certain shade is often a matter of personal preference.

Another important aspect when assessing gemstones is whether naturally occurring impurities, cracks or fissures distract from the beauty of the stone or weaken its structure. Inclusions are another means of identifying where stones come from – sometimes this can be narrowed down to the country and mine. It is worth remembering that each gemstone is unique; those of exceptional quality are rare indeed, which will be reflected in the price.

It is not advisable to give in to the temptation to buy loose stones while abroad: it is unlikely that you will achieve a better deal than a professional gemstone dealer; in fact you will probably pay more and run the risk of buying a misrepresented synthetic, imitation or treated stone without realizing it. If you wish to buy stones to be made into jewelry, there are many shows in London, Paris, New York, Germany and the United States where stone dealers exhibit. These dealers, who are recognized across the world, will ensure that you get to see a diversity of stones of good quality and, crucially, value for money.

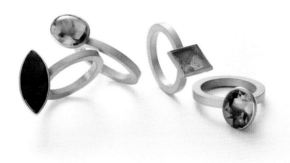

**ulla and martin kaufmann
rings, 2005**
red and green tourmaline, aquamarine, peridot and gold

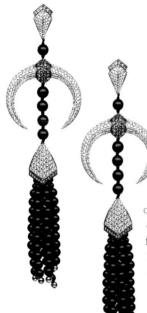

shaun leane
'tribal deco' tassel
earrings, 2008
tsavorites, white
diamonds, onyx beads
and 18-carat white gold

However, it is usually best to discuss options directly with your chosen jewelrymaker, who will be able to arrange to show you a selection of stones.

Natural pearls can be as scarce and expensive as high-quality gemstones, and therefore in the context of contemporary jewelry, designers and makers will more commonly use cultured pearls. These are formed by placing a bead inside an oyster or freshwater mussel: if the mollusc is unable to expel the foreign body it will excrete nacre (mother of pearl) to enclose the bead as a form of protection, resulting in a pearl. Cultured pearls divide into two categories – nucleated and non-nucleated. Nucleated cultured pearls are formed by grafting a small piece of flesh from a bivalve into a host (a saltwater oyster or freshwater mussel), along with a mother-of-pearl bead nucleus. The graft encapsulates the bead with a pearl sac and secretes pearly material (nacre) to enclose the bead. With non-nucleated pearls, only a piece of flesh is inserted into the graft, which forms the pearl-bearing sac; the absence of a bead nucleus means they are composed entirely of pearly material. A more recent innovation is to use a gemstone as opposed to a bead, allowing the finished pearl to be carved to reveal the coloured stone underneath. With pearls, as with gemstones, it is better not to purchase directly from producers in the Far East, as often the best pearls have already been exported for sale in the Western market.

Apart from the 'big five' already mentioned, contemporary jewellers use a wide variety of other stones such as spinels, rubelites, kunzites, peridots, demantoid garnets, paraiba tourmalines, and pink and yellow sapphires to incorporate into designs, with diamonds often being used to complement them. Many contemporary makers also use alternative materials, proving that precious metals or gemstones are not always necessary to ensure that a piece will endure. Such materials as acrylic, wood, plastic, glass, steel or rubber are often combined with precious metals, giving an additional dimension to a collection, or are used on their own. It is fascinating to see the ways in which makers successfully incorporate these materials into their work.

giovanni corvaja
bracelet, 1996
22-carat gold

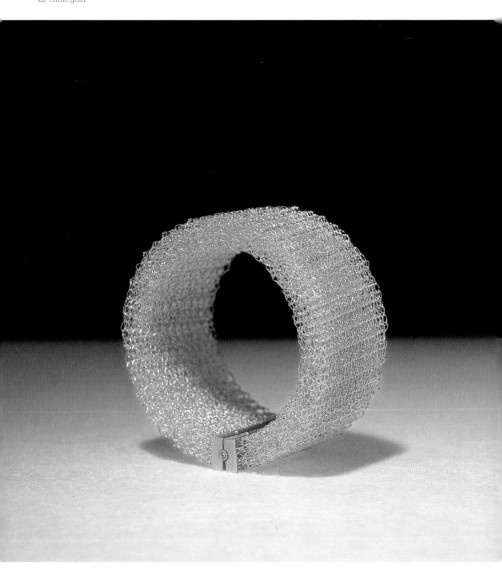

the importance of authentication

As with many other collectibles, fakes and forgeries also exist in the world of jewelry. In a similar way to paintings, a signature can verify whether a piece is a genuine example of a maker's work. When collecting in any discipline, it is important to buy items that are unique or from a limited edition – an original is always going to be more desirable than a copy or reproduction. However, this will be reflected in the value of the piece, and it is important to be aware that many contemporary jewelrymakers do not sign their creations, relying on individuality and technical skill to set their work apart.

There are synthetic gemstones made to represent real stones, with the same chemical composition as naturally occurring stones. The price difference between the two reflects the value to collectors of something formed by nature rather than by man. There are also imitation stones that look like real stones but have quite different physical properties. In addition, natural stones are frequently treated or enhanced to improve their look and increase their price.

Imitation or synthetic stones can be desirable in their own right, but it is vital that their origin and properties are disclosed and reflected in the price. To determine whether a stone has been enhanced or treated is not straightforward and requires a highly trained eye. A pleasing natural colour will invariably command a higher price, so in order to achieve a 'better' result, gemstones are often subjected to temperatures from 800 to 1,800°C. The length of exposure can be minutes, hours or even days, depending on the stone and the desired colour. How difficult it is to identify whether a stone has been treated depends on its origins and properties. Heat treatment is common in many gemstones to enhance their colour: aquamarine and tanzanite are routinely heat-treated whereas other stones, such as rubies and sapphires, are more highly valued if there is no evidence of treatment. It is also interesting to note that collectors in different parts of the world have varying preferences: for instance, a desirable ruby in India would have a pink hue, while in Europe a deeper red would be considered ideal.

If you are investing in an expensive stone – be it a diamond, ruby, sapphire, emerald or natural pearl – it is strongly recommended that

you buy it with a certificate of authenticity from a reputable gemological laboratory. Many countries issue such certificates, but only a few are internationally recognized. Most jewellers expect that the buyer will request a certificate stating whether a stone is natural, synthetic or enhanced, particularly with large rubies, emeralds and sapphires, as the difference in price between natural and heat-treated stones is significant. Discerning the difference between a natural and a cultured pearl is a more complicated procedure, and the only conclusive way is by X-ray, which must be done in a gemological laboratory. Recognized laboratories include the Gemological Institute of America, the American Gem Society and the American Gem Trade Association in the United States; the Deutsche Gemmologische Gesellschaft in Germany; the Swiss Foundation for the Research of Gemstones and Gübelin Gem Laboratory Ltd in Switzerland; and Hoge Raad voor Diamant in Belgium. In general, with contemporary jewelry design, makers often choose stones and pearls not for their value or perfection, but because the colour or particular imperfections give a distinct appeal – such pieces would not warrant the expense of a certificate, as it is the overall look, as opposed to the value, that is important.

Many jewelry pieces are marked: if a piece is made of gold, silver or platinum then you should check the assay office hallmarks, which indicate the metal content and guarantee purity and quality. Maker's marks usually appear together with hallmarks. There are differences between countries regarding the standards for precious metals and hallmarks used, and it is best to consult a reputable source (www.thegoldsmiths.co.uk, the Goldsmiths' Company website and *Tardy's International Hallmarks on Silver*). Some knowledge of hallmarks can help collectors feel more confident about what they are

adam paxon
'how tongues wag'
brooch, 2009
laminated, thermoformed, handcarved lacquer and epoxy with stainless steel pins

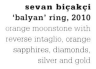

**sevan biçakçi
'balyan' ring, 2010**
orange moonstone with
reverse intaglio, orange
sapphires, diamonds,
silver and gold

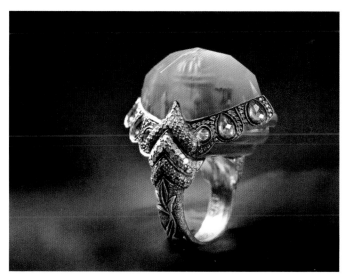

buying. Should there be no hallmark, maker's mark, stamp or engraved signature, it is advisable to ensure that the item is accompanied by the original or a facsimile design, a fitted box bearing the maker's logo and the original receipt, as these all help in authenticating the item.

commissioning jewelry

One of the most rewarding aspects of collecting contemporary jewelry is the opportunity to commission pieces directly from the designers and makers. This gives you the chance to tailor the design to suit your personal taste. Do not be discouraged if you like a certain design style but would like to commission something smaller. You are the jeweller's canvas, and they will work with you to create something you are comfortable with – your confidence as you are wearing the jewelry reflects well on the designer. It might be tempting to choose 'celebrity jewellers', but it is best to trust your own taste. Bespoke jewelry is all about creating jewels for the individual, not about wearing a brand.

The first commissioning stage is a discussion with the jeweller about what your piece should look like exactly, be it a ring, brooch, necklace or pair of earrings, and the budget available so they can make informed choices about the stones, colours and shapes. This process takes time, and sometimes mock-ups are produced to give a more concrete idea of what the finished piece will look like. Agree to a design only if you are completely happy with it. Once you have agreed on the

OPPOSITE
jacqueline mina
'cycladic' brooch, 1999
18-carat gold

piece it is a question of waiting for it to be finished as particular stones may need to be sourced. Makers are usually happy to show the various stages of a piece during its creation – a great opportunity to understand and appreciate the skill that goes into it – but it is only at the final stages of the process that a piece truly comes alive.

In recent times, a number of notable fine artists have turned their talents to designing jewels. This challenge has in the past been embraced by the likes of Pablo Picasso, Salvador Dalí, Georges Braque, Man Ray, Lucio Fontana and Alexander Calder, and now collectors have the opportunity to acquire works by such artists as Anish Kapoor, Subodh Gupta, Damien Hirst, Ron Arad, Tim Noble and Geoff Roberts. All have recognized in jewelry an art form in which they can successfully express their creativity while paying attention to the craftsmanship. Overall this is a positive and interesting development, allowing

andrew lamb
oval brooch, 2004
silver and 18-carat
yellow gold

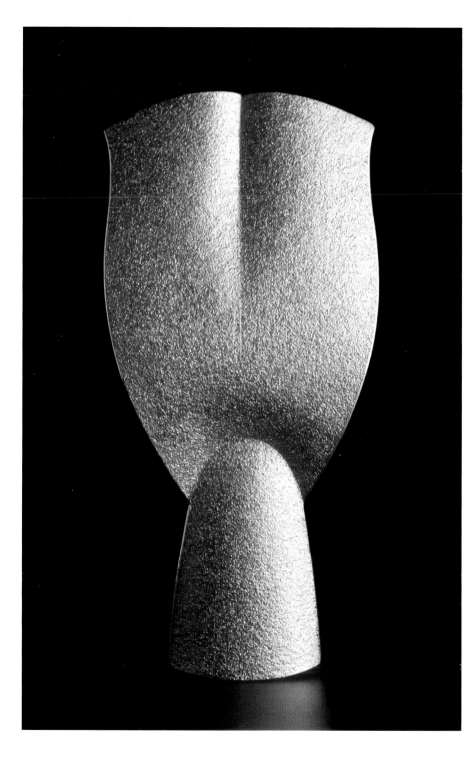

collectors to acquire affordable works by famous artists and also open-
ing the field of jewelry to discerning art collectors.

ethical jewelry

With jewelry the term 'ethical' can be contentious, but it is an area of
increasing importance. Diamond- and gold-mining have often and
rightly attracted a bad press, but there are numerous groups seeking to
ensure that minerals and stones are sourced in a responsible manner.

One of the most prominent independent certification symbols for
gold and associated precious metals from small-scale or artisanal
miners comes from the Fairtrade Foundation, which works in conjunc-
tion with the Alliance for Responsible Mining. The mark guarantees
that miners receive fair pay, work in a safe and healthy environment
and that no child labour is used; it also promotes care for the environ-
ment and social development of the communities. The goal of these
two bodies for the next fifteen years is to ensure they are used by five
per cent of the market, which is equal to fifteen tonnes of gold.

Many jewellers are working actively with local communities to help
them profit from making and selling their own work, which both
improves their standard of living and gives them the opportunity to
maintain traditional jewelry skills that might otherwise decline or
disappear. One such jeweller is Pippa Small, who tirelessly supports
projects to give disadvantaged communities the tools and materials
to set up their own businesses. Her background is in anthropology,
and she has combined her specialist knowledge with her skill as a
jewelry-maker; the pieces she designed and created together with in-
digenous communities are stunning. She has worked with the Kuna
Indians of Panama; the Tipuani alluvial gold mine in Bolivia; MADE
in Kenya, a company whose mission is to make accessories 'by the
people for the people'; and the Afghan 'Turquoise Mountain' Project.

conclusion

In collecting contemporary jewelry the relationship with the jeweller
is paramount. The reputation and integrity of the jeweller is the most
important factor in making you feel comfortable when buying or

commissioning a piece. Personally, I think different styles from a variety of makers combine well, but some collectors are devoted to a single designer and maintain a special relationship with them that has developed over many years. More than anything else, it is important to wear your jewelry with pride. I met a woman recently who said she finds it awkward initiating conversations at parties, so she wears a big brooch as a means of introducing herself. That, to me, is what jewelry is all about – a statement about yourself without having to say a word.

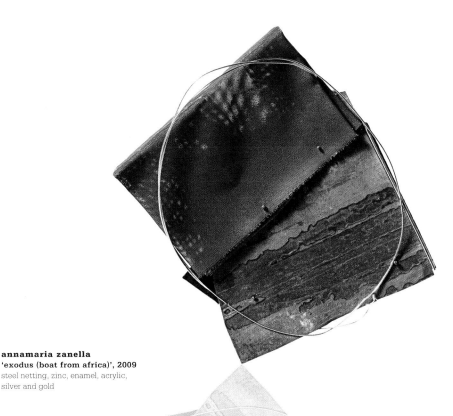

annamaria zanella
'exodus (boat from africa)', 2009
steel netting, zinc, enamel, acrylic,
silver and gold

ark

rena krishtul born: 1956, lvov, former soviet union/ukraine
anatoly krishtul born: 1957, lvov, former soviet union/ukraine

'tupo' shawl pin, 2007
pearls, diamonds, silver
and 18-carat gold

ARK stands for the initials of its founders, Anatoly and Rena Krishtul, whose work was recommended to me by a fellow jewelry enthusiast who had seen their pieces at a trade show in the United States. Their creations appealed instantly as they use familiar materials such as rubies, diamonds and gold in new ways that do not follow any trend.

Hailing from Lvov in the former Soviet Union, now Lviv in the Ukraine, Anatoly and his wife Rena, who studied glass and ceramics design, emigrated to the United States in 1979, without knowing a word of English and with only a hundred dollars. In New York the couple scoured antiques shops in search of objects to remind them of home; as Rena says: 'We bought a broken vase to remind us of our old antiques-filled apartment in Lvov. I restored the vase using the techniques I'd learned at art school, and when we took it back to the shop to trade it for something else, the owner was so impressed he suggested I start restoring things for him.' They eventually established their own business in 1982, learning the techniques to restore everything from Ming vases and ancient Chinese bronzes to pieces by Lalique, Fabergé and Tiffany & Co.

They never considered making jewelry at the time, but a trip to Córdoba, Spain, in 2006 inspired them: having admired a shawl pin in a museum, Anatoly photographed it in order to commission a similar piece from a jeweller back home. He says: 'The person we approached said he could not make the entire piece, so I decided that I would make it myself, learning the skills required for this. Someone then saw my wife wearing the pin and commissioned one for

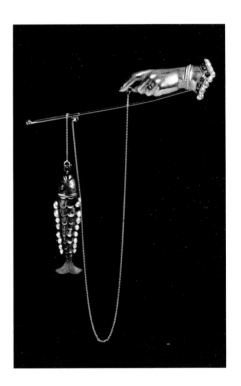

herself, followed by two articulated gold fishes as earrings to match the pin.' It is hard to believe that Anatoly and Rena only started making jewelry as recently as 2007, but they were able to draw on the skills they had developed when restoring jewels from great jewelry houses such as Cartier, Boucheron and Van Cleef & Arpels.

With a New York studio measuring 280 square metres (3,000 square feet), combining a workshop and gallery, ARK now consists of a team of five, each member covering a specific

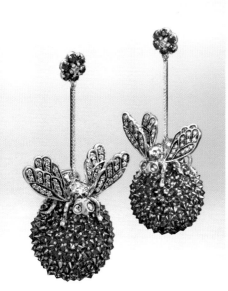

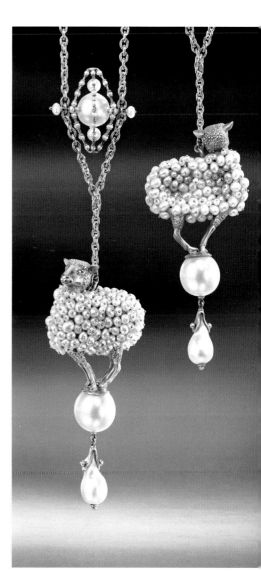

ABOVE
**'bees on a ruby ball'
earrings, 2008**
rubies, diamonds, silver
and 18-carat gold

RIGHT
'sheep' necklace, 2006
pearls, diamonds
and 18-carat gold

'lilies', 2007
diamonds, pearls, sterling
silver petals and 18-carat gold

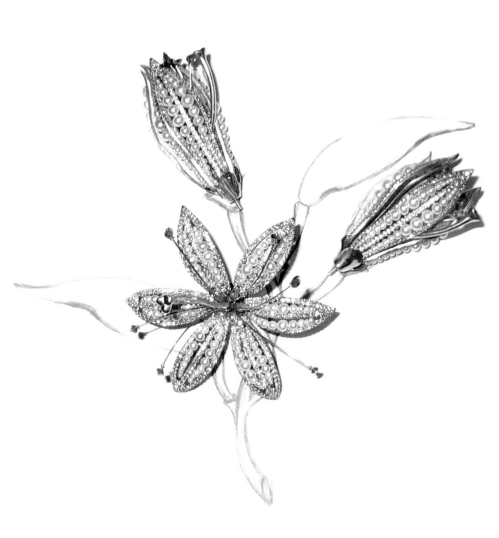

'lilies' tiara, 2007
madeira citrine, 18-carat gold and
enamelled 24-carat gold leaves

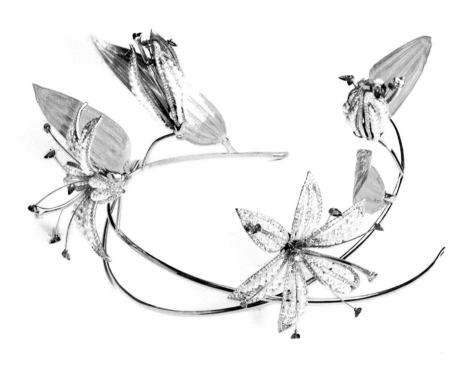

area of expertise. The restoration business continues alongside their newfound passion of jewelrymaking. Every piece they make is one of a kind, and those who commission pieces from ARK benefit from the open-minded approach that they developed when working as restorers, adapting to each new piece that needed to be repaired. 'When a client comes to us we sit with them and put their ideas on paper, first as a drawing and then as a painting, before we decide which materials to use.' One commission features a Renaissance-inspired jewel and others incorporate original antiques. Commissioning from ARK is a guarantee of originality and an opportunity to have something created that is both beautifully crafted and entirely personal.

zoe arnold

born: 1981, london, uk

BELOW
'unaware' brooch, 2010
druzy quartz, vintage
ribbon and silver

The first impression you get of Zoe Arnold's work is its freshness – it instantly engages the imagination with its inventiveness. The world according to Arnold is one of whimsically humorous chords struck between the real and the surreal: 'I find inspiration everywhere,' she says, 'in my own poetry, early cinema; animators like Jan Švankmajer, authors such as Franz Kafka, John Steinbeck, Harold Pinter or Samuel Beckett, and sculpture by Rebecca Horne and Joseph Cornell. I think Buster Keaton was an incredibly stylish man, as is anyone who wears braces.'

Arnold's originality in both concept and execution manifested itself during her studies at Central Saint Martins College of Art and Design in London, from where she graduated in 2003 with a first-class degree. Following a brief foray into the film industry, she set up her own jewelry workshop and has since participated in a number of important exhibitions and won awards for her delicately complex style.

Arnold sees herself as a sculptor first and foremost, incorporating not only precious metals and gemstones but also found objects including mother-of-pearl gaming chips, antique microscope lenses, ribbons and prints. Each work is unique and some jewels are accompanied by a limited-edition book of Arnold's own poetry – her writing is a huge source of inspiration to her – and encased in a handmade wooden display box. She went to art college 'believing I was going to become a sculptor, but as I have always liked detailed, small-scale work, it was a natural progression to become a jeweller. I still see myself as making artworks that can be worn and are supposed to

be displayed when not.' What is particularly fascinating about Arnold's work is that whatever material she is using, from 18-carat gold to wood or steel, she never compromises her standards and attention to detail.

Although she names René Lalique as 'the king of jewellers', Arnold tries to avoid the work of other makers, concerned that they will influence her design. It is this, perhaps, that ensures that her work is so rarely derivative and attracts collectors keen to acquire pieces that are instantly recognizable. Arnold's inspiration comes from eclectic sources – walking around, exploring London, visiting art exhibitions and antiques fairs to search for items to include in her designs, and writing poetry at a friend's farm.

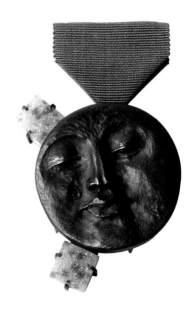

BELOW
'medal for sancho panza', 2007
brown diamonds, handcarved african
blackwood, oxidized silver, 18-carat
gold and antique print in oak box

BOTTOM
'emotions diary 2' pendants, 2010
diamonds, druzy quartz, glass lens,
enamel, fine silver, oxidized silver and
18-carat gold in oak frame

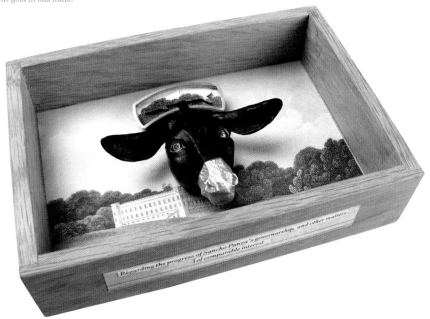

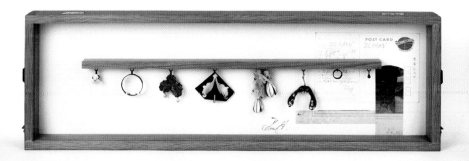

BELOW LEFT
'orbs' brooch, 2010
agate, ruby, antique photograph,
silver and 18-carat gold

BOTTOM
'emotions' necklace, 2010
porcelain, antique glass beads
from ghana and oxidized silver

BELOW RIGHT
'bee' brooch, 2007
diamonds, antique agate,
antique print, oxidized
silver and 18-carat gold

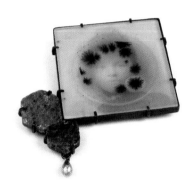

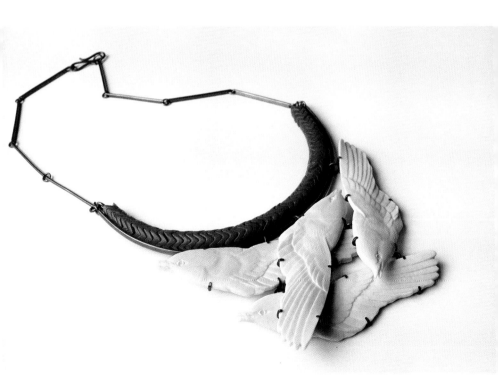

**'searching glance'
necklace, 2010**
birdseye marble and lava
cameo, druzy quartz,
mother of pearl and silver

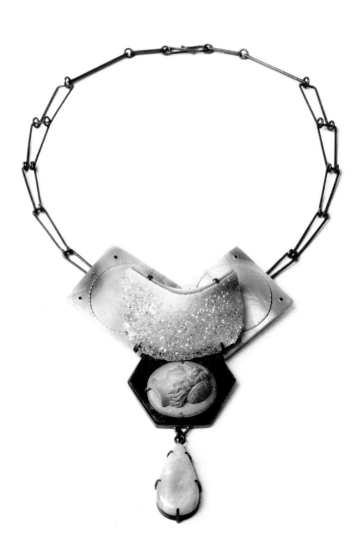

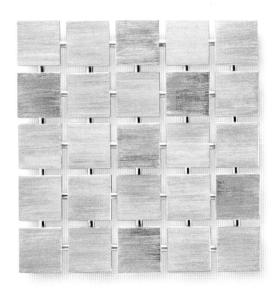

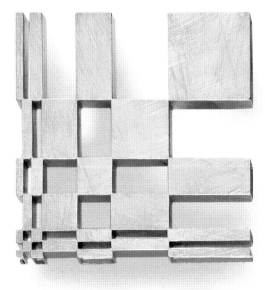

OPPOSITE TOP
brooch, 1996
18-carat gold

OPPOSITE BELOW
brooch, 2004
18-carat gold

michael becker

born: 1958, paderborn, germany

Buildings, architecture and the relationship between proportions and structure have always fascinated Michael Becker. When he started to make jewelry in 1988, he took inspiration from Italian Renaissance architect Andrea Palladio: 'I feel that beauty is achieved through order and form, which Palladio saw in nature, with his circles, squares and polygons symbolizing the universe and its planets.' Becker's gold pieces also draw inspiration from the Renaissance and Baroque. In addition he seeks inspiration in the work of pioneering modern architect Mies van der Rohe, whose symbolic designs confirm Becker's belief that absolute beauty, purity of form and structural perfection can be achieved.

Becker's pieces seem simple at first, yet on closer inspection this impression is challenged as every angle has been carefully constructed to create an element of surprise. Becker's fascination with light and how it can change perspective shows in the brushed gold surfaces. The pieces seem solid, but in fact they are incredibly light. Beautifully crafted, Becker's jewelry conveys a sense of light and space, and although his jewels draw on specific inspirations, he allows for individual interpretation, which he feels is equally important.

Becker's fascination with floorplans and city maps informs the way he works: he creates an abstract work of art while maintaining proportions and perspective, and the piece becomes 'a city without a plan; architecture without architects'. An example is his use of a streetmap of Marrakech: he feels that the city was built according to a plan that is still evident but was amended by structures being added or changed randomly. He reinterprets the plan in

several brooches, creating open spaces and enclosed three-dimensional boxes built in gold. Becker uses digital images of urban and rural landscapes, for example cornfields in America or lakelands in Canada, and interprets the pixels as contrasts of light and dark, which manifest themselves in his jewelry. He also produces small sculptures that can be worn as jewelry, constructing each piece in paper first to ensure he has the right balance of proportions to attain the harmony for which he is striving.

The creation of Becker's pieces involves handfinishing each surface by filing, etching or sanding to reveal the different shades of the gold underneath in contrast with the round polished wire links. Each piece has a natural feel; the links that form part of a necklace, for example, seem to grow from one 'mother cell', each part depending on the others and giving the work unity.

brooch, 2001
18-carat gold

bracelet, 2007
dolomite and 18-carat gold

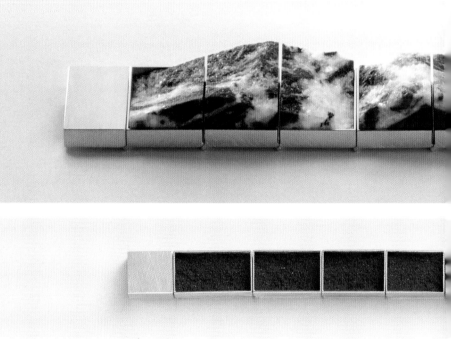

Recently, Becker has begun to use primary colours in his work and to investigate their relationship with gold and the play of light. He uses the colour from natural stone as 'it does not age or change, it stays the same, like gold'. Becker uses blocks of colour in the manner of a sculptor, taking rough lapis lazuli and setting it within articulating links to form a bracelet or necklace. At times he uses hematite, a stone with a rich metallic lustre, to achieve the depth and 'endlessness' of oil. The one colour he has struggled to find naturally is bright red; he has experimented with a red synthetic pigment, mixed with an adhesive to look like a stone, and used this striking colour as a contrast to gold, creating an artificial 'stone' that never changes in colour (see above).

Discussing his work, Becker says: 'The coloured pieces from my last catalogue ('Licht, Farbe, Raum') are almost miniature coloured landscapes. I have always explored landscapes and man-made plans from above. I am also

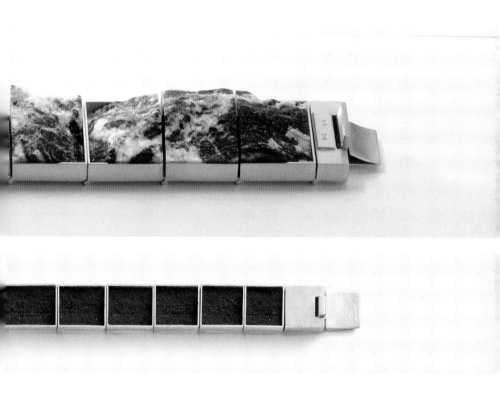

working on necklaces, bracelets and pieces
with natural-coloured stones, synthetic red
and maybe titanium, with tumbling or moving
elements.' He is planning a joint exhibition
with Annamaria Zanella (pages 180–83);
although their work seems quite different,
Becker says his pieces reflect the ethos of the
Paduan school while following his own path.
It will be a great opportunity for collectors
to explore works by two highly regarded
artist-jewellers.

bracelet, 2008
red pigment and 18-carat gold

sevan biçakçi

born: 1972, istanbul, turkey

Discovering new jewelry is a great experience and I always enjoy chance encounters with extraordinary jewellers. Turkish craftsman Sevan Biçakçi is a case in point: at a lecture I gave a member of the audience was wearing something that caught my eye. I was intrigued by the exceptional attention to detail and outstanding workmanship, so after the talk was over I enquired who had made the piece and was introduced to Biçakçi's jewelry.

He started his apprenticeship as a twelve-year-old: 'My father grew desperate about me going to school, where I had a reputation as something of a troublemaker. It was his idea for me to learn crafts.' So he was apprenticed to a local master goldsmith, and the workshop turned out to be the perfect environment to nurture Biçakçi's curiosity and creativity. Aged eighteen, he set up his own premises with two partners, working as a traditional

goldsmith producing pieces for other jewelry manufacturers. After a decade the business went bankrupt but Biçakçi says: 'This was a blessing in disguise. I was not going to do traditional work again and now have the freedom to think more creatively. I think you have to live and breathe a city to get to know it and I wanted to put Istanbul's spirit into jewelry.' He began to experiment with different designs to interpret this vision and in 2002 started his own bespoke jewelry range.

Asked to describe his style, Biçakçi encapsulates it as 'the Byzantine emperor and the Ottoman sultan meet *Alice in Wonderland*'. Each piece represents a collaboration between many skilled disciplines, incorporating the work of painters, calligraphers, sculptors, enamellers, metal chasers, micromosaic masters, inlay workers and gemstone cutters as well as conventional jewelry craftsmen – goldsmiths,

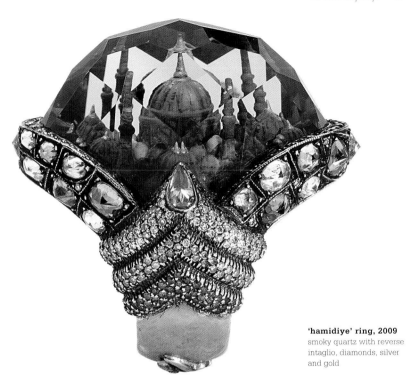

'hamidiye' ring, 2009
smoky quartz with reverse
intaglio, diamonds, silver
and gold

setters, mounters and polishers. All the craftsmen are based in Istanbul, with Biçakçi at the helm as master goldsmith and visionary. 'I am dedicated to handcrafted jewelry and love working with other skilled craftsmen,' Biçakçi says. 'I do not really use much technology – I think the only thing in my studio is a laser welder.' He produces initial sketches, which he then discusses with his fellow craftsmen to ensure that each person knows exactly what is required.

The signature of Biçakçi's studio is reverse intaglio jewelry, where a domed piece of gemstone is carved and painted from behind. This process was popular in the 19th century, and Biçakçi has taken it further by carving far deeper into the stone, giving more depth to the reliefs to create the most amazing scenes: buildings, flying doves, pomegranates, bumble-bees and peacocks, Turkish landmarks such as the Gate of Hope, Pantokrator and Seraglio

Point; and a man praying, painted to give a three-dimensional appearance. Although he has seen some Victorian examples, Biçakçi's work is definitely the product of his own imagination: 'My workshop is located in the middle of Istanbul's historic peninsula, next to the Grand Bazaar. The cultural heritage of this place is a huge source of inspiration to me: I love watching the dolphins swimming across the Bosphorus or the seagulls flying above the domes of Hagia Sophia.'

Biçakçi also uses a lot of micro-mosaic work in his jewelry, a technique that was once widely practised in Istanbul and, like intaglio, often appeared in 18th- and 19th-century jewelry. Consisting of thousands of tiny tesserae of coloured glass or stone carefully cemented together to form a picture, micromosaics possess a degree of subtlety and colour that compares to a miniature oil painting. The process is

BELOW
'okeanos un bahcesi'
('garden of oceanus') ring, 2006
rock crystal with reverse intaglio,
diamonds, mosaic with porcelain tiles,
silver and gold

OPPOSITE
'koca yilan' ('serpent') cuff, 2010
diamonds, rubies, silver and gold

extremely labour-intensive, meaning that few people practise it today – with a single piece of Biçakçi's jewelry using around 7,000 tesserae, vast amounts of patience, skill and dedication are required. Biçakçi has taken the traditional skills of both intaglio carving and micromosaics and, to some extent, divorced them from their historical context: 'I am not a jewelry historian. I like my pieces to have a timeless look, as if they had recently been excavated and discovered, but at the same time, they must have the look of today.'

Together with his team, Biçakçi makes about 300 pieces a year, although this number is decreasing as the levels of sophistication and skill increase. Eschewing commissions, for each signed work he uses a combination of metals – mainly silver, fine gold and rose gold – with bone, ebony, ceramic and gemstones. Of all the work made to date, there is one piece of which Biçakçi is particularly proud: 'I made a ring with a beautiful Colombian emerald. Its original weight was 149 carats, which I reduced to 80 by carving two beautiful putti in reverse intaglio. There was a risk of cracking the stone, and hollowing out a beautiful emerald may sound insane, but I am glad I tried since the stone is now of an incomparable beauty. It is set into a platinum ring covered with big rose-cut diamonds. The excitement of making this ring was probably the greatest for me so far.'

Biçakçi's jewels have a mystery to them and he does not like to give details of the creative ideas behind a piece, preferring collectors to bring their own interpretations to it. The lengths to which he goes to achieve his vision are unmatched and he seems to have an infinite supply of ideas. It will be interesting to watch his work develop over time: 'Jewelry is an artistic medium; you can use it as a language for expressing many things. Being born with a gift is not enough to become an artist – it is necessary to increase your skill to be able to elaborate ideas through your work. Jewelry can make this happen.'

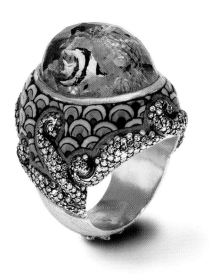

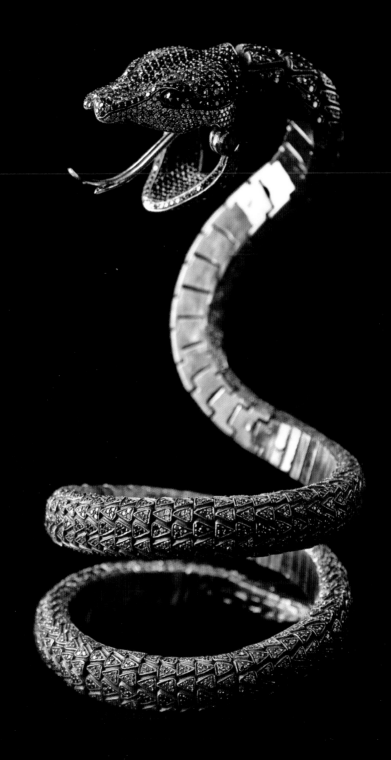

luz camino

born: 1944, chevy chase, usa

BELOW
'cactus' cuff, 2009
rose-cut diamonds, patinated bronze
and white gold

BOTTOM
'leaf' bracelets, 2006
white gold (left) and patinated bronze
(right) with diamonds, silver and gold

Spanish jeweller Luz Camino has an extraordinary passion for her work. She made history when she became the first woman to obtain the prestigious title 'Joyero Sacador de Fuego' (meaning 'Jewelry Craftsman'). Camino was encouraged to take up goldsmithing by her late husband, and even before completing her studies, she began to receive orders for work. She soon gained national and international recognition for her pieces and now works together with her son Fernando, making innovative, inventive jewelry.

Camino possesses an innate understanding of the close relationship between manufacture and design, influenced by a period spent studying fashion design in Paris, and she retains an extraordinary capacity for visualizing a piece and solving difficulties of construction. She works with a highly skilled team of craftsmen who help her implement her designs and challenges them to the limit of their talents. It is her philosophy to 'seek harmony and balance in my work, maintaining individuality, following my instincts and allowing myself to imagine and dream'.

Camino's imagination most often draws on nature. Her studio is situated in a large garden, and she attempts to capture the natural world in her work. This ongoing conversation with nature is influenced by a passion for finding new materials, textures and finishes to complement her designs. Her cactus bracelet, for example, is a remarkable feat of engineering. Starting with a watercolour drawing, the design is transferred to a computer to create a three-dimensional image, which is then translated into a wax model, from which the final piece is cast in

BELOW LEFT
miniature 'rose' brooch, 2010
rubies, diamonds, enamel,
silver and gold

BELOW RIGHT
'frozen cherries' brooch, 2008
diamonds, enamel, resin,
silver, bronze and gold

bronze. This cast is given a green patina, and the cactus spines, which are all handmade from white gold, are attached to the bracelet. Each small screw used to attach them is covered by a rose-cut diamond. Another theme Camino likes to explore in her work is the nature of time, drawing on the ocean and the cosmos for inspiration. She has designed a ring inspired by the planets and their moons, constructed from circles of pavé-set brown and white diamonds that 'orbit' the finger of the person wearing it.

The intrinsic value of the materials is not very important to Camino. Unusual combinations are a signature of her work: she uses a multitude of stones, pearls, seeds, glass, enamel, platinum, gold, silver and, most recently, titanium. Her 'Frozen Cherry' brooch (below), for example, consists of silver balls covered in red enamel, dipped in resin several times. The dripping, clear liquid is left to harden to give the appearance of melting ice, resulting in a jewel that is remarkably realistic. Bronze with

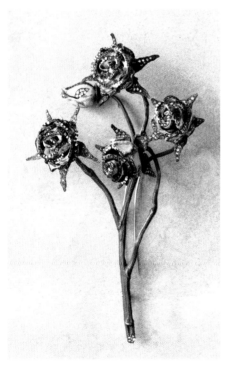

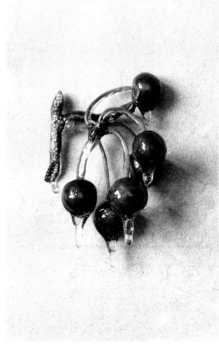

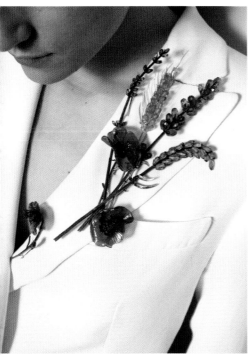

brooches: 'red poppy' (2002);
'lavender' (1998); 'wheat' (2000)
black diamonds and resin; amethyst,
enamel, silver and gold; citrine and gold

OPPOSITE
'iris' brooch, 1999
amethysts, sapphires, peridots, haliotis
shell, enamel, diamonds, silver and gold

flowers (left). Camino creates many flowers in her work, such as pansies and violets fashioned from enamel, diamonds and gold, and yucca flowers made from peridots, silver and gold.

Camino has acquired a significant portfolio of private clients in Madrid, Paris, Rome and New York, and they have one thing in common: a demand for jewels with a high degree of distinction and exclusivity. Camino's dedication to these exact principles has over the years led her to reject offers from several department stores to create pieces for them, as she does not want to compromise the standard of her work. Her method of working requires a high level of commitment; she supervises every detail, and as each piece is made by hand the output is limited. All her pieces are signed with a triangle motif next to the signature; she has always made limited editions, allowing the initial design to evolve with subtle variations. Since 2003, Camino has been showcasing her work through the New York department store Bergdorf Goodman, exhibiting new limited editions and bespoke one-off jewels.

Recently one of Camino's jewels – a butterfly made from moss agate with each wing outlined with a small line of diamonds – was chosen to join the permanent collection of the Musée des Arts Décoratifs in Paris, a great distinction. Camino is trying to create not merely jewels but 'portable works of art', and the special appeal of her work is that it can be worn with anything and yet retain the style and distinction that epitomizes the jeweller herself.

diamonds and tsavorites (green garnets), sea urchin shells with labradorite and white gold: Camino's combinations are endless and often unexpected, but they always work. She says: 'I like to take commonplace materials and make them precious through my designs', but states that not all jewelry is automatically art. It is hard work to achieve excellence, just as in every other form of artistic expression: 'Inspiration will only take you so far, but it is my desire to create pieces that do not compromise quality but allow jewels of merit to be created.'

The way a piece is worn is vitally important to Camino's creativity. She is always exploring new ways in which her jewels can complement each other, worn together or individually. A single poppy made from resin, black diamonds, silver and gold can be worn on its own or together with similar pieces to create a posy of wild

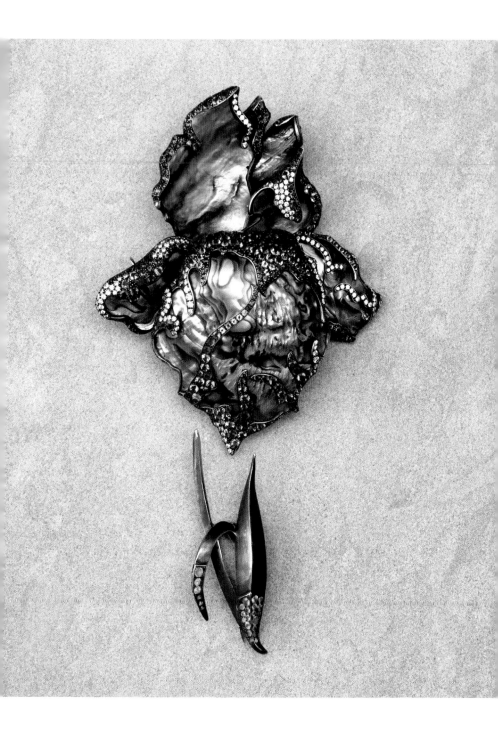

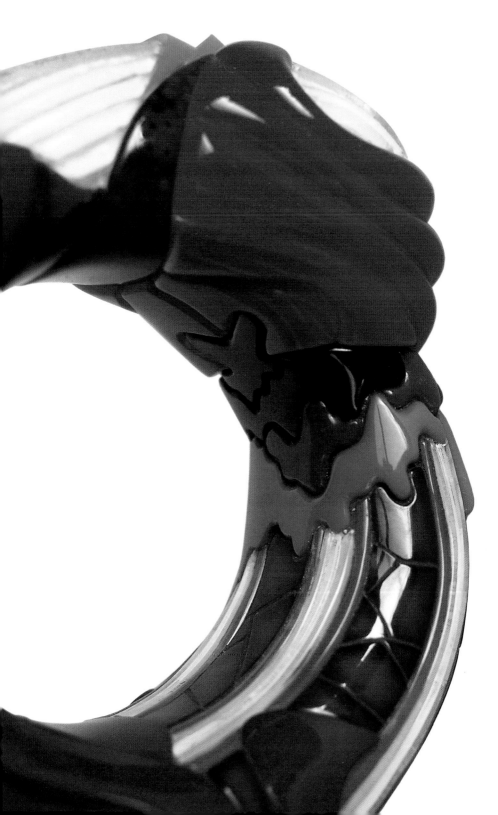

peter chang

born: 1944, london, uk

Peter Chang did not start making jewelry until
the 1980s, but his previous extensive experience
as an artist, sculptor and printmaker infuses
his jewelry. Having finished his training at the
Slade School of Fine Art in London under the
celebrated sculptor Reg Butler and at the
Liverpool College of Art (sculpture and print-
making), he spent a seminal period in Paris in
1967, studying at Atelier 17. Under the tutelage
of innovative printmaker Stanley William Hayter
(who had worked with the likes of Max Ernst,
Pablo Picasso, Jean Arp, Alexander Calder and
Jackson Pollock), Chang's ideas about materials,
colour and form were developed. He applied
these ideas to sculpture, creating pieces ranging
in height from five centimetres to five metres.
It was also through exploring such materials as
plastic that Chang was drawn to jewelrymaking,
initially making pieces for his wife.

Chang does not describe himself as a
designer and sees sculpture and jewelry as
the same discipline on different scales. He
approaches his work as a sculptor and explores
his ideas through numerous drawings. These
drawings constitute a 'thought bank' that
extends over many years: 'My preliminary
drawings are points of departure. They make
me approach and solve problems differently to
a three-dimensional piece, so a drawing is only
helpful to an extent.' Chang's pieces retain a
mysterious quality as he works on them, and
he is never sure how a piece he is making will
finish: 'I don't know which direction a piece of
jewelry will take. This element of surprise is one
of the things that keeps me going. If you know
what you are going to do, why bother doing it?
I want people to approach my work as they

OPPOSITE
'italian bracelet', 2010
acrylic, resin and gold

might a piece of music. When I go to the opera I may not understand the words but I like the music. It affects me on an intuitive level as opposed to an intellectual level. I would like my work to be approached in the same way.'

Chang has worked with plastics for more than fifty years – he was initially drawn to the material because of its wide availability but also its great potential, which never ceases to amaze him. The use of acrylics in visual arts when he first started to use them was bland and limited. Chang began to explore changing the material through heat treatment, and although the colours available at the time were often crude and artificial-looking, the plastic could be worked into something more subtle. He uses mostly recycled acrylic, mostly off-cuts from sign-writers' workshops: 'In a small way, I can encourage others to recycle. I also use small qualities of gold at times, which is also mostly recycled. This not only benefits the planet, but also decreases the use of blood diamonds and the pollution from gold extraction.' With his ethical ideas, which are so relevant today, Chang was ahead of his time. He takes inspiration from eclectic sources, from the black and yellow warning colours of wasps and tigers or the plumage of birds of paradise to the recycled lenses of car rear-light clusters or colourful running shoes. As he says: 'The inspiration for my designs comes from totally opposite ends of the spectrum: looking at the warning colours in nature I was fascinated that they can be used for attraction and repulsion, and I am also intrigued by the trainers that young kids walk around in. They come in such fantastic colours.'

The construction of Chang's jewelry is highly sophisticated, particularly in his larger pieces. They appear as though they are very heavy, yet they are incredibly light. Formed over a wooden or polyurethane foam core, each piece is built up using layers of polyester resin and fibreglass, to which sheets of acrylic are applied and heat-moulded into shape. Chang occasionally carves into the piece and at times applies additional layers of resin before sanding and polishing. He enjoys the challenge of exploring the qualities of his materials, finding satisfaction in creating glamour and sensuality out of a flat sheet of plastic. He is constantly trying to develop new techniques, although he does not use computer-aided design in his work: 'I always try to walk my own path, and try to be as original as possible. Whether what I produce is good or bad only the viewer will judge.'

Chang's unique vision has international appeal, attracting numerous collectors in Germany and America through the bold shapes and contrasting colours of his work. However, he does not take on commission work: 'I do not really consider the person who is buying the jewelry, as for me jewelrymaking is a means of self-expression. I am not prepared to fall into the trap of following fashion. As with sculpture, painting and other art forms, as an artist you have integrity. A painter would not paint a picture to match someone's wallpaper.' Chang's independence is admirable. All of his pieces are truly unique, and he does not sign them but relies on his distinctive ideas and execution to set his work apart. Chang's work is timeless and fascinating, challenging the way we perceive jewelry.

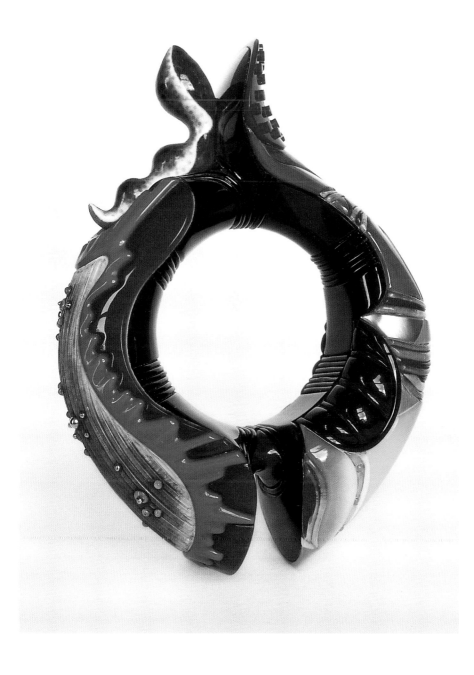

kevin coates

born: 1950, kingston (surrey), uk

BELOW
'ovid metamorphoses
(dionysus and the tyrrhenians)'
loving cup, 1995
parcel-gilt silver (part patinated)

OPPOSITE
'cerambus' mounted pin/brooch, 2007
green opal, stag-beetle head and
abdomen case, 18-carat white gold (pin)
and 20-carat yellow gold

Seeing the home of Kevin Coates and his wife
Nel, you quickly realize how many important
themes in his jewelry can be traced back to this
welcoming environment. Their house is filled
with numerous interesting objects that clearly
carry important meaning for their owners.
The walls are covered with books from floor to
ceiling, while images of Mozart can be seen
everywhere. The importance of music is evident
in the presence of a fortepiano, harpsichord,
baroque mandolin and *viola d'amore*. Coates has
always been drawn to many different disciplines.
A talented musician, he also holds a doctorate
in philosophy and has studied mathematics
and sacred geometry (he has published a book
on the subject), and he brings his interests in
philosophy, mathematics, music and poetry to
his jewelry creations.

In the same way that Coates combines his
various intellectual influences, he excels at
combining different materials in his jewelry.
Inspiration comes from numerous sources – it
may be as simple as the chance discovery of
an object such as a pebble, or come from a more
complex source. A fine example of Coates's skill
is the 'Cerambus' pin from his *A Notebook of
Pins* collection. Using a stag-beetle head and
abdomen case, he refers to the classical story
by Ovid about the shepherd Cerambus who
was transformed into a stag beetle. Coates
carved the metamorphosing body of the
shepherd from 20-carat gold, with the legs
pushing through the iridescent abdomen and
the antlers grasping a green opal.

Metamorphoses have been a long-standing
interest for Coates – Ovid's *Metamorphoses*
would be his desert island book of choice – and

a number of his jewels explore this idea of
creation and transformation. The theme also
appears in his larger pieces, such as the 'Ovid
Metamorphoses' cup, which features pirates
transforming into dolphins (above). Coates loves
to work with metal or stone with imperfections,
as in his 'Lazarus' ring made of gold with a
flawed moonstone (overleaf). Colour also plays
an important role in his work as he tries to show
the broadest possible range of tones, feeling
that the more colour he introduces to a piece,
the greater the enjoyment for the person wearing
it. Coates's work often has a long gestation
period and he develops his ideas in a notebook,

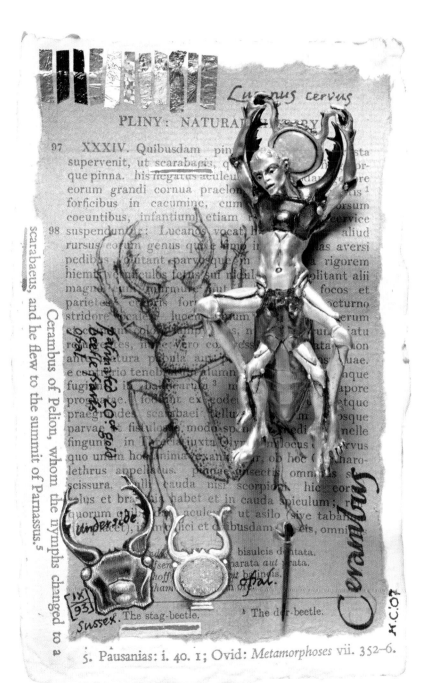

'lazarus' ring, 1991
grey moonstone, fire opals,
18-carat yellow gold and
patinated red gold

producing designs that are stunning works of art in themselves. For *A Notebook of Pins*, he felt the designs had become an integral part of the work and so he encased them in a Perspex display together with the pins: when the pieces are not being worn, the pins are fixed onto the designs so they become freestanding works of art.

Coates is a goldsmith par excellence and each piece of jewelry is lovingly executed to the highest standard. He sees his creations as complete works of art, as opposed to just smaller versions of artworks. His pieces may be physically small but they are always larger-than-life in meaning and presence. Coates pays extraordinary attention to detail, spending time on the fasteners and fixings of his jewels, which are often overlooked. This level of attention extends to Coates's consideration for those who wear his jewelry. He is aware that wearing a special piece can boost one's self-confidence, and each jewel he creates is unique.

Commissioning from Coates is a major undertaking as he takes many hours to become acquainted with a new client before beginning the design process, but this is also a wonderful opportunity for the client to get to know the artist and work closely with him. An idea usually starts to take shape during initial consultations, and the end result is worth the investment. Coates sees jewelry as a reflection of a person's stage of life. As he says: 'A piece may take three months to produce but it has my thirty years' experience in it.'

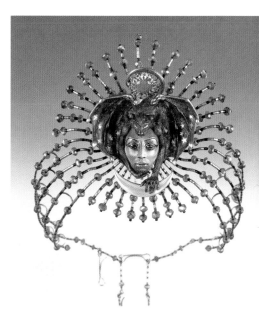

**'entry of the queen of the
night' tiara/neckpiece, 1996**
carved and inlaid grey moonstone,
fire opal, labradorite, white and
variegated mother of pearl, sulphide
patinated silver, 18-carat yellow gold
and white gold

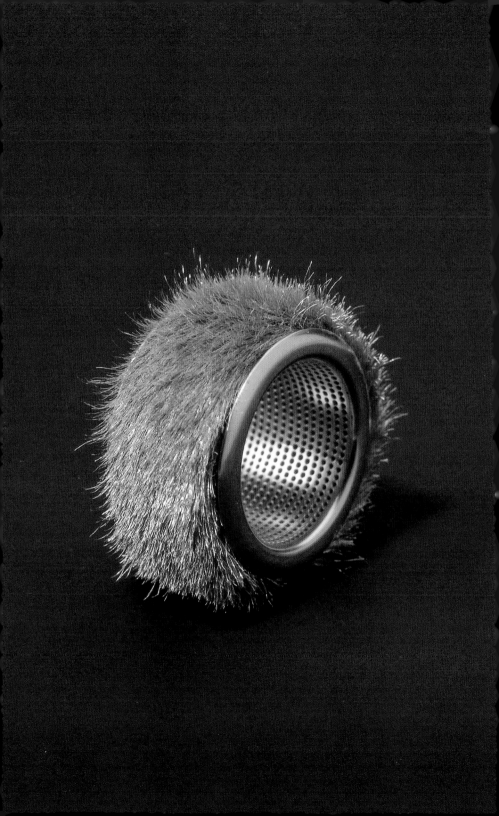

giovanni corvaja

born: 1971, padua, italy

'When I hold a piece of gold in my hand, I can feel its energy. I am aware that this is a moment of creation, a miracle of nature.' This statement conveys Corvaja's passion and the essence of his work: a deep affinity with the materials and the innovative and inventive techniques that he uses to bring out the best in them.

Corvaja was born in 1971 in Padua to a family of academics and chemists, his father being a professor of chemistry at the university. He has had an almost obsessive relationship with gold and other metals from early on: 'Ever since I was a child I have found metals interesting – the way they feel, the way they reflect light, the way they can so quickly absorb the warmth of our hand.' Corvaja soon developed a good understanding of gold. It was the beginning of a love affair – 'to me, gold and platinum are symbols of evolution and perfection' – and by the age of eleven he was experimenting with melting silver and gold with oxyacetylene welding equipment. From this moment on he knew he had to work with gold and become a master goldsmith.

From the age of thirteen Corvaja attended the Pietro Selvatico Art Institute in Padua (a secondary school with a special focus on the arts), focusing on metalwork and jewelry. He feels lucky to have been taught by Francesco Pavan, one of the greatest Italian goldsmiths. He encouraged Corvaja to approach jewelry as an art form and at eighteen Corvaja was already a highly qualified goldsmith.

Although he enjoyed the meditative, accurate work required of the goldsmith, Corvaja worked mainly in silver at first; to save the money to buy gold to work with he sold his silver jewelry to female classmates. He says: 'Jewelry is my excuse to work with gold, which is so important to me. I want to create beauty.' Even when he eventually acquired gold, the expense meant that Corvaja had to experiment in making gold wire, which would make the material go further. He loved making gold look lightweight and continues to elaborate on this technique.

Soon after graduation, Corvaja's work came to the attention of David Watkins (pages 176–79), a professor at the Royal College of Art in London. Watkins immediately recognized Corvaja's talent and persuaded him to enrol on the college's prestigious Master's course, from which he graduated in 1992.

Corvaja always makes his designs directly in metal and rarely draws sketches on paper: 'I make a drawing in my mind, with all the sizes and proportions in my memory. I put my vision directly into the metal.' His 'Golden Fleece'

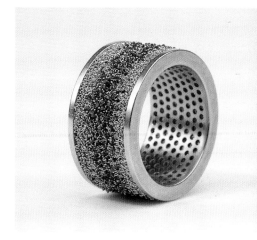

earrings and brooch, 2000
niello and 18-carat gold

collection began as a technical challenge, prompted by the idea of making cloth from gold. He developed a method of creating gold wire of extraordinary dimensions: 'The thickness of the gold wire for the pieces is only 15 to 20 microns, while the thickness of a human hair varies from 50 to 100 microns. This fine wire allows me to produce gold fur, which is one of the most tactile and pleasant materials to have against the skin.' Using a special gold alloy that is particularly ductile, he pulls the wire through smaller and smaller holes, until it reaches the required diameter. Using 18- or 20-carat gold (any

higher-carat weight would be too soft), Corvaja draws it through diamond draw plates. His experiments allow him to coil the wire and anneal it (heat it to a specific temperature and cool slowly), softening the metal so that it can be shaped and cut easily. The whole process is a truly incredible feat.

Corvaja is also known for using the ancient decorative technique of granulation: round balls of high-carat gold or fine silver packed tightly together and fused onto metal. This is a skill that he says he has spent more time researching than actually using, but it is his dream to make a

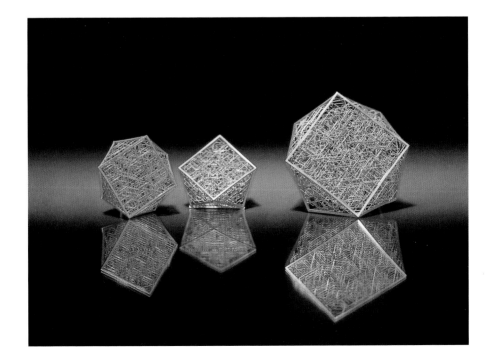

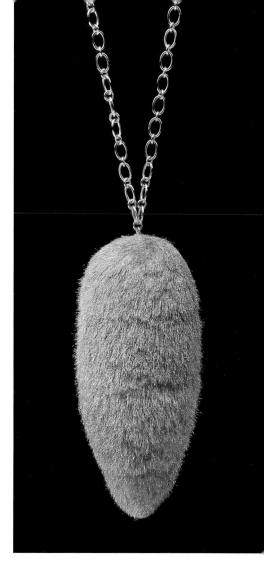

gold bridal veil, for which he has been studying lace-making techniques. He concedes that this is something that might take a few years to perfect, but his determination underlines his dedication to the craft. It will be interesting to see what he will achieve in years to come.

Corvaja insists on the importance of the right materials, always starting with pure metals: 'It is important that you work with the materials that you require, rather than trying to adapt an existing material.' He always does his own alloying to suit his requirements of hardness and colour and enjoys retaining complete control over his work from start to finish. This even extends to the packaging of his pieces and any photographs of the finished item. 'I have plenty of time to think because many of my processes are quite repetitive. I have time to consider the next challenge and how to overcome it. This time is as precious to me as the metals I work with. I am able to research a technique, which can take thousands of hours.' Sometimes he has an idea that he has to shelve at first while he resolves the technical challenges and expands his skills. One piece of his 'Golden Fleece' collection took 2,000 hours to make, while a small piece of his golden cloth took not only seven months to complete but also ten years to research.

In 2001, Corvaja moved to Todi, a historic Etruscan town in central Italy, where he now works as a freelance goldsmith artist and offers intensive private courses for experienced jewelry makers. As he says: 'Even after twenty years, I feel it is my moral duty to pass on the knowledge I gained from my teachers.' In spite of the many years spent exploring his materials, he is still discovering new properties of metal, and, quite modestly for a craftsman of his calibre, he states that he will never come close to completely understanding the materials he works with. 'There are also certain materials he has yet to use, for instance sky-blue diamonds, which are his favourite stones. The appeal lies in their distinctive lustre and brilliance, combined with pure and vibrant colour, but their extreme rarity means that he has not yet had the opportunity to work with them.

OPPOSITE
brooch, 2002
niello and 18-carat gold

BELOW
earrings, 1999 (left)
18-carat and 22-carat gold

brooch, 1999 (right)
18-carat gold (26 alloys shading
from white to red to yellow)

A Corvaja piece is a must-have for any collection, and he says: 'When a client buys a piece from me, they know that everything has been made by me.' However, he rarely takes on commissions, allowing his work to speak for itself. His collectors simply wait for his next piece, and those who bought his pieces a decade ago can now sell his work for more than double the price, which is an indication of how desirable his pieces have become. All of his work is signed, and he mainly sells through the Adrian Sassoon Gallery in London. His pieces are also exhibited in museums around the world:

'It makes me most proud when I sell a piece to a public collection. That way everyone can appreciate my work.' Corvaja is completely aware of the historical significance of jewelry and its place in history: 'To me, jewelry is an art form that has survived for millennia. Pieces that have endured have often been preserved for their beauty. While jewelry has undergone a revolution in the 20th century, it seems to have consisted of a reaction against preconceived ideas, as opposed to a positive assertion of new ideas.'

jaclyn davidson

born: 1946, pittsburgh, usa

Having grown up in Pittsburgh, Pennsylvania,
in the heart of America's steel-manufacturing
zone, Davidson was drawn to metalworking
while studying fine art at Kent State University
in Ohio after exploring a number of other craft
disciplines. As she says: 'I instantly felt a rush
from the tools that were hanging on the walls
and a great desire to know what these tools did.'

Like many creative artists Davidson had an
inspiring teacher who helped her develop her
talents. In her case it was Mary Ann Scherr,
who, as Davidson recalls, 'was this unbelievably
dynamic woman whose background was
designing cars in Detroit. When she came to
the university her ideas about jewelry were so
open. She had a conviction about what jewelry
could be, not what it should be, and from that
moment on I was dedicated to the making of
jewelry.' The material that Davidson was first
drawn to was silver, which she combined with
enamel under the guidance of another teacher,
William Harper.

Davidson recognized the commercial
potential of jewelry and, on graduating from
Kent State University, she travelled to Israel
in 1973 just as the Yom Kippur War broke out.
The contrast of this experience with university
life could not have been more pronounced.
She found a job exporting Israeli manufactured
goods, including locally designed jewelry, and
soon found herself making prototypes of pieces
for mass production. It gave her valuable
experience designing and making affordable
jewelry and using a variety of casting
techniques. 'That time was an incredible
learning experience', she says, 'I spent two
and a half years there and learned so much.

'thirteen days till winter' collar, 2007
citrine, hand-forged steel, mild steel
and 18-carat green gold

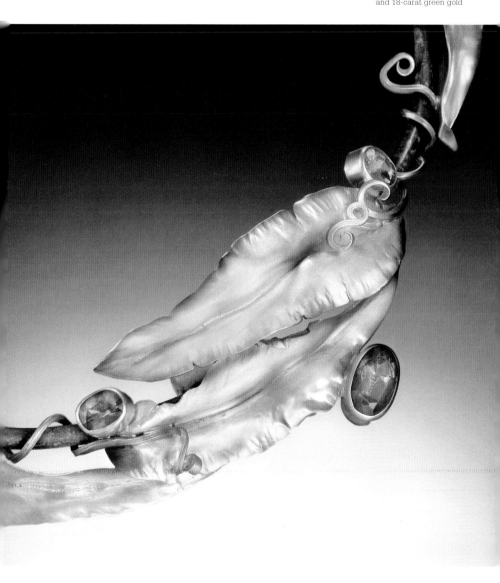

BELOW LEFT
'birch bark' pin, 2005
mild vermont steel and milled,
textured 18-carat green gold

BELOW RIGHT
'spinning forward' pin, 2011
diamonds, mild steel and hand-formed
enamelled copper sheet

I also found I was not a team player; I would get upset if someone criticized my work. The sales team would say a design was not well received and I would take it extremely personally, but I also grew up then.'

In the mid-1970s Davidson returned to the United States. While away, she had entrusted her university work to Scherr, who had entered one of the pieces in a show for young jewellers at the Renwick Gallery of the Smithsonian Institution in Washington. It was seen by Elizabeth Rockwell Raphael, a renowned patron, who arranged for a loan to allow Davidson to set up her own studio where she began to cast pieces using the skills she had learned while abroad. Raphael suggested she show pieces in craft shows, which were just starting to become established; Davidson recalls: 'I will never forget the first show I went to. I had thirty-five different pieces and I came away with $6,500. I was in tears, as I had not earned so much money before. I was about twenty-seven at the time and had met 200 or 300 people there with this fantastic sense of camaraderie.'

She began to make gold jewelry, enamelling 18-carat gold and showing a great ability to carve intricate patterns in wax, which were then cast in translucent enamel, something few makers were doing at the time. She says: 'I was making pieces with a large gold surface carved

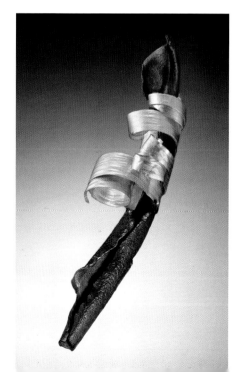

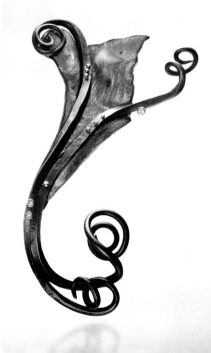

'the dance' collar, 2009
mild steel and
18-carat green gold

with a picture, which was then "washed" with enamel, leaving some areas of gold exposed. This technique drew an incredible following.'

Davidson worked in this fashion for about twenty years before starting to carve directly into the gold rather than casting it. It was, as she observes, 'an epiphany'. In designing she was inspired by the natural beauty of Vermont and sought to reproduce in gold the contrast of plants and seeds with the freshly fallen snow. In 2002, she visited some artists who were working with a blacksmith's forge and says of the experience: 'It felt so right to be surrounded by steel. For three or four years after that I would go to the forge a few days a week and help work on a couple of big projects such as fences and gates.' This experience informed Davidson's jewelry work, as she started using the blacksmith's workshop to produce jewelry in steel, decorated with gold.

Each of her steel pieces is unique, and Davidson has recently explored decorating the metal with diamonds, copper and enamel instead of gold. For other decoration Davidson uses old pieces found in antiques shops; most recently, she has taken inspiration from Japanese armour, moving away from nature themes. She uses steel with a textured surface, formerly used for farm equipment and patinated by use. Davidson keeps hammer blows to a

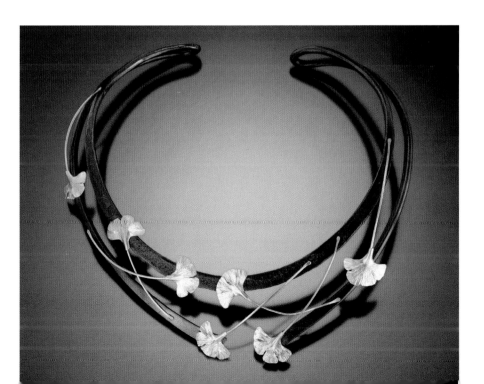

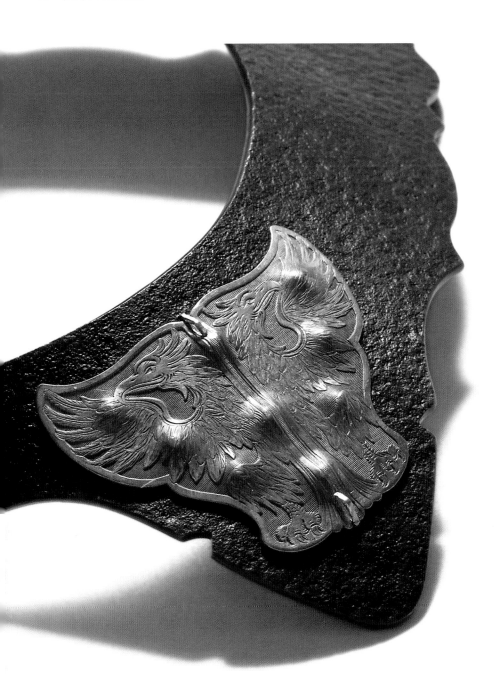

OPPOSITE
'found object' collar, 2010
hand-forged mild vermont steel
and antique brass shoe buckles

minimum when working with naturally textured steel so as not to spoil the existing texture. She combines this with rods of plain-carbon ('mild') steel that are textured with hammer blows.

The finished pieces are fastened with magnets and as the steel warms to body temperature it almost becomes part of the person wearing it, while the natural oils from the body keep the surface free from patina. When she first showed these steel pieces she was concerned that they might not be well received, but collectors have embraced her new work.

Davidson's pieces show the development of her style from when she first started, illustrating how the same techniques can be employed to create completely different forms. In addition to her technical accomplishment, Davidson's work demonstrates her creativity and joy in working with her materials. As she says herself: 'Whenever the metal moves with me or around me I feel like it is telling me a secret; it is an amazing material.'

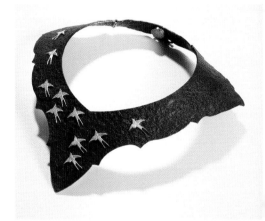

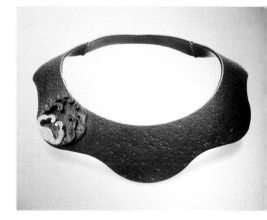

TOP
'barn swallows' collar, 2010
mild vermont steel, diamonds,
silver and 18-carat gold

ABOVE
'japanese waves' collar, 2009
mild vermont steel, diamonds
and sterling silver

tomasz donocik

born: 1981, katowice, poland

Of Polish origin, but raised in Austria, Donocik went to London when he was eighteen years old to study at Central Saint Martins College of Art and Design. The foundation course gave him the opportunity to work with jewelry and in his coursework he focused on 'vampires and the bogeyman', showing an early and enduring interest in myths. He approached popular fables from a scientific point of view, exploring the history of common myths about vampires. He found that jewelry gave him the opportunity to express himself, drawing designs on paper first, using his signature of multiple colours, then transferring these images to three-dimensional designs. He went on to take an MA, focusing on design, having realized that in order to have a brand of his own, he would need to excel as a designer. However, he does still make jewelry himself and, because he did not train as a traditional goldsmith, he feels he is fairly free from restraints: 'Sometimes you can become too good at traditional techniques, which might mean you cannot make an innovative piece, whereas being a little naive or ignorant about the techniques may actually give you the freedom to create designs that are unique. In reality I am better at designing than making pieces, so I leave that to people that are better at it than me. I am a designer who specializes in jewelry.'

For Donocik the time at college proved an opportunity to fully explore various avenues of jewelry design at leisure and also encouraged him to seek inspiration everywhere. He keeps an 'inspiration box' where he puts things that have grabbed his attention, as well as notebooks that are brimming with sketches or fragments of material or fabric that have caught his eye – all fuel for his imagination. His 'Rising Star' collection was inspired by the military uniforms of the Soviet era, adapting the characteristic star motif to cufflinks, rings, earrings and pendants. Another big influence is antique furniture and leather; he combined these

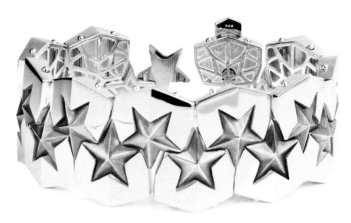

'the halo' bracelet, 2009
bronze and silver

RIGHT
**'chesterfield hunters'
bangle, 2009**
brilliant-cut white
diamonds, italian glove
leather and rose-gold,
yellow-gold, and
white-gold-plated silver

BELOW
bracelet, 2008
swarovski hematite,
leather and silver

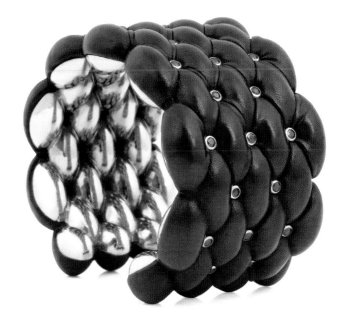

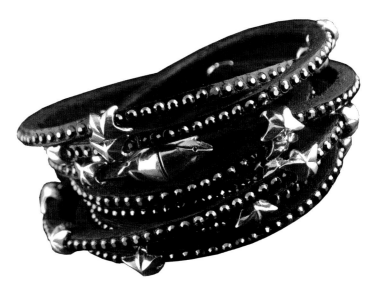

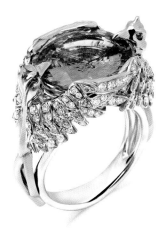

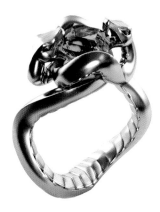

materials in his 'Chesterfield' collection. The shapes are designed on a computer before being transferred to wax and resin. He uses a technique called electroforming, where silver or gold plate on silver (gold being too brittle) is layered over the mould. He then pins leather on top, using gem-set studs to create the desired quilting effect. Donocik always constructs his own prototype: it is essential for him to do this to determine exactly how he wants it to look in order to instruct the workshop that will eventually make the pieces to his specifications, and he adapts the design as he goes along.

Working on commission is a great challenge for Donocik – he loves the opportunity to really get to know his clients and create something unique for them. In 2004, aged only twenty-two, Donocik was commissioned to design a prize for the De Beers Diamond Day at the Royal Ascot horse races, creating a diamond necklace inspired by riding equipment. He combined leather with metal, and this equestrian theme has become a regular feature in his collections, most recently he used horsehair from violin bows to create necklaces. Two years later, the celebrated jeweller Stephen Webster saw some of Donocik's work and employed him as a designer. Later Donocik decided to strike out on

his own, creating freelance designs for Garrard, the Crown Jewellers, and Links of London.

More recently, Donocik was given a brief to design sustainable jewelry to auction for 'Eco Art International', a charity that helps safeguard endangered bird species. He created a spectacular 18-carat rose-gold ring called 'The Courtship of the Hornbill' (opposite). It features the entwined heads of two hornbills, their beaks made of mammoth tusk fossil from Siberia and the heads set with yellow, black and white diamonds, with rubies for the eyes.

Using a 'pop-up' shop allows Donocik to be in touch with the public directly and affords an invaluable opportunity to develop his ideas. A leader of fashion rather than a follower of trends, he makes items that any generation would feel comfortable wearing and seeks to create pieces for a confident person but no specific age group or gender. He wants to redefine jewelry for the contemporary accessories wearer, and his brand reflects his wide-ranging interests, which include history, literature and Surrealism. Donocik is undoubtedly a rising star in the industry and has been recognized as such, winning several notable awards already. He has a wonderful, fresh approach, and it will be interesting to see how his work develops.

OPPOSITE LEFT
'the phoenix' ring, 2009
spessartite garnet, white, brown
and yellow diamonds, white
gold and 18-carat rose gold

OPPOSITE RIGHT
'medusa's hair' ring, 2010
tourmaline, brown diamonds
and 18-carat rose gold

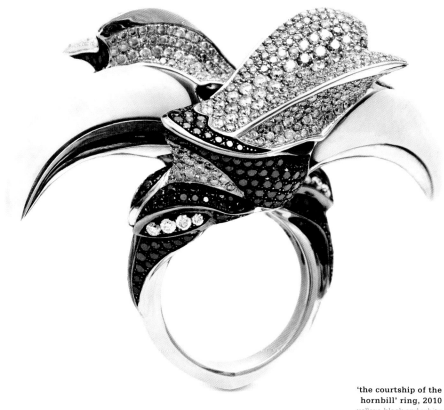

**'the courtship of the
hornbill' ring, 2010**
yellow, black and white
diamonds, rubies,
mammoth tusk and
18-carat rose gold

OPPOSITE BELOW LEFT
'disc florets' neckpiece, 2008–9
knitted and dyed nylon

OPPOSITE BELOW RIGHT
'fountain' neckpiece, 2004
beaded clear nylon with pearls

'circles' neckpiece, 2008–9
knitted and knotted dyed nylon

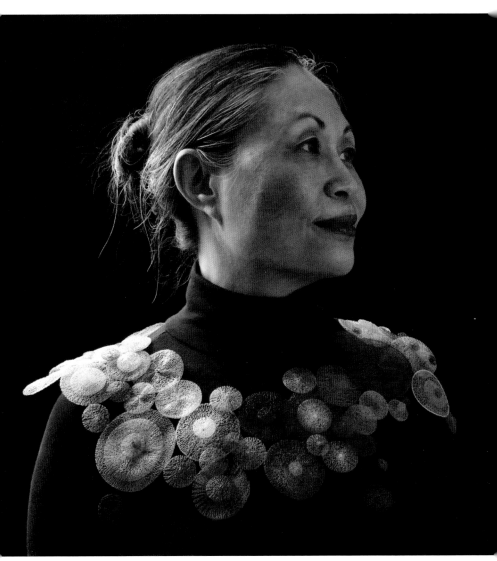

nora fok

born: 1953, hong kong, china

Born in Hong Kong, Fok moved to the United Kingdom in 1978, partly in order to change career from graphic design to jewelry-making. 'Much to my parents' confusion, I wanted to make a career as an artist. I think their response was in part distinctly practical: "art does not make money".' She came to Britain, attracted by the sense of freedom and experimentation in the field of jewelry, and enrolled on a BA course in Wood, Metal, Ceramics and Plastics at Brighton Polytechnic, the only course of this kind in the world.

Fok was fortunate to have Caroline Broadhead as her teacher. Broadhead is a highly versatile artist, whose jewelry combines non-precious materials, including nylon thread, and multi-coloured woven flax. Her work increasingly made use of textile techniques, and in 1997 she was awarded the Jerwood Prize for Applied Art (Textiles). Broadhead helped Fok to develop her techniques in acrylic and nylon. She also introduced her to Susanna Heron, a jeweller and curator who included Fok's work in a number of exhibitions. After a brief return to Hong Kong, Fok decided to settle in the UK. She now lives in Hove, where she also has a studio: 'I had to work with affordable material, in a small area and using simple equipment, which would allow me to research, experiment and make jewelry, while looking after my family.'

Nylon proved the ideal material for her work – Fok realized its potential and has been working with it for more than thirty years. During her time at college she mainly worked with resin and acrylic but since graduating she has concentrated on nylon. For fifteen years she tried to stabilize the material so it would keep its shape, and her perseverance has brought its own reward. Researching everything from wood bending to steam shaping, Fok gradually

ABOVE
'princess pagoda' headpiece, 2005
woven clear nylon

RIGHT
'walking onion' headpiece, 2006
knitted and knotted clear nylon

OPPOSITE
'this is life' neckpiece, 2010
knitted dyed nylon
with nylon rods

**'the future is at our fingertips II'
finger extensions, 1999**
knitted, dyed and pigmented nylon
with multi-coloured nylon balls

developed her own techniques for preventing
the nylon from snapping back to its original form.

Knitting has also become a key element in
Fok's work, partly thanks to the influence of her
grandmother. She uses four knitting needles –
'like knitting socks' – and joins the pieces
together with invisible thread, but 'all my
needles end up crooked at the end because
nylon is such a strong material and there is
quite a bit of tension involved'. Again,
stabilizing the forms and shapes she had
created proved a major challenge. Heat turned
out to be the key, but the problem was ensuring
the consistency of both temperature and
application. Her 'eureka moment' came in 1994,
courtesy of an unlikely source – Victorian hair
jewelry. She discovered that hair was plaited
around an object, then immersed in boiling water
and left to simmer. When taken out of the water
it was left to dry, resulting in the desired shape.
Fok experimented with many different ways of
applying heat, including hair-dryers, baking,
steaming and boiling. Eventually she knitted
nylon around a golf ball, which was then placed
in cold water and gently heated so that the nylon
held its shape when the ball was removed. Fok
says: 'I had tears in my eyes as I knew I had
cracked it.' Recently, Fok's son has started to
help her transfer her ideas to computer models,
which can then be translated into metal or
plastic. Although she closely controls the
quantity of output in limited editions, this
technique does enable her to create affordable
pieces and make them widely available.

Jewelry does not necessarily need to be
made from precious materials, and Fok's work
is produced to a standard as high as any

jeweller's who is working with gemstones or gold. Every item is one of a kind and she makes only six large pieces a year, in addition to a series of ten or fifteen smaller pieces. In some of her work she incorporates parts of plants: for example, she used physalis shells with finely knitted and dyed nylon monofilament to create earrings, with fittings made from hooped nylon thread, making it seem as though the earrings are suspended in thin air. Fok relies on the originality of her technique as a signature and dyes all her nylon herself, finding shop-bought nylon too harshly coloured. She makes the piece before dyeing the nylon, applying layers of colour like watercolour paint and building up the intensity with each application: 'It is nerve-racking when you are dyeing the finished piece because if the colour goes wrong you have ruined something that has taken months to make.'

Fok recently put together her first-ever solo exhibition at the Harley Gallery in Nottinghamshire, featuring a necklace with 4,000 knitted balls. The show celebrated the unique nature of her pieces – they are unlike anything ever seen before; the beauty and delicacy encapsulated in the nylon are extraordinary. The finished colours are delicate, flowing into each other, and the material is incredibly light for such bold creations.

maria rosa franzin

born: 1951, tripoli, libya

OPPOSITE
'hartung' necklace, 1993
steel, silver and yellow 999-gold

Padua's Pietro Selvatico Art Institute is widely recognized as having produced some of most important and influential designers and teachers in the contemporary jewelry world. One of its founders, the late Mario Pinton, was determined that students of art and design should think beyond established practices. While respecting traditional methods for such materials as gold and silver, Pinton encouraged students to explore working in an unconventional manner, treating jewelry as an art form and exploring the full range of textures and surfaces that could be achieved.

At the young age of fourteen, Franzin knew already that she wanted to attend the Padua Institute and when she started out in the 1960s,

she had the chance to learn from some of the greatest teachers of jewelry, Francesco Pavan and Giampaolo Babetto, who was then aged only twenty-two himself. Both were disciples of Pinton, and the space they shared, according to Franzin, felt 'like a working studio rather than a lecture room'. Franzin worked with Pavan in his studio in the afternoons, which left her with plenty of free time to explore her other passion, painting.

Having left Padua to take a diploma in painting at the Academy of Fine Art in Venice, Franzin returned to the Institute in 1986 to teach metalworking and goldsmithing. Her knowledge of painting and design proved invaluable to the school, and Franzin now

'albero' brooch, 2007
coral, silver and yellow
999-gold

works closely with fellow jeweller Graziano
Visintin (pages 168–71).

The paintings of fine artists such as Francis
Bacon and Joseph Cornell, as well as her own,
heavily influence her jewelry. Franzin has spent
the past thirty years exploring the connection
between the two disciplines: 'I think jewelry
is an important expression of art. I have had
important teachers who established jewelry
as an art form from the start rather than an
industrial process.' Each of her works begins
life as a drawing, before its three-dimensional
complexities are explored more fully through
models, allowing Franzin to establish the
proportions of each piece before distorting its
geometry to create an abstract shape.

Influenced by numerous art forms, Franzin
has a great ability to reinterpret paintings
and turn them into wearable art: 'I have made
a piece inspired by one of Jackson Pollock's
paintings: I attempted to change the silver
surface of the piece by putting gold in powder
form on it. I applied heat until the two blended
together, then hammered the metal so that the
coloured surface looked like a canvas with colour
dribbled on it.' Another example was inspired by
a painting by Hans Hartung from 1963 that she
transformed into a flexible necklace made of
silver, gold and steel wires.

Using files, drills, saws and punches as in her
student days, Franzin aims to make the surfaces
of her jewelry look as though they have been

painted. Franzin likes contrasts and often uses stones or coral for colour, as well as other materials such as steel yarn, niello and sheets of resin combined with gold and silver. The surface texture is important to her work, and she invests a great amount of time in her techniques, for instance using gold dust on silver, heating it from underneath so that the gold fuses to the silver. She oxidizes silver to achieve a bronze tone and also applies sulphuric acid to lighten the colour of the metals. She often uses pure gold leaf and incorporates it into the characteristic moveable element of her pieces, for example decorating a sliding bar in the middle.

Franzin also has some experience in curating exhibitions: in 2009 she worked on the 'Moon Jewelry' exhibition in Padua, which combined jewelry and music and featured original compositions that reinterpreted classics such as 'Blue Moon', 'Moonlight Serenade' and 'Moonglow'. Twenty-two international contemporary jewellers displayed pieces connected to a piece of music, and Franzin herself designed a silver, gold and blue resin brooch entitled 'Blue Moon'.

Franzin combines her studio work with teaching, seeking to inspire her students and to challenge them to come up with new ideas. The spirit of the Pietro Selvatico Institute will surely continue to thrive, with both Franzin and Visintin as teachers, as the passion of these two dedicated artists will inspire students to produce truly inventive jewelry.

'dark' brooch, 2010
silver, resin and
yellow 999-gold

'blue moon' brooch, 2009
silver, resin and yellow 999-gold

gimel

kaoru kay akihara born: 1944, hyogo, japan

Kaoru Kay Akihara's workshop is the tidiest, most orderly that I have ever visited. In this it reflects the composed and contemplative nature of the designer's work. What is instantly apparent is the proximity of the workshop to nature, with glass walls giving a sense of unfettered access to the magnificent setting, which is one of Gimel's most important influences. It is her conviction that creating beautiful jewelry requires a harmonious environment, so Gimel relocated in 2003 to its present studio, which is surrounded by Japan's Rokko Mountains National Park. Akihara's wonderful sense of humour is evident everywhere, even extending to jewelled bugs in the bathroom (at first a slightly alarming sight). Her surroundings are an important source of creativity for her: 'My inspiration comes from whatever I experience – through sight, hearing, smell, touch and taste', a philosophy that extends beyond jewelry design.

The humour and serenity manifest themselves in her jewelry. The former can be found in each of her pieces – however small, they feature a small gem-set bug, hidden where only the wearer would be aware of it. The simplicity of design and exquisite workmanship stem from her early education in traditional Japanese arts and practices such as flower-arranging, painting and tea ceremonies.

Having moved to Canada, Akihara enrolled in a jewelry-making summer course offered at Sheridan College in Toronto, which was taught by a former chief assistant to the great Danish silversmith Georg Jensen. There she learned about silver castings and embossing. The course further inspired her to enrol at the Gemological Institute of America in Los Angeles and on graduating she determined to set up her own jewelry company. It was also at this time that she decided on the name for her company, adopting 'Gimel' at the suggestion of a Jewish friend – the word is shouted during the game of Dreidel, traditionally played during the Jewish holiday of Hanukkah, and Akihara felt it was 'a lucky charm'.

Gimel pieces are exquisite because of their attention to detail, their simple design and the fact that Akihara uses only the best stones to obtain the desired effect – she personally chooses the stones with an uncompromising eye. Should a piece require it, Akihara will have faceted stones recut *en cabochon* (shaped and polished)

OPPOSITE
'ant playing with lotus flower' brooch, 1998
diamond, pink diamond, sapphire, demantoid garnet and 950-platinum

RIGHT
'red chili pepper' brooch, 2010
diamond, sapphire, demantoid garnet, 950-platinum and 18-carat yellow gold

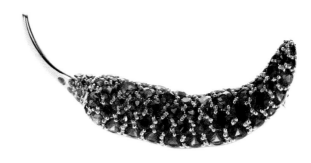

to ensure the best quality. Each Gimel piece is memorable for the subtle gradation of colour attained by the careful choice of specific gemstones. Akihara combines them with gold for rich colour and radiance to convey an enduring feeling of 'purity and nobility'. Platinum is her favourite metal – it has 'a brilliant pure white radiance with a strength that never changes over time', which makes it the perfect material for jewelry to keep for life.

Akihira's attention to detail is second to none, and she expects nothing less from her employees, a group of full-time craftsmen and some part-time staff. She only uses graduates from her own workshop in order to maintain the level of craftsmanship: 'Using other craftsmen is unthinkable, the quality of the work differs too much.' Using a jeweller's loupe, each of the craftsmen is responsible for the whole process of creating a piece, from the polishing of the stones to the final setting, making sure that the original concept is perfectly realized. The attention to detail extends to the reverse of the piece: each back hole is hexagonal in shape and individually polished, which is hardly ever done in contemporary jewelry. Gimel also never uses computer-aided design.

Designed for both men and women, Gimel's creations reflect Akihara's fascination with the natural world. She has always been driven to reproduce and interpret the perfection she finds in nature. Her detailed botanical knowledge adds another dimension to her creativity: her 'Iris' collection, for example, consists of three beautifully executed brooches, set with graduated white diamonds for the petals, yellow diamonds for shading and demantoid green garnets for the leaves and stems. Each brooch represents the flower opened or closed at a particular time of day, allowing the wearer to choose the iris that corresponds to the time they want to wear the piece. Realism is also of vital importance – whether a brooch is in the form of a chili pepper, a four-leaf clover or a maple leaf, each will be true to nature. I am fortunate to own a small Gimel brooch in the form of two leaves, pavé-set with demantoid green garnets. There is a tiny diamond set at the end of the stalk, and behind one of the leaves is her trademark, a bug, set with a cabochon sapphire. Despite being so small it is often the first thing people notice when I walk into a room, such is its vibrancy.

A Gimel piece is the pinnacle of any jewelry collection, standing the test of time and demonstrating how much can be achieved through skill and dedicated craftsmanship. Few artists are able to make jewels to such a high standard without compromising at some level. Akihara says: 'For the future, I just want to leave something beautiful for the world to see' – she has already more than fulfilled her own wish.

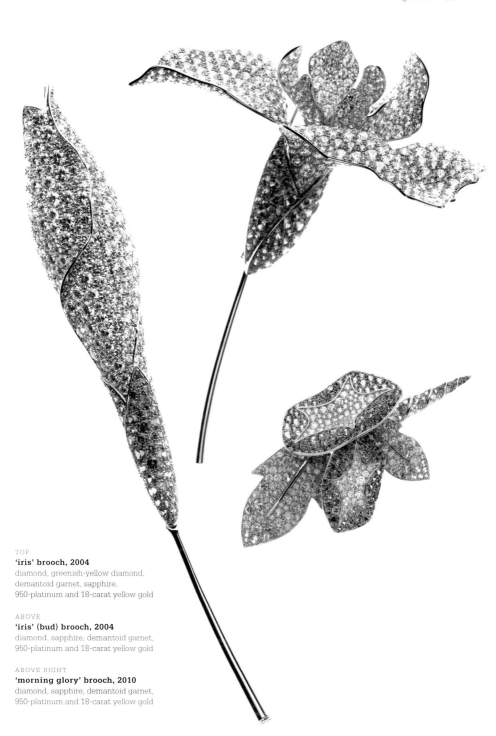

TOP
'iris' brooch, 2004
diamond, greenish-yellow diamond,
demantoid garnet, sapphire,
950-platinum and 18-carat yellow gold

ABOVE
'iris' (bud) brooch, 2004
diamond, sapphire, demantoid garnet,
950-platinum and 18-carat yellow gold

ABOVE RIGHT
'morning glory' brooch, 2010
diamond, sapphire, demantoid garnet,
950-platinum and 18-carat yellow gold

michael good

born: 1942, pittsburgh, usa

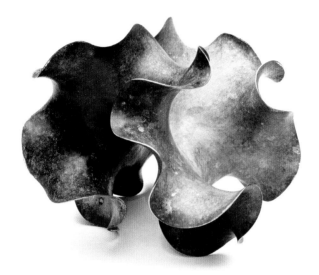

**'wave' sculpture,
c. 2004**
patinated bronze

This book would not be complete without an introduction to the work of Michael Good. One of the great contemporary master goldsmiths, his name is synonymous with the technique of anticlastic forming. Reminiscent of a technique first used by ancient Celtic craftsmen, it involves forming a flat sheet of metal by compressing the centre and stretching the edges so the surface develops two curves at right angles to each other. The variety of forms achieved depends on the shape of the original sheet and the skill of the craftsman. The process results in the metal being shaped into sinuous curves that give the jewelry a natural harmony. To some extent, with Good's pieces this sculptural, architectural quality reflects not only his enduring love of art but also aspects of his training; he recalls: 'In 1962 I went to New York, and spent eight years as a failed social activist, which is not necessarily the best training for the job market. But I got a job with sculptor Robert Perless, who made these elegant forms out of metal and also created jewelry. He taught me the basic techniques of jewelrymaking.'

Armed with these skills, Good began to create his own jewelry. Working in Washington State where he had moved with his wife, he started on a small scale: 'I had a tiny amount of gold and started working with it, which was something I had not done before. I managed to sell a piece now and again and got by living hand to mouth.' The couple then relocated to Maine, where they are still based, and Good would travel to New York to sell his work and gradually build up a following.

Good's signature anticlastic technique grew out of his love of architecture and, in particular, the work of Richard Buckminster Fuller, who

BELOW
'ruffle' cuff and 'torque'
earrings, c. 2009
patinated bronze
and 22-carat gold

BOTTOM
'oval ruffle' pin, c. 2009
tahitian pearl and
patinated bronze

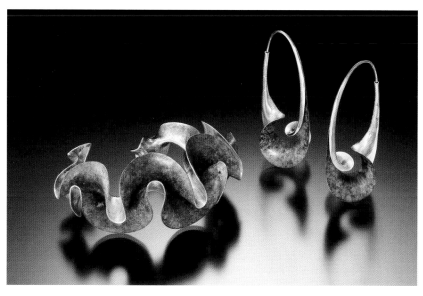

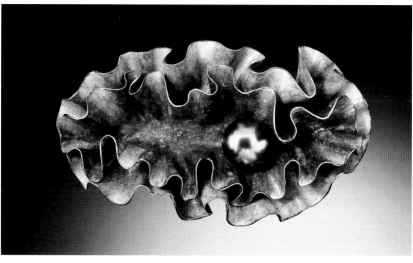

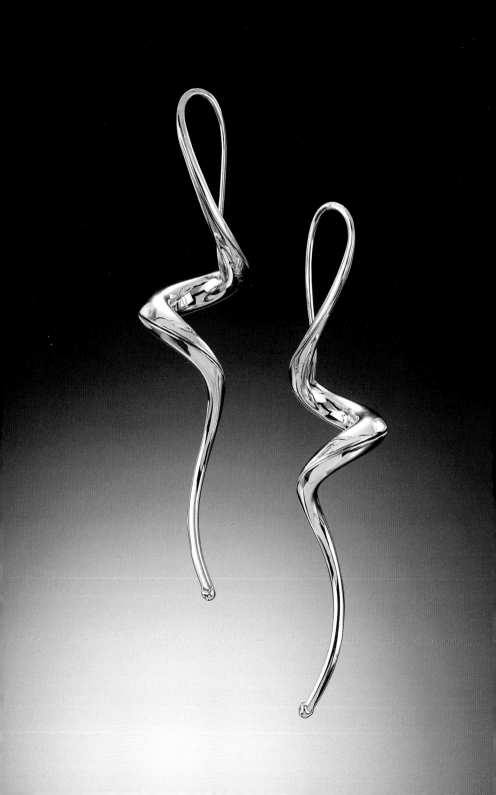

'helicoidal' earrings, c. 1981
18-carat gold

'single loop' earrings, c. 1980
18-carat gold

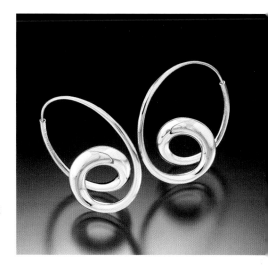

built huge geodesic domes designed to cover maximum space without internal support. These ideas drove Good to explore hollow structures. He recalls: 'Without knowing it I had started to develop the technique now called anticlastic raising. It became a passion and no longer just a means to make jewelry. I was not prepared to compromise. I was now thirty years old and had no training as a goldsmith.'

When Good was given a copy of Finnish jeweller Heikki Seppä's seminal book *Form and Emphasis for Metalsmiths* and discovered that Seppä was teaching a workshop the following year in Maine, he decided to meet the acclaimed gold- and silversmith. The pair had an instant affinity; one of the most innovative and influential silversmiths of the late 20th century, Seppä helped develop the technique of reticulation, which involves applying localized heat so that the material can be shaped into ridges, as well as anticlastic raising.

In the early 1980s, Good was invited to join a collective of designer/makers known as Aspects. Formed in the late 1970s, the group included artists such as Spanish jeweller Majoral, Michael Zobel (page 186) and Bernd Munsteiner (page 129), who shared similar values and attitudes to jewelrymaking and design and exhibited groundbreaking work at the Basel Jewelry Show. Today the group has expanded to include American jewellers such as George Sawyer, Sarah Graham and Barbara Heinrich, and they regularly show their work at the Couture Show in Las Vegas. Their ethos is to avoid market trends or fashions in their designs.

Good remains an innovator. With a thriving workshop and four employees, he happily undertakes commissions and has held workshops across Europe and the United States. He has recently started to add patina to his jewelry, using chemicals and heat to achieve nearly any colour to create a contrast with gold and silver. He has also refined a 'double helix' structure for some of his pieces, where a flat sheet of metal is turned around on its own axis, like a spiral staircase without a centre column. For many years he has also fashioned earrings from a single sheet of metal, down to the wire that fastens them to the ear. Underlying all of his innovations is Good's fundamental attitude to his materials: 'It is the movement within the metal itself that gives me inspiration. It is almost like playing a musical instrument where, instead of following the harmonies, I am following the "movements" of the metal in my head.'

mary lee hu

born: 1943, lakewood, usa

BELOW
bracelet #60, 1999
18- and 22-carat gold

One of the joys of writing this book has been broadening my knowledge of jewellers around the world and following up on recommendations from others in the field. American Mary Lee Hu was brought to my attention by celebrated British jewelry designer Wendy Ramshaw (pages 136–141). I discovered an artist whose work is distinctive in its natural, fluid structure as a result of her innovative 'weaving' technique.

Wanting to become an artist from childhood, at sixteen Hu began a summer course in fine art at the University of Kansas, but was immediately attracted by the course in metalsmithing and within an hour changed her mind. She was fascinated and announced to her family that she wanted to be a metalsmith: 'My parents were instantly supportive of my newfound love, and I was lucky that they did not try to steer me away from pursuing a career in the arts.'

Following her undergraduate studies, which gave her an excellent grounding in metalsmithing, Hu focused on techniques she could use in jewelrymaking. She took a weaving course and started to combine textile techniques with metalsmithing; she recalls: 'We were exploring weaving that did not require a loom, and I discovered macramé, and the structure of knots and patterns intrigued me. I was more interested in line, pattern and form than colour, so I started experimenting with wire. I spent

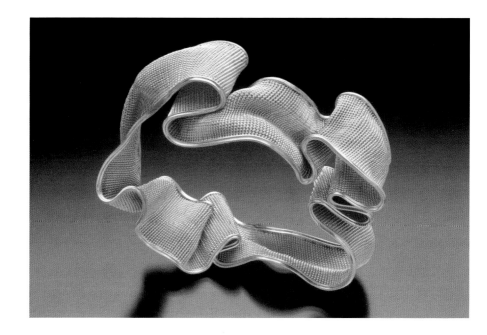

the rest of the year exploring how to twist, wrap, knit and knot metal to make earrings and little objects as if I were "drawing" with metal. I was trying to make realistic little insects and aquatic creatures.' It is interesting to see Hu's early work from the 1960s, as it is so different from other pieces produced at the time, which were characterized by spiky, textured surfaces with bold uncut crystals. Hu recalls: 'I was not looking at commercial jewelry, fashion or fine art, I was just playing, constantly looking at books on insects to figure out how they were put together, how the wings came out and how the legs came out, thinking I could make them.'

Following her marriage, Hu and her husband moved to his native Taiwan in the late 1960s, but after his premature death she returned to the United States a few years later, finding solace in perfecting her weaving technique in silver and entering pieces in competitions. Her experimentation led to her creating pieces with long protruding wire tapers, the ends of which she would melt until they resembled the tentacles of sea creatures: 'As I was working I would see what shapes would develop. Then I would see which animal it resembled and improvise my woven tapers accordingly.'

From the late 1970s, Hu worked as a teacher, first at Michigan State University, then the University of Washington in Seattle, before retiring in 2006. She remains involved in education and is active as a visiting lecturer. Her teaching work also meant she could afford to begin using gold, having previously only worked in silver.

Hu's more recent work from the last decade is spontaneous, as her techniques continue to

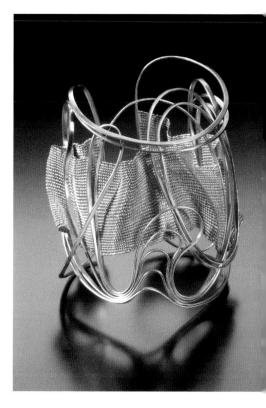

bracelet #61, 2001
18- and 22-carat gold

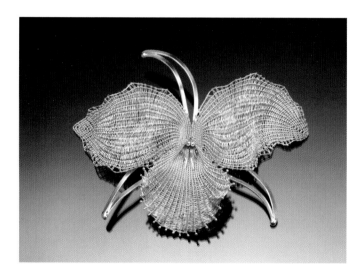

LEFT
brooch #33, 2010
18- and 22-carat gold

OPPOSITE TOP
choker #83, 2000
18- and 22-carat gold

OPPOSITE BOTTOM
choker #90, 2008
18- and 22-carat gold

evolve: 'I had some woven gold left over from a bracelet that was too large to be a ring and too small to be a bracelet. I slid it onto the ring mandrel and struck it with a hammer until it fit my finger. It had a large piece of crushed metal on the top that I really liked. This idea sent me in a different direction and I would carefully weave my pieces into a circle before hitting them with a hammer until they fit as a bracelet or a necklace.'

Although Hu has taught traditional jewelry-making techniques such as casting, setting and metal piercing, she has continued to use and develop her own weaving technique and still creates every piece by hand. Represented by the Facèré Jewelry Art Gallery in Seattle and Mobilia Gallery in Massachusetts, Hu does not produce many commissions, preferring to make her own pieces. All her work is stamped with her surname, and each piece has a number, of which Hu has a record even if the piece itself is not stamped. Choker number 70, for example, was her first piece in gold and she has just finished necklace number 90.

A studio jeweller, artist and craftsperson, Hu is able to turn gold into a work of art that gives its owner enduring pleasure. As she says: 'My ultimate goal is for my pieces to be worn and loved, and passed from generation to generation as an heirloom. This is now something of a problem, however, as I am trying to get pieces back for a retrospective exhibition and am finding that people do not want to loan them because they wear them every day.' This only serves to show how popular Hu's jewelry has become.

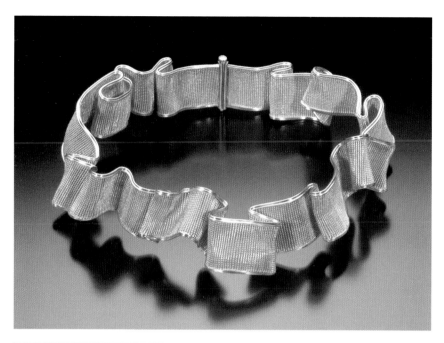

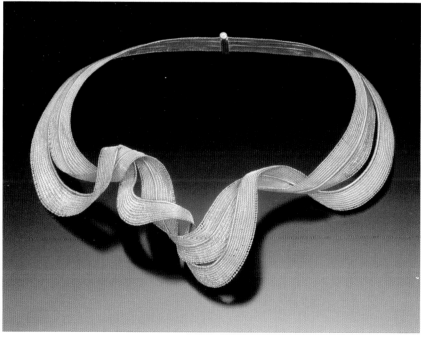

martin and ulla kaufmann

born: 1941, hildesheim, germany

Looking at the Kaufmanns' work it is immediately apparent that their striking jewelry and silverware is created by two people who are completely in tune with each other and at peace with their environment. Ulla and Martin Kaufmann are inseparable, having lived and worked together since the early 1960s. Their work is so intertwined that they can almost be regarded as a single person.

As jewellers, the Kaufmanns are not easily categorized. When speaking of their work they say: 'The attraction of creating something valuable and beautiful with our own hands has been with us since we were children. Later it became important for us to make our own statements, with the ultimate challenge to achieve perfection.' They are most interested in clean lines, encapsulating space in simple and fluid forms in both their silver vessels and their jewelry. After many years of experiments,

they have pushed 18-carat gold and silver to the physical limit, achieving maximum flexibility and elasticity, and balancing tension to retain the chosen shape. Refining their technique to the highest degree in terms of both craftsmanship and design, the Kaufmanns use bands of gold created by hammering, and each piece feels as if it retained an internal energy generated by each blow.

In the mid-1960s, Martin and Ulla Kaufmann trained at the workshops of Carl van Dornick in Wohldenberg and Theodor Blume in Hildesheim, respectively, after which they spent a year in Norway. They returned to work on Ulla's family farm in Hildesheim, and as it gradually ceased to be a working farm, they converted the buildings into workshops. With a large garden and on the edge of town, it is their ideal sanctuary: 'There is such peace and quiet. We can work without distractions and it gives us the strength to face the world and its challenges.'

Within this environment, the couple combine the strong points of their respective characters: Martin is more outgoing, while Ulla is more pensive. With Martin as the 'doer' and Ulla the 'thinker', and their shared attitude of 'let's give it a go', their work – though minimalist in shape – exudes life; it blends materials, modern design and provocative ideas into creations of simple beauty. In addition, their work conveys a level of quality that only comes from decades of experience.

Beyond jewelry, the Kaufmanns also aim to bring design to functional, everyday objects such as cutlery and tableware. They accepted a commission

OPPOSITE
'band' bracelet, 2006
gold

BELOW
'only tin' bracelet, 1999
gold

from Bremen silver manufacturers Wilkens & Söhne to design the 'Palladio' cutlery collection. Under the guidance of industrial designer Walter Storr they prepared handmade models, which could then be used for industrial mass production. The collection proved an immense success, receiving several awards in 1992, and led to further collections of cutlery and kitchen utensils. The couple were able to apply the skills and techniques of silver- and goldsmithing and combine it with their characteristic simple forms and clean lines. Their skills are perfectly adapted to the industrial market, and they continue to produce award-winning silverware and industrial design alongside their jewelry. They take on commission work only for industrial design, while jewelry clients are free to choose from pieces they have already made.

It is jewelry that really lies at the heart of their work: 'We have a distinct style that we wish to develop further, exploring the boundaries of our materials and production techniques. Our work originates from a primary idea and form, combined with historical and modern elements to create a minimalist final design. We would describe our style as "classic modern".' Their signature technique uses hammered and worked strips of metal, reminiscent of wood shavings, which subtly explore the idea of the relationship between inner and outer space. The Kaufmanns wish to create a sense of trapped space that is seeking to escape, and the arcs in their designs never

quite close as a circle. There are no solder joints, no hinges or stiff ends, which gives the pieces a natural feel; they are often unexpectedly adorned by a diamond or some other touch. The characteristic forms can be adapted into hoop earrings, magically held in place by tension only, necklaces that wrap around the neck or bracelets that wind around the wrist.

Bracelets are the pieces that the Kaufmanns regard as the most accessible jewelry for new collectors of their work: 'We feel that bracelets are equally appropriate for men and women. The three-dimensional nature of a hoop emphasizes the personality of the person wearing it. The act of slipping a bracelet onto your wrist creates a close relationship between the piece and the body, and this connection grows stronger through movement. When you wear a bracelet,

**'drops' bracelets
and rings, 2009**
diamonds, gold and silver

you perceive it as a whole object: you can see it, observe it on your arm, feel it move and see the changes. A bracelet is perfect for a first encounter with jewelry.'

The inspiration for their work comes from a range of sources, but primarily from discussing ideas together. The whole process from beginning to the end is collaborative, and they experiment with paper, card and brass to develop the desired shape of the pieces. The materials are a source of inspiration in themselves, which also provides continuity: 'By recognizing the potential of gold as a material, we realized that our ideas did not require new technology. We developed our forging process, bringing a traditional skill into the 21st century. The extraordinarily warm colour of gold repeatedly refreshes us. The appeal derives from the opposite poles – the hardness on the one hand and the soft gleam on the other. New ideas continually broaden the spectrum of processing and expression.' Kaufmann pieces feature in numerous museum collections, and praise for their work has been well deserved, underlining their position among the most important contemporary gold- and silversmiths.

'architecture' rings, 2004
tourmaline, aquamarine
and gold

'twins' neck jewelry, 2008
tahitian pearls and gold

'twig' neck jewelry, 2006
diamond and gold

helfried kodré

born: 1940, graz, austria

It was never Helfried Kodré's intention to become a jeweller. He met his first wife when he started his studies in art history at Vienna University and without any formal training he learned directly from her, helping to design and make pieces in their shared workshop. As he became increasingly immersed in the field, he gave up his art history studies to concentrate on jewelrymaking. For the next decade, he contributed to exhibitions at galleries across Europe, producing organically shaped work. In the beginning Kodré was influenced by his wife but at the same time he was already looking for his own expression and style.

In 1975 he was lecturing at Vienna University and at the same time working as a technical assistant to his first wife. He says of this time: 'I was working only with my hands, not my head,' and so he interrupted his jewelry-making career to resume his art history studies, taking a PhD. After ten years of working at the university he decided to return to jewelry, and his profound knowledge of art manifested itself in his work –

you can see his fascination with Italian Renaissance architecture, Palladio in particular, in his geometric jewelry. That said, Kodré finds it difficult to say where his influences come from exactly: 'I must admit I do not think about inspiration. It only comes when I am working and derives from a continual development and thinking about what I am making. There are no new beginnings; inspiration is always a continuation of my thoughts. I have seen so much art and architecture, historical and contemporary, it is impossible for me to pinpoint a specific source of inspiration.'

Throughout his career Kodré has focused on silver and gold, but since resuming his jewelry work he has combined them with other materials such as brass, glass, bronze, stainless steel and various minerals. Rather than making pieces entirely from gold, Kodré prefers to use it as a special addition. The results are highly effective, as shown in two brooches from 2009 and 2010 (page 96). He prefers not to use precious stones. When he does occasionally

BELOW LEFT
ring, 2010
agate and silver

BELOW RIGHT
ring, 2010
agate, chrysoprase and silver

use gemstones he chooses them for their natural beauty, irrespective of their value, and frequently uses lapis lazuli and turquoise.

Kodré began to work with steel in his jewelry designs in the 1970s and over the last decade has also started using it in his sculptures. He had always been keen to try his hand at sculpture, and in 2000 he was invited to take part in a sculpture project for a public space at the Riviera del Brenta near Venice. He has continued to create sculptures ever since: 'It is good for my jewelry, as the two influence each other and make me think about both areas. They require different thought processes.'

Experimentation is key to Kodré's work, and his most recent innovations have been creating surface patterns and textures on silver. He subjects sheets of silver to intense localized heat so that only the surface melts and then puts the sheets through rolling mills, which flatten the surface texture and create random patterns that resemble etching. The process is complex and unpredictable and Kodré makes numerous trial

brooch, 2008
amazonite and silver

OPPOSITE TOP
brooch, 2010
stainless steel, silver and gold

OPPOSITE BELOW
brooch, 2009
lapis lazuli, silver and gold

BELOW LEFT
earrings, 2010
silver and gold

BELOW RIGHT
earrings, 2009
gold

sheets before selecting the best. Unlike gold, the finished sheets of silver can then be oxidized to create contrasts of light and dark.

An early exponent of casting jewelry, Kodré uses the process not to reproduce designs but to achieve a specific result – an example of how he adapts a technique to the individual piece he is creating. He has never used computers for his sculptural designs and does not feel this would benefit his jewelry: 'It is too easy. It helps with the technical execution but it does not help with design or ideas. The creator must have their own ideas.' Kodré's way of working has changed in recent years, moving from a process of meticulous planning to working directly with his materials without any forethought. 'My initial ideas may not be so precise, but I experience the metal more. A piece develops according to the reactions of the materials, which the maker is not always entirely in control of.'

Describing his style as 'abstract, geometric minimalism, with traces of non-organic, natural structures derived from my early work', Kodré stresses the importance of an individual style. This takes time and effort, and while it is important to show work in galleries and exhibitions, Kodré never completely adapts or compromises his work for these requirements: 'It is tricky, as modern galleries want more mainstream work, whereas in the 1960s and 1970s when I started out, jewellers were more individual.' It is rare for Kodré to undertake commissions, as he prefers people to buy what he has already made: 'I want my work to be an expression of my creativity, but I also want each person who sees it to bring their own thoughts, ideas and emotions to their interpretation of it.'

constantinos kyriacou

born: 1972, nicosia, cyprus

I first came across Constantinos Kyriacou's work in 2007 at Collect, London's annual celebration of craftsmanship at the Saatchi Gallery. I was immediately struck by its expressive and intriguing qualities. Born in Cyprus, Kyriacou discovered his creativity at an early age, playing in the workshop of his parents who made chains and traditional jewelry. Later he 'drifted' into the arts, and finally, at the age of twenty, enrolled at Le Arti Orafe Jewelry School in Florence, where he specialized in design, production and stone-setting.

At the beginning of his career he saw jewelry as part of the fashion world, not as an important artistic medium in its own right, and some of his first pieces were created for Yves Saint Laurent's Spring/Summer 1999 'Millennium' collection. Despite the glamour, Kyriacou felt jewelry in this field was too commercial and did not provide an

expressive and personal medium. What he sought was absolute creative freedom and to achieve this he moved to creating jewelry that allowed him to convey deep emotions and thoughts: 'It was like discovering a new world, which is hard to express unless you are a poet. In fact, I often find writing poetry helps me to crystallize my thoughts.'

In 2006, at the Alchimia Contemporary Jewelry School in Florence, Kyriacou joined Giovanni Corvaja on a granulation course that explored an ancient technique originally used by the Etruscans and the Greeks to decorate a surface by applying tiny grains of gold or silver. This was followed by a year studying sculpture at the Philippos Yiapanis Art Studio in his native Cyprus, which had a profound influence on him as he developed a deep interest in sculpture, which has informed his jewelry work. Kyriacou experiments a great deal with mixing materials: sterling silver, 18-carat gold, fine silver and gold, wood, Plexiglas and iron. It is also important for him to experiment with colour – 'It changes my mood. It works; it provokes the senses' – and he gravitates towards warm tones such as red, orange, gold and brown. He uses acrylic paint on silver, which he then stabilizes with gentle heat, applying additional layers to build up the right density of colour. Kyriacou does not prefer any particular stone, finding beauty in every stone, be it rough or cut, precious or semi-precious.

He draws further inspiration from travelling, absorbing the culture, architecture, food and people of a place, and bringing back a sense of it all to his home in Cyprus. There he finds the necessary isolation to work: 'In Cyprus I have the opportunity to digest what I have seen, to

OPPOSITE
'circles' bracelet, 2008
sterling silver, fine silver
and fine gold

translate those ideas into designs. Sometimes
isolation is good – it is only then that you are
able to gather your thoughts in a creative way
and put them into practice.' He considers his
work the product of a process of 'inner research'.
Kyriacou primarily seeks to pass on the essence
of his state of mind at the time of creation but it
is not essential to him that everyone understands
the personal meaning the process holds for him.

Kyriacou is fascinated by the perfection and
harmony of the human body, and he often places
a small figure in his pieces. When he is working
on commission he tries to get a sense of how
the person in question sees themselves and
how they express their individuality. His
working practice does not vary much, however:
he makes a drawing of his initial ideas, which
he then transfers to metal, seeing the drawings
and the jewel as part of a whole. When his work
is displayed, he gives great consideration to the
presentation to ensure that the item is isolated
from other factors. Kyriacou believes a person
should buy a piece of jewelry because they feel a
connection to it, which will continue to develop
as they own and wear it. His pieces are personal
and a great deal of emotion goes into them:
'There is a huge amount of truth, energy, thought
and feeling in the process of making a piece.'

ABOVE
'dheos' brooch, 2005
red thread and
sterling silver

BELOW
'spark' ring, 2009
red acrylic, sterling
silver and fine gold

BELOW LEFT
'relativity' brooch, 2010
red and yellow acrylic
and fine silver

BELOW RIGHT
'closed (to red)' ring, 2005
red pigment and 18-carat gold

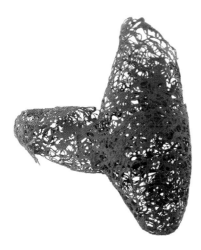

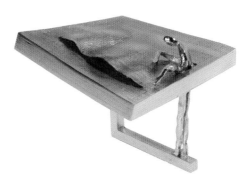

Kyriacou brings an intensity to his work but does not mask an element of humour, which is a strong feature of his personality. His most recent and favourite collection, entitled 'Paramythi', includes a knitted silver brooch representing a drooping penis. Named 'Just Joking', it is a comic reflection on masculine exaggeration. The collection is made of silver wire, which Kyriacou coats with acrylic paint. In this he returns to his earliest roots, since fashioning silver wire into filigree work is something he learned from his father, while the handmade chains used in the same collection make use of techniques he picked up from his mother. Kyriacou has also made a return to his early years as a jewelrymaker by agreeing to make some pieces for an Athens-based fashion designer. His collections encompass a wide range of subjects and moods, and his response when asked to name his style icons is: 'Anyone with a contented smile.'

BELOW LEFT
'think again' brooch, 2008
red fabric, sterling silver,
fine silver and fine gold

BOTTOM LEFT
'looking back' brooch, 2008
red fabric, sterling silver,
fine silver and fine gold

BELOW RIGHT
'red excitement' brooch, 2007
artificial elastic and sterling silver

BOTTOM RIGHT
'saved thoughts' ring, 2008
sterling silver, fine silver
and fine gold

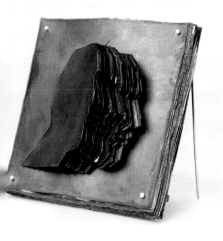

andrew lamb

born: 1978, edinburgh, uk

One discovers new jewellers either by word of mouth or, more thrillingly, through seeing someone wearing a piece. I first saw Andrew Lamb's work worn by the host of a London exhibition: what appealed to me was the craftsmanship and design, which were unlike anyone else's – an important benchmark. Fortunately Lamb was also in attendance, so I was able to discuss his work with him directly.

Lamb's inspiration derives from patterns he sees repeated in nature, and the more closely he observes them, the more the details fascinate him. This fascination is combined with a love of textiles, which is reflected in his jewelry: he invented his own technique to give the metal a 'woven textile' feel. It is exceptional in that it creates the impression that the piece is fashioned from a different metal depending from which angle you look at it. Lamb's 'illusion technique', as he calls it, is a closely guarded

secret. He shows impressive perseverance when seeking a solution to technical challenges and wants to create something that has not been done before to ensure his pieces stand out: 'I do not use traditional weaving techniques, but in using metal I adapt techniques to create something completely new.'

The complicated process requires Lamb to first make a model of each piece (sometimes in paper), which allows him to see the work in three dimensions before he makes test pieces in silver or a base metal. Occasionally, while making a piece he may alter the design during the process. When Lamb is making a necklace the design may involve twelve linked sections, and he will first make just three to help him visualize the scale of the piece: 'Sometimes I might sit down at the computer to map out the overall shape and then make the model.' It is only after this that he takes the plunge with

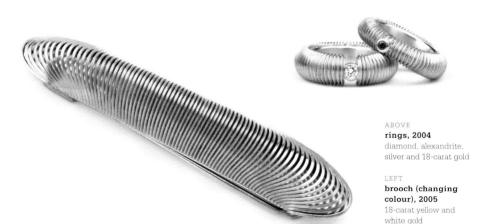

ABOVE
rings, 2004
diamond, alexandrite,
silver and 18-carat gold

LEFT
**brooch (changing
colour), 2005**
18-carat yellow and
white gold

gold, and this method of working means that often it is not until the final stage that Lamb sees whether a piece has turned out well: 'It is a long process and even then, only at the final stage – when someone tries it on – will you find out if a piece has really worked.' He also uses gemstones occasionally, again applying his 'illusion technique' to the metal of the settings.

The Edinburgh hallmark adorns all of Lamb's work. He has a studio in Edinburgh and also holds a post as lecturer in the Silversmithing and Jewellery department at Glasgow School of Art. He places great emphasis on the importance of a solid foundation in goldsmithing techniques before branching out into other areas, and it must be stimulating for students to learn from him. He finds teaching inspiring and loves the fact that it keeps him abreast of new equipment and techniques. Although Lamb uses computers occasionally for design, it is for planning rather than working on items: 'My pieces are individually designed and crafted, employing traditional hand skills and bench work. I embrace new technology as long as it preserves the integrity of my work.'

Lamb is continually honing his skills and in 2010 he won an Arts Foundation Fellowship, which he used in part to study at Giovanni Corvaja's workshop in Italy (pages 52–7), where he learnt alloying, specifically combining gold alloys to achieve different colour, strength and hardness. Lamb is proud of this recently acquired skill: 'The experience was truly amazing, a stunning location, and the workshop had everything you needed.' He feels it gives him a wider palette to work with, and now he wants to experiment with different colours of gold (always 18-carat), which will look extraordinary combined with his 'illusion technique'.

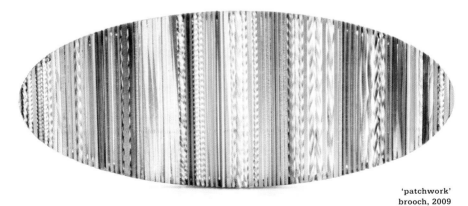

'patchwork'
brooch, 2009
yellow, red and white
gold, silver and platinum

'ovals' necklace, 2009
18-carat yellow and white gold

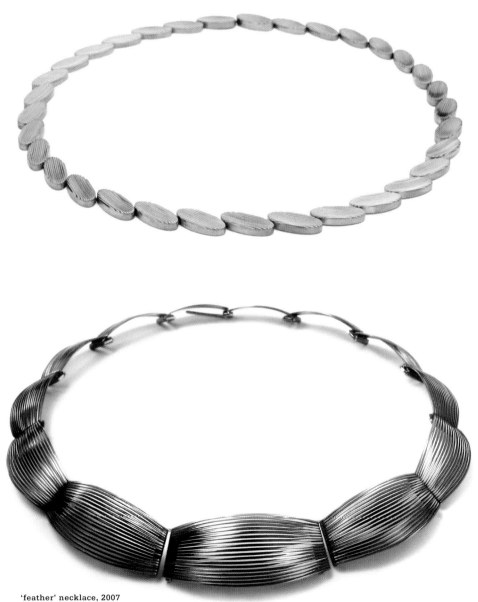

'feather' necklace, 2007
oxidized 18-carat yellow gold and silver

Given the subtlety of Lamb's pieces, the amount of work invested in them is not immediately obvious. But it is important to appreciate the exceptional technical skill, and Lamb finds that once people understand the complexity of the processes, they are keen to commission bespoke pieces, recognizing the individuality of his design. Lamb's commission work is always undertaken on his own terms, allowing him to express his signature style, but he enjoys the process of making pieces for specific clients. It will be interesting to see how Lamb's designs develop in the future and, in particular, how he incorporates the new alloying techniques in his work.

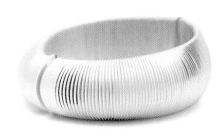

bracelet (changing colour), 2004
18-carat yellow gold and silver

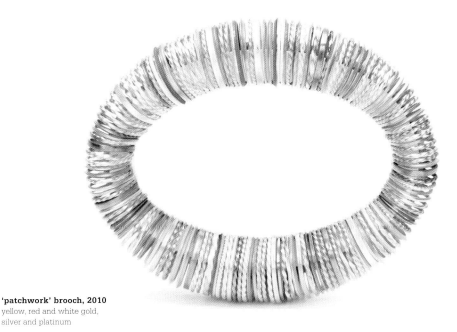

'patchwork' brooch, 2010
yellow, red and white gold,
silver and platinum

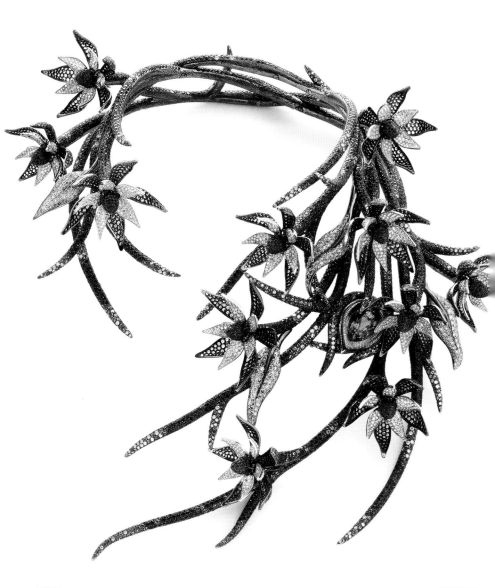

'homage to boucheron' necklace
(shaun leane for boucheron), 2008
purple sapphires and blackened gold, pavé-set with
sapphires, white and brown diamonds and rubies

tahitian pearl and
thistle brooch, 2008
tahitian pearls, black
spinel and silver

shaun leane

born: 1969, london, uk

When Shaun Leane met Alexander McQueen in 1992 it was a meeting of kindred spirits. Impressed by Leane's traditional skills and attention to detail, McQueen asked if he would work with him on jewelry designs for his shows. Leane had always wanted to work in the field, so it was the fulfilment of a long-standing ambition for him: 'Alexander McQueen allowed me to create the pieces I always wanted to create. There were no restraints of commercialism, just freedom of creativity. We both believed that no matter how big or small a piece is, it should be executed to the highest standard, and he helped push me to take the skills I learned as a goldsmith and apply them to the catwalk pieces that we created. I was in a world of traditional jewelry, an area which I totally understood and appreciated, but at the same time Alexander opened my eyes to the world of fashion…and in his eyes it was a world with no boundaries.'

It was through this connection with McQueen that Leane began to fuse traditional jewelry-making skills with modern concepts, pushing the boundaries that formed the style of his work. At the time of the meeting Leane was already an accomplished and experienced jewelrymaker and designer. He had taken a foundation course in jewelry design and manufacture at London's Kingsway Princeton College, followed by a seven-year apprenticeship in Hatton Garden, London's famous jewelry quarter. Working for a company called English Traditional Jewellery, which produces work for jewelry houses such as Asprey, Garrard and Van Cleef & Arpels, he learned traditional skills of manufacture and production. He spent thirteen years in Hatton Garden, working on various

pieces, from solitaires to tiaras. This invaluable training has given Shaun an insight into how established skills can be combined with contemporary design to create a fascinating range of jewels to suit all clients.

Leane is very charismatic in person and takes an interest in many different things; he finds inspiration both in life's riches and in its darker side. He says that he would like his work to be known as 'Modern Romance', creating beauty that is darkly romantic, powerful and elegant. However, his jewelry also has a sense of fun about it, and his designs appeal to the stylish and fashion-conscious who are looking for jewels that are different and recognizable, but also beautifully crafted. Leane has created one-off pieces for Sarah Jessica Parker and Daphne Guinness, and worked on collaborations with Boucheron (opposite) and Forevermark to create magnificent, unique pieces.

Based in London, Leane takes advantage of the city's many museums, seeking inspiration

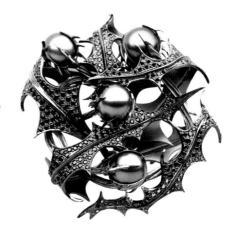

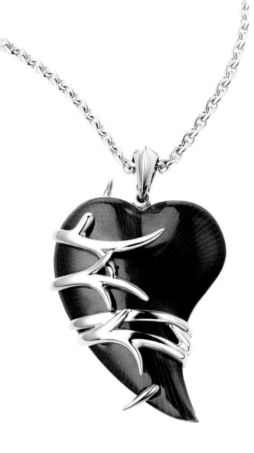

**'thorned heart'
enamel locket, 2005**
red enamel and 18-carat
yellow gold with a silk-lined
keepsake compartment at
the back of the pendant

Leane makes jewelry for both sexes and when creating a piece, he always devises the concept first, then sources the stones that best complement the design. His style incorporates elegance with beautiful curves and formations, while retaining an element of structure, using sharp lines or knife edges. Contrasts are important in his work as he plays different materials and textures off against each another. Gold is Leane's preferred material – he loves its weight, warmth and contrasts as well as the range of colours available, from white and yellow to rose and green gold. It allows Leane to apply traditional techniques such as engraving and enamelling, which have become more sophisticated as his work has evolved. His favourite stones are diamonds because of their pure brilliance and history: 'The fact that you can wear an object that has been on earth for over 900 million years is awe-inspiring.' His fine jewelry makes bold statements, combining diamonds with other stones such as purple, blue and red sapphires, and less expensive stones such as amethyst, moonstone and rhodolite. He uses a wide range of materials for his catwalk pieces, combining everything from bird's claws and feathers to Tahitian pearls to decorate corsets and breastplates made from aluminium.

Although the focus is on fine craftsmanship and materials, Leane uses computer technology to allow him to create objects that would previously have been impossible. He uses it to design a prototype to give him an idea of the proportion and structure of the piece. This prototype can then be cast in silver and filed to give it sharp lines, which would be unattainable

in the Science Museum and the Natural History Museum (particularly the insect displays) and the Asian galleries at the Victoria and Albert Museum. As he says: 'When the new Jewellery Gallery opened at the Victoria and Albert Museum in 2007, my work was selected to become part of the permanent collection. Not only is this my favourite museum, but it is also the place where I first felt inspired as a young apprentice, so it was a great honour for me.' He combines this inspiration with influences from different styles and cultures, often incorporating complete opposites such as Art Deco and Victorian designs. Simple lines, proportions and a provocative touch of darkness run throughout his work, best seen in his iconic 'Hook My Heart' motif, which plays with the concept of love.

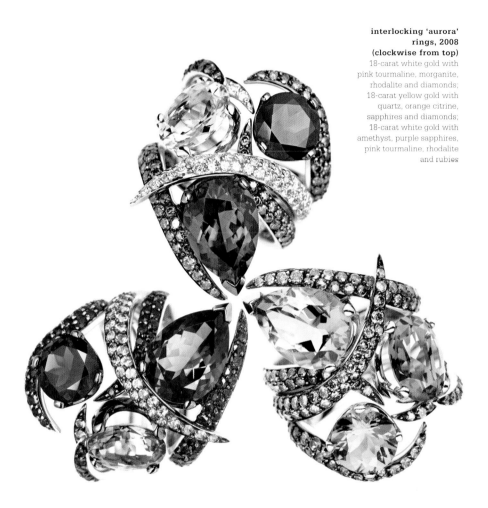

**interlocking 'aurora'
rings, 2008
(clockwise from top)**
18-carat white gold with
pink tourmaline, morganite,
rhodalite and diamonds;
18-carat yellow gold with
quartz, orange citrine,
sapphires and diamonds;
18-carat white gold with
amethyst, purple sapphires,
pink tourmaline, rhodalite
and rubies

without computers. Many designers rely on computer design alone, but Leane feels that the object should retain the special quality that is afforded by being worked by hand. His method is a perfect example of traditional craftsmanship successfully combined with technology.

Leane is passionate and dedicated to his work. He does not compromise on quality and is famous for his attention to detail, but his work always remains accessible. Big commissions are a large part of his business, and he finds clients want something tailored to them but also in the Shaun Leane signature style. His other jewelry ranges start at reasonable prices for collectors on a modest budget. What he wants is for those who wear his jewelry to feel both proud and confident: 'Jewelry is an art form. I feel it has many enduring qualities, and the one I admire the most is how it can encapsulate a certain time in someone's life. Every time you wear it, you relive that moment and I want people to always recognize a Shaun Leane piece, whether today or in fifty years' time.'

myungjoo lee

born: 1959, seoul, south korea

The graceful, sculptural shapes are what first catches the eye about Myungjoo Lee's jewelry. The pieces combine clean lines with bold, original design. It is instantly apparent that the artist sees her jewelry as miniature sculptures. As a child Lee was inspired by her grandmother, who was always making things with her hands, but she concentrated on her studies first before deciding to take craft classes when she was eighteen years old, initially working with ceramics and wood. Seeking a new challenge, she began to explore using metal, but at the time when she was studying, in the 1980s, jewelry was not seen as an art form and her training focused on metalworking rather than goldsmithing.

In 1985, she moved to the United States and began to study jewelrymaking, finding true inspiration in the form of her teacher, Lesley Leupp, who encouraged her students to consider jewelry a sculptural art form. This prompted Lee to approach her work differently: 'Before, I had always seen jewelry as something simply decorative.' After finishing her studies in the early 1990s, she sold pieces at galleries across the United States before returning to

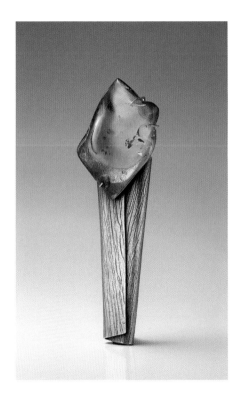

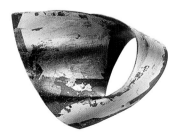

Korea. Back in her homeland, she found a studio in a building owned by a former Buddhist monk who painted and used *kinpakuoshi*, an ancient technique for gilding statues by fixing gold foil to a surface with lacquer or glue. Lee learned this from him as well as another technique, that of *keum-boo*, attaching 24-carat gold foil to silver, iron, steel or copper. In the 1980s, she had been one of the first to adapt this technique to jewelrymaking: 'I try to make gold leaf look like it has been painted, leaving brush-stroke effects on the metal.' Lee has also been influenced by the antique jewelry of the Shilla Dynasty and by *jangpanji*, a traditional Korean paper made from the mulberry tree: while thin sheets are used for drawing, larger, thicker pieces are used as flooring, with numerous layers combined. The underfloor heating commonly used in Korea

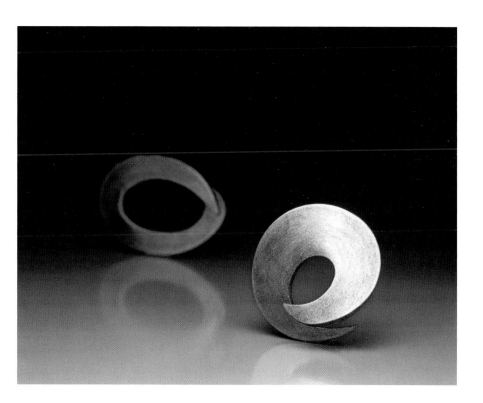

causes the colour to change from yellow to brown, and Lee has adapted this effect for her sculptural pieces, subjecting the paper to various temperatures to achieve a variety of shades. She was drawn to it as it was the floor covering she remembers from her childhood.

Lee also works in silver and loves diamonds, using them sparingly to highlight her designs. She works with two goldsmiths, one of whom she trained herself, and she also makes signed, bespoke pieces. Continually searching for ideas, Lee uses her mobile phone as a visual notebook to capture things that inspire her. Serene and beautiful, her work is uncluttered and very modern despite her use of ancient techniques. Her work keeps traditional skills alive, showing that they can be adapted for a modern setting and audience.

fritz maierhofer

born: 1941, vienna, austria

BELOW LEFT
ring, 2003
corian and gold

BELOW RIGHT
brooch, 2000
aluminium

BOTTOM RIGHT
ring, 1998
aluminium

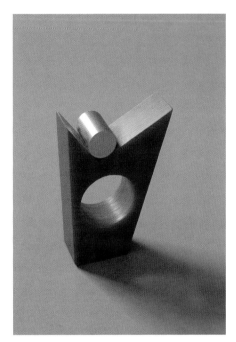

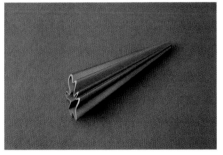

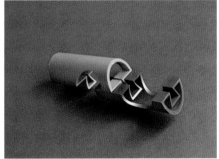

Since the 1970s Fritz Maierhofer has been one of the most important innovators in European contemporary jewelry. His pieces, whether small-scale jewelry or larger sculptures, are timeless works of art, but when asked about his methods he states that there are no shortcuts or formulas for being a successful artist. Maierhofer would have liked to be a draughtsman or a graphic designer, but in the immediate post-war years it was not possible for him to attend the Academy of Art in Vienna, so he trained as an engraver and silver- and goldsmith instead. Having completed a goldsmithing

apprenticeship and qualified in the mid-1960s as a master craftsman at the renowned Viennese jeweller Heldwein, Maierhofer moved to London, where he was employed by the jeweller Andrew Grima to work on an ornamental watch collection for Omega. It was at this time that his interest in contemporary jewelry started to develop, and he established contacts with fellow artists Reinhold Reiling, Claus Bury and Gerd Rothmann as well as David Watkins (pages 176–79) and Hermann Jünger.

Building on his knowledge of goldsmithing, Maierhofer acquired a good grounding in

brooch, 2005
corian, acrylic,
magnets and silver

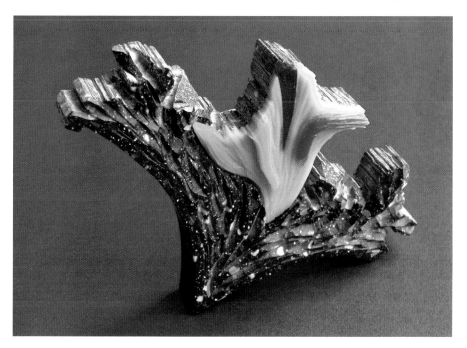

jewelrymaking at the Grima workshop but he quickly realized that he wanted to do his own work. London became an important inspiration to him, and the 1960s and 1970s were a stimulating time. Colour proved essential to Maierhofer's designs: he was inspired by the bright window displays in Soho and the neon lights and signs in Piccadilly Circus.

Throughout the 1970s, Maierhofer experimented with incorporating synthetic materials such as acrylic into his work, pushing the boundaries of what was classified as jewelry. His first pieces were created using cheap everyday materials including acrylic glass, contrasted with precious materials: 'What is important to me is to show the "inner value" and characteristics of the materials without compromise: tin is pliable, plastic colourful and gold as strong as steel.' Having worked extensively with gemstones during his time at the Grima workshop, Maierhofer has rarely used them since, and when he does now he combines them with non-precious metals. By 1995 he had begun to explore how computers can be used in jewelry design and he also experimented with tin and gold, making the most of the form and

BELOW
brooch, 2007
corian, gemstones, magnets,
silver and gold

RIGHT
ring, 2005
corian and gold

malleability of these materials. Pure tin is extremely soft, and Maierhofer has created pieces that take advantage of this attribute: they can be bent into different shapes by the wearer, with small segments of gold worked into each piece to hold the jewelry in place. Using cheaper materials gave Maierhofer the chance to move beyond the small pieces he had previously worked on, as he was able to make objects on a much larger scale without being restricted by the cost of precious metals. He has always made large-scale sculptures as part of the creative process, finding it gives him 'a sense of freedom'. He sometimes designs a paper model of his work (regardless of size) before transferring it to a solid material.

Maierhofer first discovered the material Corian – a synthetic stone similar to pumice or marble, depending on the exact composition – purely by chance: 'In 2000, a client of mine had her kitchen redesigned with work surfaces made of Corian. She gave me some offcuts from which I created two rings.' From this initial experience developed a love of the material, and he now combines it regularly with different metals such as gold and silver.

Although he retains a love of bright jewelry, his more recent pieces are mostly monochrome and he now creates pieces from blackened silver. Renowned for his attention to detail, Maierhofer has focused on all aspects of jewelrymaking, from the overall concept to the fastenings, and he always signs and dates his work. He is saddened by the fact that attention to detail seems to be diminishing. Catches and fastenings are prime examples that he sees as vital aspects of a piece: 'There is nothing to be gained from neglecting the basics. Your work will not survive if it is not made properly. Fittings are perhaps boring but you have to do them well.'

He says of his work: 'When I make a piece, I want those who see it to have an emotional response, just as they might when looking at a painting.' His jewelry is not for the faint-hearted – it takes a confident person to wear his pieces. He says that people no longer want to conform and are more adventurous in their choice of jewelry, whereas in the 1970s the idea of modern jewelry had to be pushed. Maierhofer rarely, if ever, takes on commissions, as he is wary of the time required to get to know the person properly before he feels it is possible to make jewelry for them. He prefers to work freely, spending his time making pieces according to his ideas rather than particular requirements.

Recently, Maierhofer has been working on a project for the Caroline Van Hoek Gallery in Brussels. He had been asked to make one hundred rings out of various materials but 'I said I could only make seventy, as it is the year of my seventieth birthday'. One distinguishing aspect of Maierhofer's work is its continual ability to surprise, and the same is true of Maierhofer himself: his wide-ranging interests include sheepdog trials, for example, a passion he has had from an early age. Maierhofer has always kept reinventing himself, so he is able to create up-to-date jewelry. As he says himself: 'It is from different materials, different resources and opportunities that new meanings arise'.

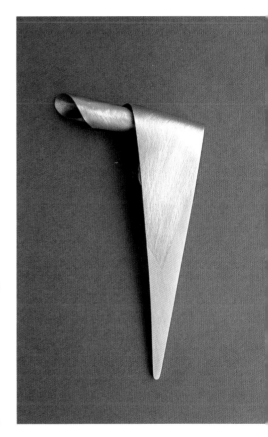

earring, 1985
tin and gold

'circle of petals' necklace, 2009
fine platinum, fine gold and 18-carat gold

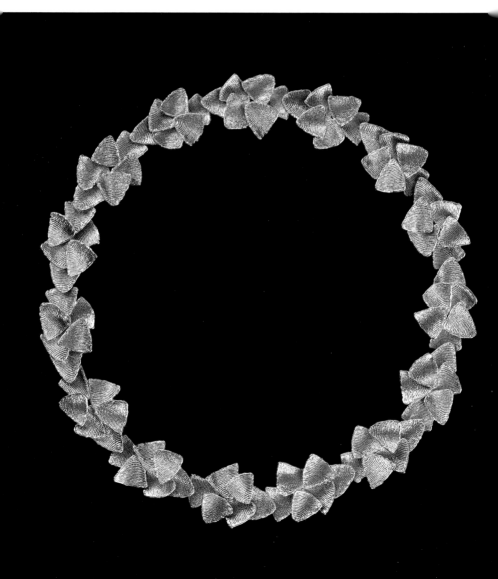

catherine martin

born: 1949, london, uk

'leaf and tendril' earrings, 2010
18-carat gold

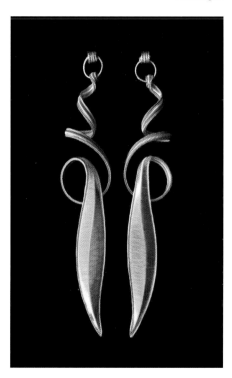

One of the joys of working in the jewelry world is discovering the various journeys designers and makers have made to get to where they are. Having started to make and design jewelry only in her early forties, Catherine Martin's route into jewelry has been convoluted. As a violinist and classical singer, she lived in Japan for some time and learned the complex art of *kumihimo* silk braiding, about which she later wrote a book. On her return to the UK she focused on developing this braiding technique, and it was this that led her to jewelrymaking. Martin was asked by jeweller Charlotte de Syllas (pages 164–67) to make some braiding work for her jewelry and she decided then to learn all she could about jewelry, attending a basic course at Sir John Cass College in 1989. She was intrigued by techniques that made use of wire and began to experiment braiding wire with silk. Her tutors recognized the potential of her work and encouraged her to take a postgraduate course to develop her ideas further: 'I started a part-time beginners' course to learn how to make metal endings for my textile circles, mastering the basics of cutting, filing and soldering. I still do not quite know why but I also started using wire instead of silk in my braiding work. I could immediately see the potential, but it took a long time and a lot of research and refinement before those early experiments could actually be called pieces of jewelry.'

Occasionally, tradition can stifle creativity, and had Martin followed a more traditional route into jewelrymaking, she may not have explored the idea of braiding metals. During her time at college she was encouraged to try platinum for her braiding rather than focus on traditional techniques. Having never designed a piece of jewelry before, Martin created a pair of earrings that won the prestigious Platinum Award (no longer in existence, it was given to designers for outstanding works in the metal) and was acquired by the Victoria and Albert Museum in London for its permanent collection. Following this, Martin attended the Royal College of Art, where she completed a research degree, having been the first jewelry maker to be awarded a

Darwin Scholarship, which gave her the financial independence to pursue her work. She was taught by Jacqueline Mina (pages 124–27), who helped her gain a better understanding of working with gold and platinum.

Martin finds ideas in the music she listens to, mostly Bach, but she dislikes the word 'inspiration' as it implies looking to external influences: 'My work comes from the inside. Why do I have to look for inspiration? It is there – I just have to tap into it. I do not look at nature, I do not draw anything or photograph anything. It comes all from what my music makes me feel.'

Martin makes all of her pieces in silver first, to get an idea of the proportions and the length of wires required. This is vital as each wire must be of a continuous length, and there may be as many as twenty-four different wires used in one piece. Once she is happy with the design, she creates it in 18- or 24-carat gold or platinum. While she is weaving, no heat is applied to the material so that the wires do not fuse; once braided, the platinum and gold resemble a delicate piece of 'metal textile', which then has to be edged and stabilized with a backing. Gold of this carat weight has a great affinity with platinum – it will melt into the platinum while maintaining its colour.

Martin accepts about five commissions a year, usually based on variations of her completed pieces: 'Since my work takes a long time, I concentrate on developing new designs and prototypes before making pieces in gold and platinum for exhibitions.' She is always keen to develop her skills, and is now using a technique where she flattens the metal once weaved, which creates a unique relief effect in gold and platinum. Each of her finished pieces is laser-hallmarked. This kind of work cannot be hurried, and she is never happier than when working in her studio, a private, fairly secluded space. Her work relies on solitude, which allows her creativity to flourish.

Knowing Martin's story is vital to understanding her work. The techniques she has created have been made possible only through hours of painstaking research, and the results are certainly timeless. Martin has never paused in her quest to create different techniques and skills, combining tradition with innovation. Her work will always be distinctive and will add to any collection. As she herself says: 'I never know what I am going to do next. Looking back there seems to be a logic about what I do, but at the time I am unaware of it.'

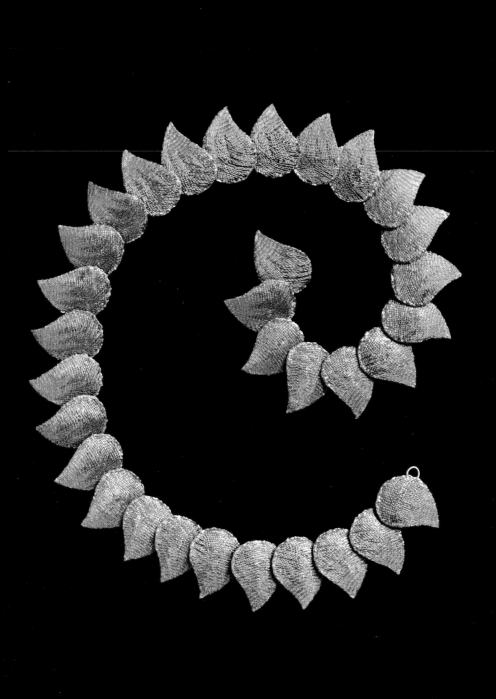

märta mattsson

born: 1982, stockholm, sweden

Contemporary jewellers continue to innovate and expand the parameters of their field, and Swedish jeweller Märta Mattsson is a shining example, as she brings a completely fresh and innocent approach to the subject. Her love affair with jewels began when she was rooting through her mother's jewelry box as a child, and from a young age she has kept a visual diary of ideas and designs. There has been the occasional hiatus (she began to train as a marine biologist) but she always returned to jewelry in the end.

Mattsson first trained as a silversmith, acquiring the traditional skills and techniques, and then completed a course that encouraged her to use different materials in her jewelry, mixing precious and unconventional materials. One of the most intriguing projects from her degree course was the use of jewelry as a means of treating phobias. Mattsson would discuss people's problems with them and then introduce the materials or objects they feared into her work, so that they could be handled with less trepidation. She even made a range of insect jewelry, partly to confront her own dislike of the creatures. Using insects that had died naturally, she found that her revulsion 'subsided the more I worked with them and, by the end, I would think nothing of removing the insides of an insect in order to dry it to use in my jewelry, or of placing the wings of one insect on the torso of another to create a fantasy piece'.

These examples encapsulate the philosophy of Mattsson's work: she takes something that is potentially quite ugly and transforms it into something beautiful and wearable. Her sense of beauty is unconventional and in part inspired

'black beetle' brooch, 2010
cubic zirconia, copper, lacquer and silver

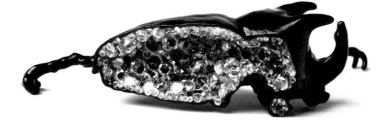

by an avid interest in the natural world (she collected animal skeletons as a child). Her materials are unusual and include animal skin that is moulded, dried and laser-cut, or contrasting, colourful synthetic stones, combined not only with silver and gold but also with the outer shells of insects, 'replacing the yellow gunk that oozes from their bodies with yellow cubic zirconia'. Held in place with resin and with a pin attached, these combinations become an unusual brooch, for example, with the clever use of precious materials appealing to a broad audience.

Mattsson is interested in the Victorian obsession with biology and collecting samples and curiosities for display. She loves the aesthetics and craftsmanship of Victorian jewelry and stresses the importance of jewelry being both beautiful and well made. Her graduation piece for her MA at the Royal College of Art was called 'Rebirth': the idea was to take a dead animal and 'give it a second life in art', creating a new fantasy breed.

Following her graduation in 2010, Mattsson established her own studio in Stockholm. Her ideal commission would be for someone to bring a bug and ask her to experiment with it. She does not, however, undertake commissions lightly and only when she feels they relate to her own ideas (she even declined to make an engagement ring for her brother). Mattsson's jewelry is limitless in its ambition; the themes of attraction and repulsion are key to her work but she also takes the craftsmanship very seriously, which is an area where she will not compromise. It will be fascinating to see her work develop.

'beetle juice', 2010
cubic zirconia, lacquer,
resin and silver

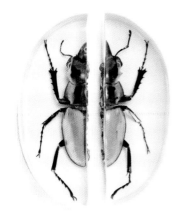
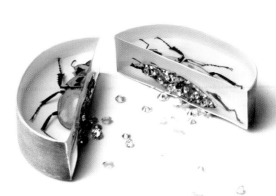

BELOW AND OPPOSITE TOP
'the nest' necklace, 2010
goatskin, butterflies and gold

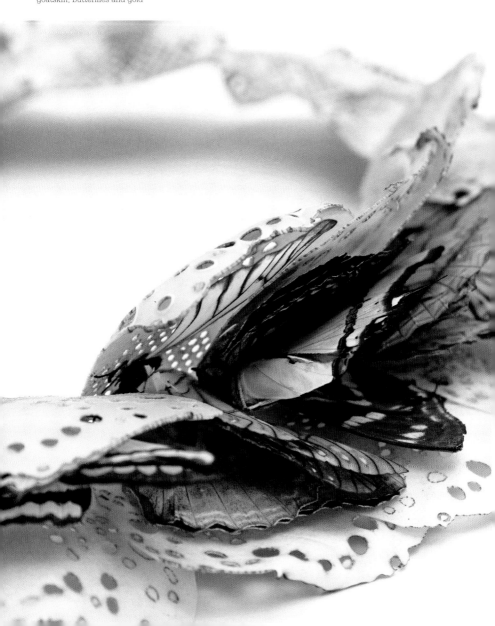

BOTTOM
'skin bow' brooch, 2010
reindeer skin and silver

jacqueline mina

born: 1942, slough, uk

It came as no surprise when Jacqueline Mina was chosen for a solo exhibition at the Goldsmiths' Hall in London in 2011: this remarkable honour for a jeweller acknowledges the importance and influence of their work. Mina has been a central figure in the world of contemporary jewelry for decades and worked as a lecturer at the Royal College of Art for many years. Mina's reputation is based on her continued exploration of the possibilities of fusing gold and platinum by using traditional goldsmithing techniques in unexpected ways.

Mina was intrigued by the 1991 book *The Colouring, Bronzing and Patination of Metals* by Richard Hughes and Michael Rowe. It inspired her to start exploring how metals could be combined with gold, focusing on platinum as its high melting point means it requires no solder. The fusion technique she uses creates a unique pattern every time, which is one of the trademarks of Mina's work. Just as there are no duplicate gemstones in nature, all of her pieces are one of a kind, although some have only slight variations between them. Mina explains that with her technique she has been trying 'to extend the possibilities of fusion between gold and platinum, employing platinum gauze, mesh, distressed fragments, tesserae, wire and gold dust to create a variety of surfaces'. She rarely does a drawing of a piece before making it, preferring to create it directly in metal.

necklace, 1984
platinum, fine-gold dust fusion and 18-carat gold

BELOW
necklace, 1985
platinum filigree and
fine gold

BOTTOM
bracelet, 1993
oxidized 18-carat gold with
platinum-mesh fusion inlay

Platinum is not the only metal with which Mina has experimented. She has recently started working with titanium again, marking a return to the material she first attempted to use in the early 1980s. She initially found it limiting and difficult to shape using only hand tools and requiring a hydraulic press. Now, however, she has managed to texture it before colouring the metal with a flame. She has experimented putting it through a rolling mill together with a textured sheet of paper that leaves its impression on the metal, and filing the surface in different directions. To Mina, one of the attractions of titanium is in fact its restrictions, which influence how she uses it together with gold. In her opinion, 'limitations are a challenge for creativity', and in addition to gold, platinum and titanium she also uses gemstones, in particular labradorite. She signs her work using a signature punch to spell out her surname, but only on larger pieces; the smaller items bear only hallmarks. Interestingly, Mina was instrumental in getting the hallmarking laws altered to allow two hallmarks on a single piece of jewelry that contains both yellow gold and platinum, for example.

Her titanium pieces have brought numerous requests from galleries such as Electrum and the Contemporary Applied Arts Gallery in London for Mina to create collections for them, although nearly half of her work consists of private commissions. Her approach is to get acquainted with her clients' life and style, so that she can create pieces that fit into their world. It is her view that jewelry should be worn regularly: 'I want my pieces to be worn, not brought out only occasionally.' To Mina jewelry

OPPOSITE
'swivel' bracelet, 2004
18-carat textured gold

BELOW
brooch, 2009
titanium and 18-carat gold
with platinum-dot fusion inlay

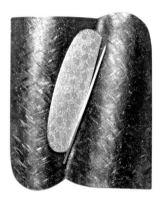

is precious for its sentimental value and its capacity for individual expression. Her advice to any collector is to buy something with an emotional connection, rather than buying a certain brand or purely for investment. She does not find it difficult to part with her work: 'I want people to have my pieces. It gives me so much pleasure to hear how they have been appreciated by others.'

In addition to travel, art and music, Mina finds inspiration in her materials: 'My whole way of working is built on an extensive knowledge of the technical aspects of goldsmithing, through which I express a contemporary aesthetic. I intend my craft to remain at the service of my art and am focusing on the surfaces of precious metals and their form; juxtaposing light and lustre with expressions of angle, curve and line.'

Mina's goldsmithing skills are exceptional – the subtle form and sophisticated texture of her work are executed to the highest quality of craftsmanship. She is without doubt one of the best British goldsmiths working today, and she always seeks to push the boundaries of her craft. She is also renowned for her attention to detail, in particular fastenings, which require great precision. It is her ability to envisage the artwork as a whole as well as her inspired, ever-evolving design that has kept Mina at the forefront of her field for such a long time: 'I have a "grasshopper mind": always wanting to move on whenever I feel the work has become formulaic. I stay open to all kinds of possibilities and avoid fixing any detail right up to the completion of a piece.'

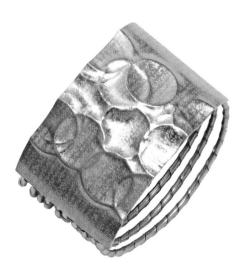

LEFT
bracelet, 2010
18-carat gold with 10- and
18-carat gold striptwist wires

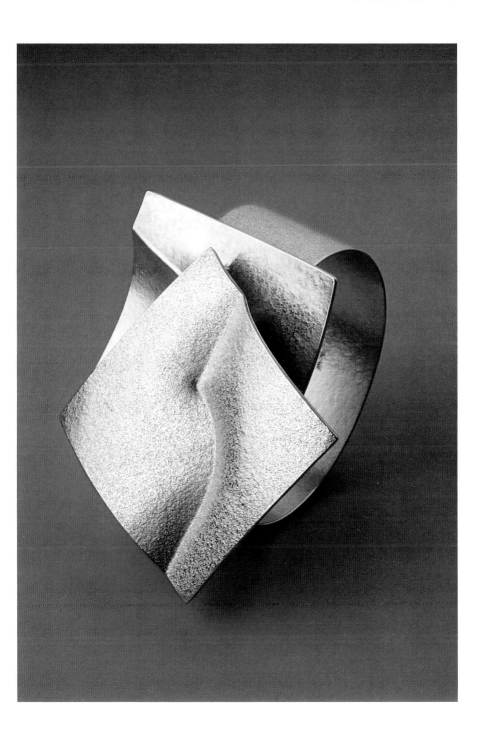

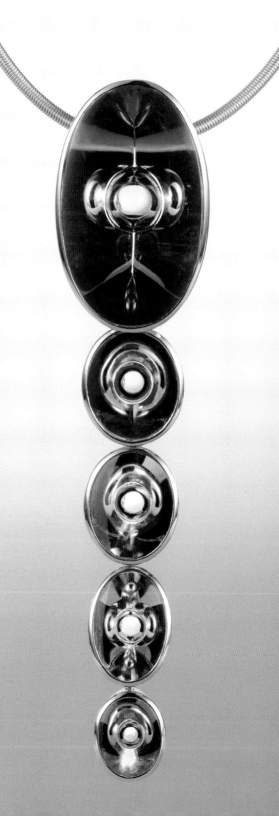

atelier tom munsteiner

bernd munsteiner born: 1943, mörschied, germany
tom munsteiner born: 1969, bernkastel-kues, germany
jutta munsteiner born: 1968, hermeskeil, germany

I first came across the work of the Atelier Tom Munsteiner at the Inhorgenta Fair in Munich and was instantly fascinated: the stones they use are common enough, but in their skilled hands it seems as if something new has been discovered. Unable to resist, I bought a square purple amethyst, which was cut to create the illusion of a large bubble suspended in the centre.

There are three people working in the atelier – Tom, his wife, Jutta, and his father, Bernd – and they are assisted by eight employees. They are among the most celebrated stonecutters in the world today, able to transmit new magic while applying traditional skills to their work.

The atelier is essentially a family business, with Tom Munsteiner representing the third generation of gemstone cutters. It was his father who established the atelier as a centre of innovation and art. After an apprenticeship with his own father, Bernd studied at the Pforzheim School of Design in the early 1960s.

There he was 'given wings and helped to fly', learning not only about gemstone cutting, metal sculpting and jewelry design, but also about painting and art history. Bernd discovered that the art of cutting and polishing gemstones had hardly changed since the Renaissance, a realization that spurred him on to break with the traditions of the craft. Grounded in traditional techniques, he was able to develop his own concept of gemstone cutting, creating works of art in hardstone and always seeking to obtain maximum reflection from his materials. Initially, however, many established stonecutters viewed his work with scepticism, some even claiming that his cuts actually disfigured the gems. Despite the sceptical reactions in his homeland, in the mid-1960s Bernd Munsteiner managed to sell his stones in Denmark, where modernist jewelry was embraced. Around the same time he also founded his own studio, and his creations, while remaining somewhat controversial, began

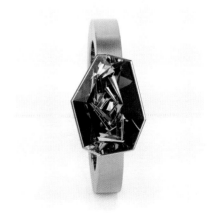

OPPOSITE
'magic eye' necklace
by tom munsteiner, 2008
tourmalines and 18-carat yellow gold

RIGHT
'lucrece' bracelet
by tom munsteiner, 2010
amethyst and 18-carat yellow gold

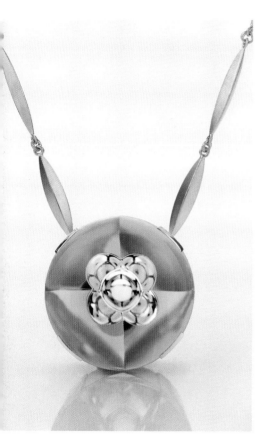

necklace
by tom munsteiner, 2010
cut citrine and 18-carat yellow gold

The studio is based in Stipshausen in the Rhineland, and Bernd remains active in the business – Tom says of him: 'He is like a dictionary for me. If I need an answer to a problem I can ask him.' Tom's stones are often featured in jewelry designed in collaboration with his wife, Jutta, who is an innovative and celebrated goldsmith and jewelry designer herself. Jutta brings her own ideas to the designs, believing that women wear jewelry to show who they are as a person. Therefore her jewelry focuses on the design rather than the intrinsic value of the gems and metals.

Tom Munsteiner has his own distinctive way of stonecutting, making it easy to differentiate between his work and that of his father. As he says, 'less is more' – he seeks to be minimal in his approach, using polished and unpolished facets to give the stone a greater three-dimensional feel. All stonecutters learn to create the most polished stone possible, so it is relatively uncommon to have rough crystal showing. Traditionally, cutters also try to leave no inclusions or flaws – something that both Tom and his father like to do in their work, following the philosophy that imperfections give a stone character and should be enhanced. They attempt to cut in such a way as to ensure any inclusions are reflected into another part of the stone: 'We do not look for carat weight, but look at the beauty of the stone. When faced with prominent inclusions, I always ask the question "Is it a flaw or an artistic opportunity?"'

Working with larger rough crystals, the Munsteiners do not cut rubies, sapphires or diamonds but prefer stones below 8.5 on the Mohs hardness scale (ten being the hardest).

to receive favourable reactions, particularly in San Francisco, where he held a show in 1981.

Tom Munsteiner was always going to follow in the footsteps of his family and become a stonecutter as well. He was first taught by his grandfather Victor: 'It was never a question whether I would become a stonecutter,' he says. 'As a young boy I used to spend my holidays at my grandfather's house and, from about age seven onwards, I was allowed to play with cutting stones. I had the freedom to explore and experiment. I am lucky that my job is also my hobby – I am so happy cutting stones as there is always something new to discover.'

BELOW
**'meduna' sculpture/necklace
by jutta munsteiner, 2010**
rutilated quartz and 18-carat
yellow gold on quartz base

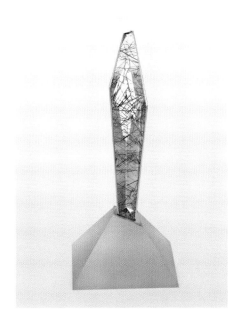

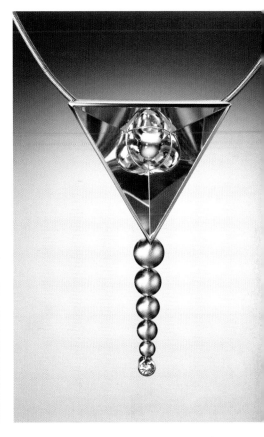

aquamarine necklace by jutta munsteiner, 2008
aquamarine, spirit diamond and 950-platinum

There is always a risk when cutting stones that they might shatter on the cutting wheel, so Tom will only take the risk of cutting his own stones in case they break. Just like his father and grandfather, Tom has an outstanding skill. He does not draw or write about how he aims to approach each stone but studies it to see where cuts can be made safely, and as he works the nature of the stone is revealed. He loves to use aquamarine, tourmaline and rutilated quartz, but is attracted by any coloured gemstone: 'We are a company seeking quality not quantity. I will visit Brazil to view many kilos of quartz. I am happy to pay a higher price for quality and I usually have an idea of how to cut each piece.' Each stone is unique, and Munsteiner's technique enhances this originality; stones come with a certificate to indicate that they were cut by Munsteiner, a photograph and a description detailing the type of stone and weight. The atelier has created a truly innovative gemstone-cutting style, and its pieces will undoubtedly stand the test of time as exceptional works of art.

adam paxon

born: 1972, penrith, uk

BELOW
neckpiece, 2009
acrylic, lacquer, epoxy,
enamel and acrylic paint

The son of jewellers and silversmiths, Paxon was exposed to jewelrymaking and design from an early age. He considered many careers within the creative arts, from graphic design to sculpture, but always found himself returning to jewelry. He says he is interested in 'the value and properties of different materials, how they metamorphose and what value various materials give to a piece. I like to work with challenging materials to see what they can offer and how to change their structure.' In choosing jewelry (rather than sculpture, for example) Paxon is able to explore his fascination with the way an artwork can connect to the body; he makes unique pieces that should be worn on special occasions, just like couture, and mean something to the owner. It is through wearing and handling that jewelry stays alive.

While Paxon now works full-time in his studio, his route to earning a living from jewelry

was convoluted and informs the designs he produces. For a number of years, while he was studying at Middlesex University, he also worked as a prop maker in film, theatre and television, and discovered materials he may otherwise not have considered for jewelry-making. For example, he fashioned silicone and polyester castings for the film *Judge Dredd* and used polyester, acrylic and lead to create jewelry for *Braveheart*. This discovery of synthetic materials proved a revelation for Paxon: 'I found these materials that had colour all the way through, meaning I could work with colour in three dimensions.' His experiments with sheet acrylic (from which much of his jewelry is made) allow him to convey the impression that his pieces are fashioned from a liquid substance. 'I want to give the work a liquid feeling, as if colour has been caught in motion,' says Paxon, 'I am trying to "humanize" a material that is actually not from the earth and make people say "This is not plastic" and start to question what the piece is as a whole and whether it stands the test of time.'

Paxon's workshop is in his native Cumbria, and he gains inspiration from the surrounding landscape, although he does still need his 'regular fix of the hustle and bustle of London'. The blend of tones he brings to his work is reminiscent of the change of colours across the Cumbrian landscape: 'It feels like I am painting and, as light travels through the three-dimensional material, it takes the colour with it and changes the material accordingly. When I am creating something unique and different, nothing stays the same.' Plastic is usually thought of as synonymous with mass

neckpiece, 2007
acrylic

'brooch with four eyes', 2009
acrylic, lacquer and enamel

'how tongues wag, no. 2'
brooch, 2010
acrylic, lacquer and cold enamel

'pair of rings with tails
in mirror', 2008
acrylic

production, yet each article of Paxon's work is unique. The materials he uses have no intrinsic value, meaning those who collect his work are buying solely to own his designs. Like many contemporary makers, Paxon does not sign his pieces, feeling his distinctive style has the same function as a signature. Similarly, he prefers not to take on commissions, although he does work with a fictional person in mind: 'When the right person comes along it is a moment of magic for me. I get enormous pleasure from knowing that a jewel has found its rightful owner. There is nothing I love more than hearing stories of how jewelry is passed down through generations, still remaining beautiful and noticeable. I heard of someone who was wearing one of my pieces on a plane being asked where it was from – I love the idea that the jewelry sparks a conversation between two complete strangers because of their mutual appreciation of the work.'

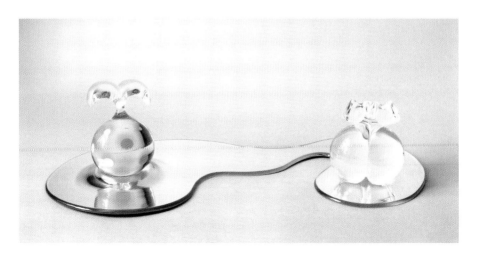

wendy ramshaw

born: 1939, sunderland, uk

Wendy Ramshaw is a legendary figure in the jewelry world and an icon of her time; her inexhaustible imagination has made her one of the most influential and accomplished jewellers working today. To own, or wear, a Ramshaw creation is a privilege, and there is no doubt that her pieces will endure as works of art and continue to inspire for a long period of time.

Ramshaw came to jewelry design by accident. While making prints at Reading University, she decorated intricately detailed copper printing plates with small designs and drilled holes in them to make earrings and hair clips. The result was that other students asked her to make pieces for them and gradually she began to establish herself, making first copper and then silver jewelry. In the early 1960s, while at Reading, she met her future husband, fellow artist David Watkins (pages 176–79), with whom she eventually moved to London.

They worked together on innovative projects creating acrylic and paper jewelry, before Ramshaw returned to using precious metals, initially silver, then 9-carat gold. The impact of her work was immediate, as she took the conventional jewelry industry by storm with her famous ring sets. Each ring, when not being worn, is designed to be stored on a matching lathe-turned Plexiglas or metal stand, thereby becoming an integral part of a unique, free-standing miniature sculpture. These rings and stands earned Ramshaw the Council of Industrial Design Award in 1972, an accolade that had never before been presented to a jeweller. Such recognition helped to put contemporary jewelry on the map and offered great encouragement to other jewellers working at the time. It also meant that Ramshaw attracted a wide and enthusiastic clientele from the United States, ensuring a level of international recognition that has continued

LEFT
'white queen' ring set, 1975
pale sapphires, moonstone,
enamel and 18-carat gold
on acrylic stand

OPPOSITE
**ring set
('small collection'), 1977**
garnet, cornelian and 18-carat
yellow gold on brass stand with
transparent resin

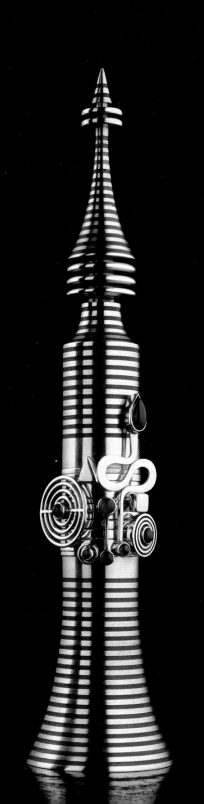

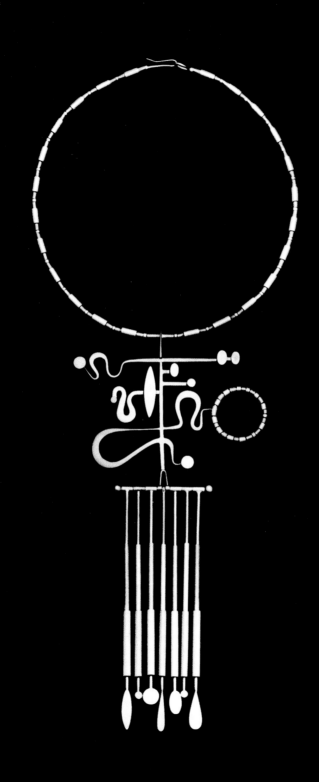

neckpiece with pendant, 1973
white and yellow gold with
sandblast surface

'pillar rings' (set of five), 1972
semi-precious stones and silver

**'wendy ramshaw and wedgwood':
two long pins, 1982**
wedgwood jasper and
18-carat yellow gold

to grow over the years. Ramshaw frequently undertakes special commissions for clients, seeing them as 'one of the joys of being a jeweller'; for collectors, being able to commission from a living artist is an added bonus. Although she does have assistants, she often works on her own so the creative input is entirely personal. She hallmarks the pieces that are made from precious metals but does not sign those made from other materials, as she feels this could spoil the design.

Ramshaw remains unafraid to challenge tradition and is unapologetic in her quest to push the boundaries of art and design. There is a spirit and energy to her approach, in the way that she seeks to be entirely immersed in the creative process. Her inspiration comes from the world around her, and among her many sources are architecture, art and machine-made objects. She never compromises on the attention to detail, whether she is designing for the mass market (a rare event) or a one-off piece. Ramshaw uses the different properties of her materials as inspiration, taking their qualities to determine particular ways to make objects: 'The two materials I like to work with the most are 18-carat yellow gold and paper. I have on a number of occasions combined them in one piece and both are rewarding to work with. Some materials I have used are hard to work with, but the finished design always has a quality or colour I could get no other way.' Drawing also plays an integral role in the creative process. Rather than simply sketching, she makes detailed pencil drawings of a piece before making it.

This focus on drawing led to another of her innovative jewelry collections, 'Drawings in Gold'

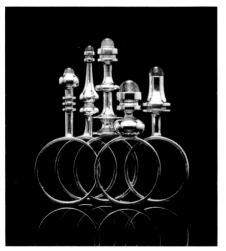

**'measure': pair of unmatched
earrings, 1987**
semi-precious stones and 18-carat
gold on nickel alloy stand

OPPOSITE
'performance' brooch, 2008
gold

– a series of pencil lines on paper translated into lines of fine gold wire. The resulting creation is worn as a brooch, with a pin at the back, turning the drawing into a piece of jewelry. These 'Drawings in Gold' underline Ramshaw's talent for appreciating the complexities and challenges each material brings and her ability to highlight its best qualities, pushing its boundaries without losing its identity. Ramshaw's approach to materials extends to an awareness of how new technology can assist in the design of her creations. Microwelding, for instance, allows different metals to be joined together, while laser welding gives even greater precision, enabling makers to fashion increasingly delicate jewelry. However, for Ramshaw, the tool that is most important to her creativity is more traditional: a lathe, used to create both the jewelry and the stands that hold the ring sets: 'In the late 1960s I was creating pieces by hand, but it was hard to control and finish to the standard I required. It became clear that such pieces could be produced much more exactly with the use of an industrial lathe and, as they say – "the rest is history".'

Another material employed by Ramshaw is glass: her creations resulted in her becoming artist in residence at Pilchuck School of Glass in Seattle in 2006. It is recognized as the greatest centre for creative glasswork in the world, and Ramshaw's work in this field culminated in the exhibition 'Journey Through Glass' in 2007, which featured a collection of glass jewelry and tabletop vessels.

In 1989, Ramshaw began a series of works that would take ten years to complete. Entitled 'Picasso's Ladies', it is a collection of jewelry inspired by sixty-six portraits of women by Picasso. Made from a multitude of materials, the pieces echoed the colour, emotion and shapes found in the works of the Spanish master and were fashioned in numerous different techniques to relate directly to the paintings. The complete collection was exhibited at the Victoria and Albert Museum in 1998 and has proved to be influential on many levels.

Ramshaw's work epitomizes the past five decades of jewelry design – a formidable feat for any artist and one that has been widely recognized. She is a Liveryman of the Worshipful Company of Goldsmiths and was made a CBE (Commander of the Order of the British Empire) in 2003, while her pieces are part of many major public collections including the Victoria and Albert Museum in London and the Metropolitan Museum in New York. She has also undertaken numerous prestigious commissions, among them the bronze gates for the residential complex One Hyde Park in London. Her huge commitment and drive have never waned, and her appetite for challenge and new ideas seems inexhaustible.

pin, 2007
raw diamond macles,
raw diamond cubes
and 18-carat gold

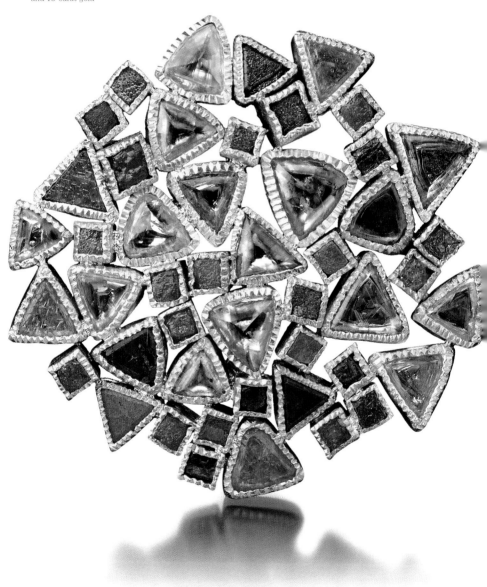

todd reed

born: 1973, winston-salem, usa

The work of American jeweller Todd Reed reminds me of my time as a rough-diamond valuer and grader in London. Rough diamonds are sorted into categories from gem quality to 'near gem' to industrial stones; the latter were rarely seen in jewelry until recently. Reed's pieces are characterized by the use of rough diamonds rather than polished stones.

As with many of the jewellers in this book, Reed's philosophy is that 'jewelry is an art form'. His interest in the inherent beauty of uncut stones grew from studying geology at high school. His love of crystal forms combined with an awareness that industrial diamonds were often used in the most prosaic environments; with his knowledge of the diamond business, Reed wanted to challenge how people saw diamonds and gauged their value.

Aged eighteen, Reed taught himself to make jewelry, also discovering a love of design. Rather than studying at college he started his own business, learning his trade while working at exhibitions. In the 1980s and 90s, he was among the first jewellers to raise the issue of sustainability in jewelry, a subject on which he has lectured regularly. He uses rough diamonds partly because they are more affordable than cut and polished ones, but also because their origins can be more easily tracked.

Reed loves the idea of recycling and reusing: 'Having the right relationship with the planet is important to me.' It is essential for him to use materials that are sustainably and ethically sourced. He looks at third-party audit reports on diamond mines and cutting factories before buying so he can be sure of their working conditions. Reed also sources gold from

Harmony, a socially and environmentally responsible mining company, feeling that by using a single supplier he can more easily monitor the origins of his material. He has recently started using palladium, again bought from Harmony. It is light, strong, inexpensive and hypoallergenic with a beautiful deep grey colour – 'If you want something really cool, then palladium is a really sexy metal.'

Most of Reed's diamonds come from Canadian or Australian mines, but he also thinks there is no need to excavate more, since plenty of gold and abundant gemstones are available already: he buys diamonds from old collections, recently for example from a toy company that had bought stones from the Argyle Mines in Australia in the 1980s. Another source is clients who bring their own stones to be redesigned into new pieces of jewelry.

Reed is interested in the fact that diamonds have long represented love and passion, but that this message is conveyed only if the stone is set in a piece of jewelry. In using rough, uncut diamonds he aims to challenge these traditional notions. Industrial diamonds would have been difficult to buy a few years ago and unpolished gem-quality crystals would have been unavailable since the stones were more valuable when polished. However, availability has increased recently, as designers and jewellers have come to appreciate stones for their natural beauty, seeing any flaws or inclusions as features to be enhanced and embraced in the design.

Reed's inspiration comes from numerous sources. He admires the work of British artist Andy Goldsworthy, who uses natural materials for outdoor sculptures, and there is a similar

pin, 2008
rose-cut diamonds,
brilliant-cut diamonds,
raw diamond cubes,
silver and 18-carat gold

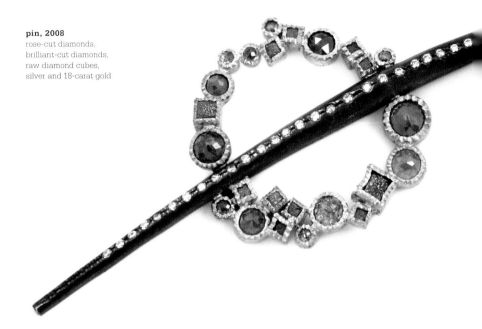

influence of nature in Reed's work. As he says: 'I love how the sun pokes through the clouds, the way a leaf loses and changes its colour when it gets wet. I love any form of expression, and my designs are part of this. I look at each piece as a new piece, a new concept.'

Reed offers a signature collection in various stores in addition to the pieces in his own shop in Colorado, and his firm produces about 3,000 commissions a year. He loves to make one-of-a-kind pieces: 'I want to design and make pieces that make people smile, without being overly complicated or technical. If the design is strong enough it will speak for itself and mark its own course. It is like having a meandering trail in the garden that seems to be going nowhere in particular but when you get to the end it leads you to a beautiful view. The trail is part of a process that takes you to another place. The path is only part of the whole.' Each piece starts with a drawing and he conveys to his

team of designers exactly what he wants created. If he is making his own work, Reed often adapts the design as he proceeds.

Reed's Colorado store is also home to his small firm, which is characterized by integrity and good craftsmanship. Not being a chain or brand gives his team the freedom to work with whomever they choose and with the materials that appeal. The shop is traditional-looking and the workbenches are exposed: 'So much machine-made jewelry is white and bright and untouched by human hand. If you want that, go to a big department store. Sometimes we have crowds of people looking through the windows watching our craftsmen. We are keen that all the work remains handmade.'

If diamonds are conventionally valued by the four Cs – cut, clarity, colour and carat – Reed adds a fifth, standing for character. It is this that makes his work so compelling.

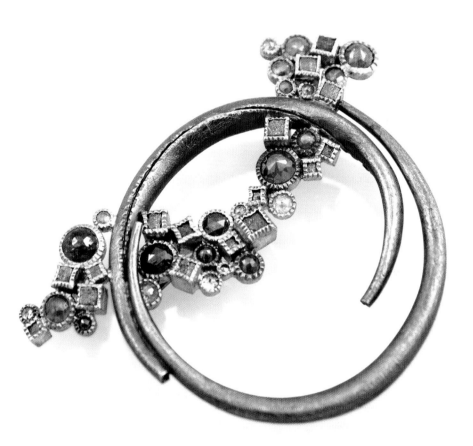

pin, 2008
rose-cut diamonds, raw
diamond cubes, silver
and 18-carat gold

fred rich

born: 1954, rio tinto, spain

LEFT
opal 'daisy' brooch, 2007
opal, enamel and 18-carat gold

OPPOSITE
necklace and earrings, 2009
diamonds, enamel with 22-carat
gold *cloisons* and 18-carat gold

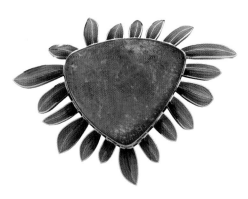

One in a long line of mining engineers, Fred Rich was expected to follow his father into that field. However, a chance encounter with a jewelry-maker and a single evening class showed him he had the talent to become an artist and designer. Having never considered a career in the arts, he approached the Central School of Arts in London to apply, and, after a slight hiatus to complete the portfolio required for entry, Rich began to study jewelry full-time: 'I have always loved jewelry and working with my hands, but because my background was science-based I really had no notion that art school even existed, let alone that I would end up going there, but I followed my heart and have not looked back since.' The course was a revelation to him, opening his mind to the creative possibilities of jewelrymaking. Having explored a variety of techniques and materials, a discussion with his tutor, the jeweller Kevin Coates (pages 48–51), led Rich to establish his own business after college: 'Kevin said I should definitely not work in someone else's studio, which was the expected route to take after college. I remember him being quite adamant

and saying, "Go and work for yourself straight away", which really hit home. I was traditional in my outlook at first, preferring diamonds, gold and enamel, and really focused on using my technical skills, which I found more interesting than designing.'

Rich was extremely ambitious with his use of enamel even as a student, finding the enamelling process particularly fascinating. He loved its permanence and range of glorious colour, but was also attracted by the difficult and demanding nature of the medium, which requires the highest standards of workmanship. Rich describes the firing process as something quite magical: 'You never know what is going to happen, and, although you try to stay in control, you are always aware that you are teetering on the edge of disaster. This gives you a profound sense of achievement when something is finished and you feel as though you have pulled it out of the ether.'

After graduation, enamelling for jewelry-makers including Leo de Vroomen (pages 172–75), Roger Doyle and later Stephen Webster gave Rich the confidence to develop his own techniques – in part a reaction against such traditional enamelling techniques as *champlevé* and *cloisonné*. He uses 22-carat gold wire soldered to a metal background to create his design. The background is carved in relief before a layer of powdered coloured glass is applied, which is then fired and turns into enamel. Up to four thin layers of enamel are used and ground down to reveal the gold wire underneath. Finally, the piece is flash-fired for a glossy finish, which is further enhanced by polishing.

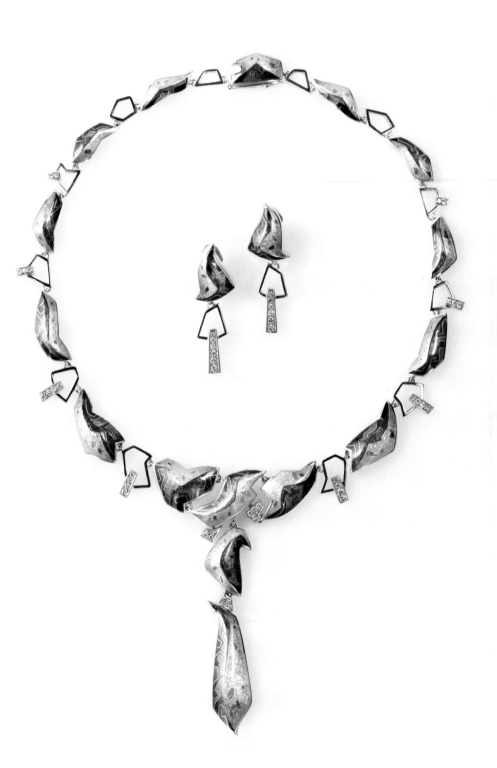

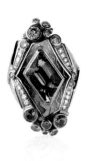
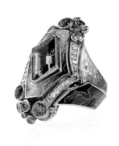

LEFT
rings, 2010
aquamarine, diamonds,
enamel with 22-carat gold
cloisons and 18-carat gold

BELOW
necklace, 2008
aquamarine, pearls, enamel
with 22-carat gold *cloisons*
and 18-carat gold

OPPOSITE
**'leopard shark' and
'blue shark' brooches**
brown diamond (left) and blue
diamond (right), enamel with
22-carat gold *cloisons* and
18-carat gold

In 2000, Rich began a business partnership with Adrian Butcher, which operates under the name Fred Rich Enamel Design. Rich works with a small team of silversmiths, spinners and polishers and closely monitors the whole process, demanding nothing less than technical perfection. He insists on the best-quality craftsmanship, and while he is aware that modern technology can facilitate creativity, Rich remains adamant that traditional skills are the basis of good design. For him, confidence and imagination are key to individuality, and that is why his work is never subject to fashion or trends – he wants his clients to buy his pieces only if there is a real connection.

Rich's main source of inspiration is the natural world, and his fascination with detail and colour is apparent in all his pieces. The importance of colour shows in the range of materials and processes he experiments with in his jewelry – paint, patination, refractory metals, dyed feathers, nylon and hand-printed polyester. In addition, he is influenced by artistic achievements from previous generations and many different disciplines, notably Romanesque sculpture, which holds an enduring appeal for him. The two jewellers whom he respects and admires the most are René Lalique and his former mentor Kevin Coates, for their superb craftsmanship combined with sensitivity and creative use of material. Rich mirrors these sentiments in his own work, and when working on commission for jewelry and silverware he is happy to take the client's suggestions on board. He likes to work around a client's particular passion and will often incorporate something personal into a piece that only the client will recognize. He also regularly creates new pieces by reworking inherited jewelry.

Rich is keen to work on male jewelry as well, designing small pieces for jacket lapels. His current silver pieces showcase his soldering skills: the process involves soldering fine silver to sterling silver before adding a 22-carat gold wire design to which enamel is applied. This gives a unique, 'encrusted' effect, but is still proving quite difficult and costly; he would like his pieces to be fairly affordable so aims to develop the technique to make it more accessible.

Rich has been working with enamel for thirty years now and is still learning. There are few people who have his talent to master the complex skills required for this work. His pieces exude love of life, humour and kindness: 'The funniest things make me tick, combinations, things I see, associations. I like to be able to create a spark of magic – it does not need to be imbued with meaning. I look for a timeless, precious quality that is not simply about expense, but about the desire to hold and keep and look after something.'

OPPOSITE LEFT
brooch, 2008
vitreous enamel and 18-carat gold

OPPOSITE RIGHT
ring, 2008
vitreous enamel and 18-carat gold

OPPOSITE BELOW
necklace, 2006
freshwater pearls, vitreous
enamel and 18-carat gold

jacqueline ryan

born: 1966, london, uk

I first met Jacqueline Ryan at an exhibition in North London that was attended by a curator from the Victoria and Albert Museum, who was there to acquire a piece for its permanent collection. The fact that Ryan had been chosen for this signal honour is testimony to the importance of her work and the esteem in which she is held in the jewelry world.

Ryan originally wanted to study fine and applied arts, attracted by her interest in painting and drawing, but 'quite unexpectedly, while on a foundation course for the arts I discovered I had a flair for creating small-scale three-dimensional objects.' This led her to change direction and study metalwork and jewelry, finishing with an MA in Goldsmithing at the Royal College of Art (RCA) in London. She was fortunate to train under excellent jewellers including David Watkins (pages 176–79), Michael Rowe, Jacqueline Mina (pages 124–27), Cynthia Cousens, Kevin Coates (pages 48–51) and Onno Boekhoudt. While at the RCA she met fellow student and goldsmith Giovanni Corvaja (pages 52–57), who had come to London from the famous Pietro Selvatico Art Institute in Padua. It was Corvaja who encouraged Ryan to use red gold, a trademark of the Paduan school. She still uses it, augmented with copper and silver alloys. Having finished her studies, Ryan returned to Italy with Corvaja. They shared a workshop together in Padua before establishing separate workshops in Todi, outside Rome.

During her time in Padua Ryan met other jewellers: 'This was such a stimulating time for me. I got an insight into how gold was used; the Paduan jewellers work with a technical perfection I have always admired. It was such a privilege to be able to work alongside great masters like Giampaolo Babetto and Francesco Pavan.' Ryan still lives in Italy, which she finds a great source of stimulation.

Her training began with an emphasis on design and she remains passionate about the power of her craft to express ideas and concepts. Believing that to maintain originality it is necessary for inspiration to come from beyond the world of jewelry, Ryan draws on diverse sources. Some ideas have been inspired by childhood trips to Epping Forest in southern England and various museums, which gave her a lifelong fascination with the forms, structures, textures and colours of the natural world. As she says herself: 'I could be anywhere in the world as long as nature surrounds me, and would love the opportunity to study the flora and fauna of another, warmer continent such as Australia or the Americas.' She regularly visits botanical gardens and zoos to sketch growth patterns, decay, order, structure and composition, which she then translates into her beautiful, intricate pieces: 'I start by sketching a natural object and then move on to develop the drawing into a design, followed by a paper model which I always keep. Throughout this process, the abstraction of the piece evolves, eventually reaching fruition in the final design. It is like the four stages of a butterfly: egg, caterpillar, chrysalis and butterfly. It never goes exactly as planned. There is always a surprise element and that is the pleasure I get from this journey of creating something unique, especially when I look back at the original concept. That variation gives the piece its life.'

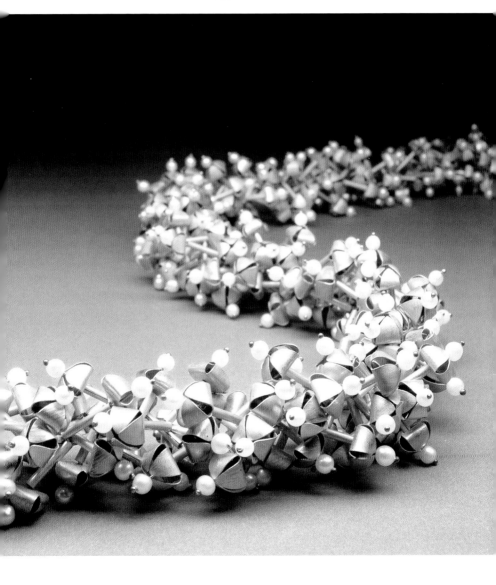

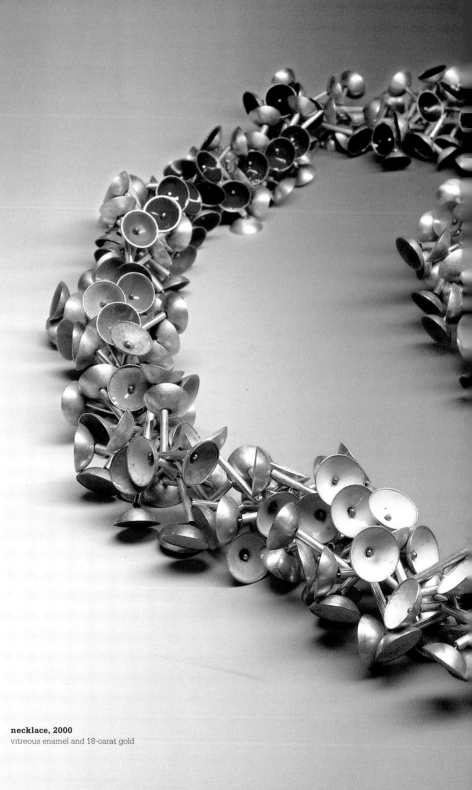

necklace, 2000
vitreous enamel and 18-carat gold

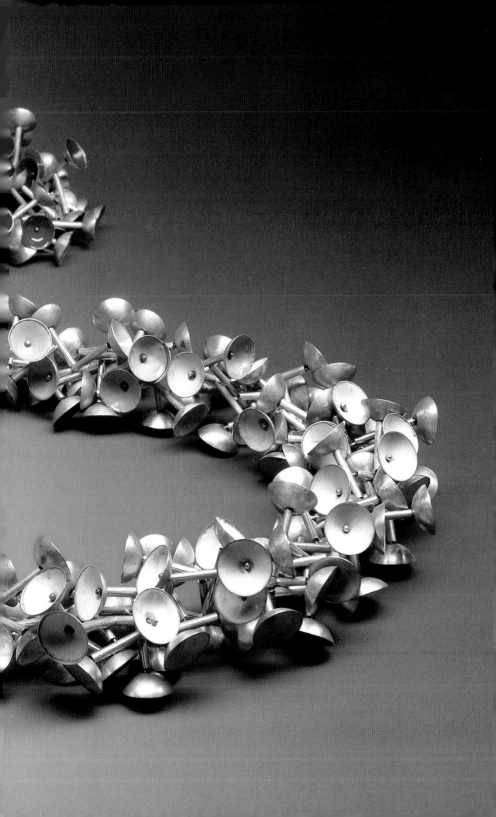

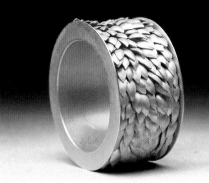

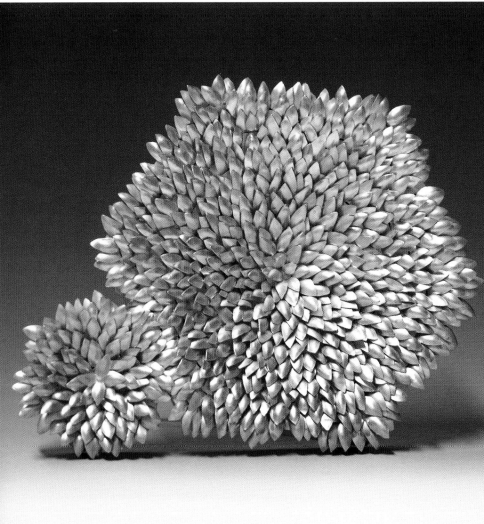

Ryan also draws inspiration from the decorative arts of ancient Egyptian and Etruscan cultures, seeing the timeless nature of their art as something to emulate in her work, expressed in her own contemporary visual language. She is always seeking out new ideas: 'I always take my camera with me, so if I see something that catches my attention I can capture it and then store it away for future use. I will find that I come back to it years later.'

Ryan's work consists of loosely fixed, moveable elements connected by pins. A piece comes to life when the wearer's movements are transmitted to the jewelry: 'My work is intended to be worn. While I always aim to make it visually stimulating and aesthetically exciting, I think it is the tactile qualities of jewelry that make this art form so appealing. Ultimately it is the interaction of the wearer with the work that truly brings the piece to life and fulfils its function.'

Signing and dating every piece, Ryan prefers 18-carat gold in its natural opaque and unpolished state and mixes her own alloys in order to obtain the warm colour she prefers. 'I use red gold which has a strong yellow-orange colour and a colder colour such as blue to contrast the warm gold. I like this combination, and at present I use different shades of blue, from light to dark; when I tire of this I will move on to other colours.' Her blue tones are provided by turquoise, lapis lazuli, pearls or vitreous enamels that fuse to the gold, employing the same process that René Lalique used a hundred years ago. She rarely incorporates stones but when she does it is primarily for colour rather than value, and in their natural state as opposed to cut or faceted.

Dismayed by the general decline in technical skills, Ryan ensures that her jewelry is beautifully crafted. Her goal has always been to make works of art: 'I do not believe that commercial, mainstream jewelry will retain its validity. I hope that my work, and that of others who share my beliefs in craftsmanship, aesthetic distinctiveness and creativity, will be appreciated by future generations.' She also chooses not to use digital technology in her work: 'It would take the enjoyment out of it for me. Nothing compares to the joy of developing a drawing into a three-dimensional work of art, labouring over it for days, weeks or months. I make 'slow' jewelry, something that remains a healthy contrast to mass production.' That is partly what makes Ryan's work so distinctive: every single part is worked on solely by her, from concept to final piece, which can be very labour-intensive, especially when multiple editions are created.

Commissions are generally left to Ryan's discretion, but parting with her creations can be difficult for her. While this is less of a problem with the pieces that already have an owner, it is less straightforward with other works: 'All my emotions over three or four months have gone into designing and making the piece, all my frustrations, my pain and joy. I become attached to the piece and find it hard to part with it as it feels like a small part of me.'

robert smit

born: 1941, delft, netherlands

Robert Smit's work stands out in its innovative use of colour combined with gold, and he has been working with the same materials – fine gold, lead and coloured paint – for many years. He applies his goldsmithing skills to work with high-carat gold, but instead of polishing the precious metal, he uses it as a painter might use a canvas, applying colour to the surface. He found that while it is usually possible to fix paint to metal through oxidation, fine gold does not oxidize. He eventually devised his own technique that allowed the application of paint to gold without it coming off: 'Many people have asked me about the paint I use, but I am not giving that secret away. It has taken me years to find the solution.' While he often creates jewelry series, each of Smit's pieces is made to be worn on its own. He occasionally scores the surface to reveal the precious material underneath and always leaves the reverse unpainted so the unadulterated metal surface touches the skin of the person wearing it.

Smit is one of few jewellers whose work can be described as 'conceptual jewelry'. He has explored the ideas and influences behind his work in a book entitled *Empty House,* telling the story of a house and those who lived there through jewelry, inviting the reader to one of the most extraordinary encounters with this art form ever to have appeared in print. Recently Smit has been exploring a new way of working, expressing himself by creating pieces that would almost be more suitable for display in an art gallery than for wearing. These pieces differ considerably from his early work, yet Smit does not see them necessarily as separate. He hopes to make around thirty pieces in this new style.

Since the late 1960s, Smit has been regarded as a leading figure in Dutch avant-garde jewelry. His pieces can either be worn as jewelry or displayed as artworks, offering a natural progression from his work as an artist. He is influenced by numerous artists and art movements, from the Dutch Cobra Movement of the 1950s to the geometric abstractions of Piet Mondrian. Sculptor and performance artist James Lee Byars and conceptual artist Piero Manzoni also influenced his work. One piece of jewelry is dedicated to a 1957 work by Manzoni: it consists of a white-painted canvas, measuring 20 x 12 cm (8 × 5 in.), with a line of gold buttons across the middle; it is mirrored by another similar work where the buttons are painted with white acrylic paint. Smit first came across the work of Lee Byars in the 1980s and he still feels his influence strongly: 'I think he is a fabulous artist who is rich in feeling – a magician.' Smit has produced a number of works inspired by Lee Byars: one consisting of a textured lead sheet; another a white-painted wooden board with a star motif outlined in fine gold wire; a third, a wooden board covered with painted, crinkled paper with the relief highlighted with fine gold leaf. Each can be worn or, alternatively, displayed on a table or wall.

Aged sixteen, Smit met the renowned Dutch artist Jan Schoonhoven, who gave him an insight into the thought processes and mentality of a working artist. He now realizes the importance of those meetings: 'When you are young you are just absorbing all this information, but not really understanding what is going on.' When he was in his twenties, Smit was working in a wide variety of media, and spent six months

'near border' necklace, 2005
gold, silver and paint

**wall objects (from
three-volume work), 2010**
gold, lead, pencil and paint
on chipboard

repairing jewelry, which gave him his first
introduction to the subject and ultimately led
him to study the subject in Pforzheim, Germany.
He worked during his training and made lifelong
friends with fellow jewellers, including Bernd
Munsteiner (page 129), with whom he studied
from 1962 to 1965.

Returning to Holland after completing his
course, Smit first established a jewelry-making
workshop in Delft. However, he moved away
from the craft in the early 1970s to concentrate
on photography and fine art, feeling his work
had become 'too big' to still be classified as
jewelry. Approximately a decade later he
returned to jewelrymaking, producing pieces
in gold that provoked debate within the jewelry
world. Although he had always used precious
metals, Smit continually questioned traditional
jewelry concerns about beauty, wearability,
material and technique. In the mid-1980s there
was a strong movement in European jewelry
(Dutch and German jewelry in particular) to
reject traditional precious metals in favour of
other materials, including anything from
wallpaper to drawing pins and elastic bands.
In 1985, the Stedelijk Museum in Amsterdam
hosted a major group exhibition entitled 'As Far
as Amsterdam Goes', showcasing gold jewelry
and art, which included Smit's work. Vocal

opponents such as leading Dutch industrial
designer Gijs Bakker saw the show as deviating
from the idea of jewelry as a form of conceptual
art. Smit's work was seen as a step back
towards the exclusivity and cost associated
with traditional precious metals. However, Smit
showed that precious materials could also be
conceptual – a turning point in the development
of the field in the Netherlands, which inspired a
generation of young designers to go back to
working with precious metals.

The Rijksmuseum in Amsterdam is
assembling a gallery dedicated to Dutch jewelry
from the 8th century to the present day: a huge
collection of nearly five hundred modern pieces
of jewelry has been donated by renowned art
historian and collector Marjan Unger. Spanning
the entire 20th century, the collection focuses
on the period from 1930 to 1970 and includes
Smit's 'Sleeping Beauty' pendant. The prospect
of being part of such a prestigious institution
is exciting for Smit: 'It gives me great pleasure
to think that my work will be displayed in
the same building as some of the great Old
Master paintings.'

Many collectors of Smit's work are Italian,
and he feels they have a particular affinity with
gold jewelry. His love of Italy has led him to work
in Florence, and he will be exhibiting works in a

'**looking for madonna dolomiti VIII' brooch, 2006**
gold, silver and paint

travelling exhibition dedicated to Mario Pinton, the founder of the legendary Pietro Selvatico Institute in Padua.

Smit teaches in various schools but thinks that opportunities for innovation and originality are limited and that many jewelry buyers prefer fairly conservative pieces. Nonetheless he enjoys teaching and aims to instil an innovative way of working in young jewellers. Energetic and spirited, Smit is incurably curious with a capacity for enthusiasm that belies his age. Now approaching his seventieth birthday, he is taking some time for personal reflection, reviewing his artistic life and output. Smit's work is at the edge of what is conventionally defined as jewelry, but his pieces challenge the public and force them to see jewelry in a new light. As he says: 'I have had wonderful opportunities to work with galleries with lots of space, which has afforded me total freedom in my designs. Sometimes I have difficulties envisaging my jewelry being worn, so I imagine it hanging on the wall. Whatever I do is always centred on jewelry. It is deep inside my body. It feels so natural.'

'**not far from cortina' brooch, 2005**
gold and paint

georg spreng

born: 1949, schwäbisch gmünd, germany

Georg Spreng has come a long way since his first exhibition at the Munich trade fair 'Inhorgenta' in 1991 – he had a tiny stall then, displaying his first creations, the 'Ice-cream Cone' rings. Nowadays he presents his collections in grand style, with assistants impeccably dressed in Issey Miyake.

Spreng's route into jewelry making was convoluted. In 1971 he co-founded a successful industrial design company, which he ran for fifteen years before feeling the need to escape office life. In an audacious move in the mid-1980s, he and his partner, Sabine, left Europe for Canada, where they spent a decade living in a log cabin without electricity or running water. Spreng converted some of his money to gold and hid an ingot beneath the cabin floor. A visit from a goldsmith led to the ingot being unearthed, and having long been interested in the subject (Spreng's father was a goldsmith), he starting to work on his first piece of jewelry, a necklace. When he returned to his native Germany he showed the necklace to some people who loved the design, which gave him the confidence to try working as a jeweller.

Gold is the material Spreng most likes to work with. As he says: 'You must start working with the best materials. It takes so much effort to make a piece of jewelry, you may as well begin with precious metals.' He often combines platinum with 18-carat red and yellow gold. Colour is important to Spreng, and it is an element that he brings to his work through the extensive use of gemstones. Indeed, he is famous for this preference and dealers often bring new stones to him first. He has quite specific criteria and does not use stones that are unusually cut, as he feels that 'they are not my work if I have not cut them myself'.

Design infuses all areas of Spreng's life. He designed his own unconventional house together with a company of young architects and, keen to live close to nature, integrated the landscape into the living space through large

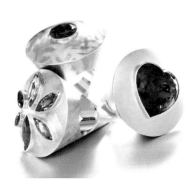

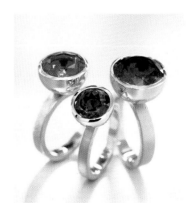

'octopus' ring, 2007
amber, diamonds and
yellow 750-gold

LEFT
**'ring o' roses'
necklace, 2008**
aquamarine, morganite,
amethyst, citrine and
950-platinum

BELOW
'blub' ring, 2005 (left)
moonstone and 950-platinum

**'mini mini' ring,
2005 (right)**
diamond and 950-platinum

open-plan rooms with glass walls. His industrial design background gives him a rather different perspective on jewelry design from someone who trained as a goldsmith, for example, and he is unencumbered by preconceptions. He had the idea to make a ring in a day, with impressive results. He often creates large sculptural pieces on impulse and generally draws inspiration from nature or directly from the gemstones he uses. His design ideas are usually spontaneous: 'I dream them. I literally wake up in the morning with an idea and immediately start to make a piece.'

As no two gemstones are the same, each of his pieces is different. His trademark style combines simple design with bold, colourful stones. Even his most basic range of rings is striking, featuring a plain shank set with a colourful stone: simple and modern, yet timeless.

Many of his smaller pieces are light in weight, although they often look heavy, with a textured finish created by treating the entire piece with a burnishing tool. Ingenious construction is another Spreng hallmark, with some of his necklaces counterbalanced with a piece of wood at the back to keep the pendant at the correct length when worn. Spreng never takes on commissions, preferring to wait for the 'right person' to buy his pieces. While he loves to make rings and necklaces, he is less comfortable making earrings, as 'they are something I do not wear and so do not know how they should feel when worn'. There are three goldsmiths who work with him but he always makes a prototype from his own design first, translating the drawings from the loose sheets he uses for sketching, before handing over to the goldsmiths.

BELOW
'white blossom' necklace, 2009
diamonds and 950-platinum

Spreng pays great attention to detail and obviously enjoys the process of making jewelry and, which is evident in his work. To him, it is quite simply fun. Spreng's jewelry is something that can be worn every day, bringing with it a sense of his free spirit. His colourful and boldly crafted pieces have a playful, mischievous quality about them, reflected in the names of his collections: 'Ice-cream Cone' rings, 'Heart' pendants, 'Blub' rings (named after the German word for the sound of water as it reaches boiling point). Spreng calls it 'keep-happy jewelry'.

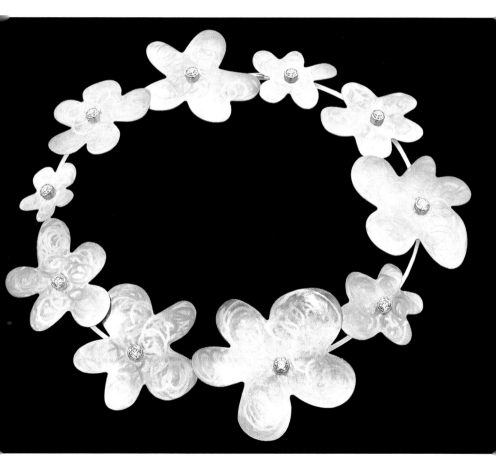

charlotte de syllas

born: 1946, bridgetown, barbados

Renowned for her figurative and natural designs, Charlotte de Syllas says of her early training. 'In a way, if I had been formally taught and trained in stonecutting, I probably would not have explored more unconventional things, as I piece things together like a jigsaw, which is not something I have seen other makers do.' A graduate of London's Hornsey College of Art, De Syllas was taught by Gerda Flockinger, an important artist-jeweller. De Syllas's love of colour drew her to enamelling, but she found applying enamel to a three-dimensional object limiting, as the piece has to be sectioned to allow the enamel to adhere. The advent of diamond burrs and diamond files in the mid-1960s caused the art of stonecutting to flourish,

and Flockinger taught De Syllas the basic skills for cutting a stone *en cabochon*. De Syllas was drawn to carving and felt compelled to teach herself more complex skills, using the book *Gem Cutting: A Lapidary's Manual* by John Sinkankas as her guide. The attraction of the technique was that it was possible to carve 'a lump of pure colour into a three-dimensional piece of art. I tried working with glass but found the particular way I use hollow forms was as time-consuming as carving stone. Financially, this did not work, although I retain a strong interest in glass.'

Although she would later teach there, De Syllas decided against attending the Royal College of Art in London, preferring to set up on her own as a jeweller in 1966. It is admirable

ceremonial bracelet, 2000
black wyoming jade, white
russian jade and 18-carat
white gold

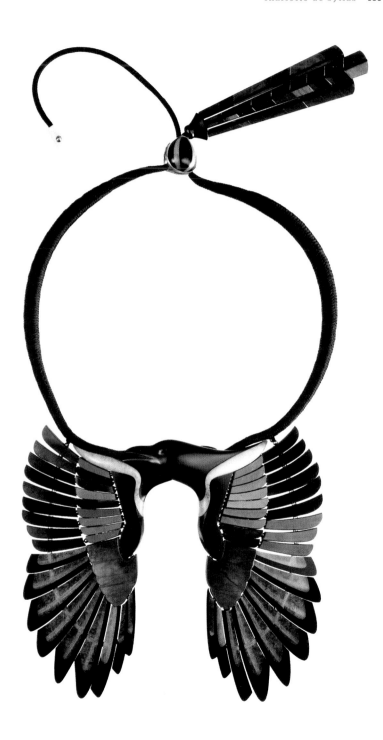

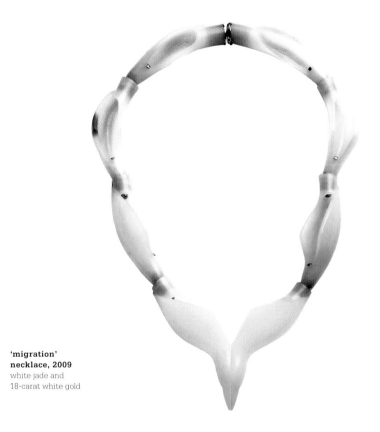

**'migration'
necklace, 2009**
white jade and
18-carat white gold

that she has never compromised her work by making overly commercial items. For the last four decades De Syllas has worked on commissions only, enjoying a level of demand that is testament to her talent. Some of her work takes fifteen months to produce, and she also restores Chinese and Oriental works of art. Although she needs to balance this carefully with her other work commitments, it does give her greater freedom to work independently. Recently, she has started making more pieces for gallery stock; she feels there has been a change in the public's confidence: 'People are more comfortable buying something they see immediately, rather than commissioning something that they have to wait for and worry if they will like it.'

This change in buying habits has had an impact on the pieces she makes: 'When you are commissioned by someone you have them in mind – what they look like and who they are. You tend to make something to suit that person alone. When you are making for stock you have no one in particular in mind, so I tend to make items that I might wear.' This is an interesting approach: she is more inventive when not working on commission but loves to make pieces that she knows will be worn by a specific person. Identifying the sort of person who buys her work she says: 'They dress more confidently and have an individual style. They seem to know what they want and do not feel the need to buy from a well-known person or brand.'

De Syllas often designs a piece first, then searches for the right stones, but with precious stones she approaches the process the other way round. She finds a special gem, then

'tulip' ring, 2003
tourmaline and 22-carat red gold

'heliodor twist' ring, 2002
heliodor and 22-carat yellow gold

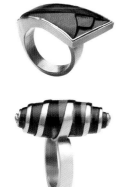

'jellyfish' necklace, 2004
rock crystal, edwards black
jade and synthetic ruby on
black silver-gilt chain

designs around its colour and size. She initially explores her ideas thoroughly in model form, fashioning the shape and trying to anticipate any problems that may arise, and only then starts to work on the actual piece. De Syllas loves working with lapis lazuli, chalcedony, beryl, rock crystal and jade for larger pieces, while for smaller pieces she prefers tourmalines for their variety. At present she is making a necklace from synthetic ruby crystal, which is the only material she could use to carve on the scale she requires (natural ruby or tourmaline crystal are extremely expensive and rare).

In order to create her extremely accurate work, De Syllas uses the same techniques and equipment that dentists use for complex bridgework that requires an exact fit. For certain designs she needs to burnish the metal so it fits

with the carved stone. She never uses glue with rings, and where it is necessary with other pieces she always applies a secondary fixing so the piece will not fall apart and can be repaired easily. All her catches and joints are made from metal, and De Syllas ensures all the material used is hallmarked; where there is not enough metal in a piece, she signs the stones.

It is often the case with such highly crafted pieces that once they are completed it is hard to imagine the great effort that has gone into producing them. However, after hearing De Syllas explain how she makes her pieces you quickly realize how talented she is – in her combination of creativity and craftsmanship, De Syllas is hard to rival. Her creations surely rank as some of the most important in contemporary jewelry.

necklace, 2008
enamel, white gold and 18-carat yellow gold

graziano visintin

born: 1954, padua, italy

Graziano Visintin is one of the most renowned artists and teachers in the world of jewelry-making today. Since 1976, he has been teaching at the famous Pietro Selvatico Art Institute in Padua, where he had previously studied himself under Giampaolo Babetto, Francesco Pavan and the late Mario Pinton – some of the most influential jewellers of the 20th century.

Founded by Pinton in the mid-1940s, the goldsmithing course proved revolutionary in its mission to teach secondary-school pupils the highest possible standard of craftsmanship while encouraging them to think beyond conformity in their work. The institute has a deserved reputation for producing highly talented craftsmen such as Annamaria Zanella (pages 180–83), Stefano Marchetti, Giovanni Corvaja (pages 52–57) and Maria Rosa Franzin (pages 74–77), who were all encouraged to approach the craft of goldsmithing with an experimental eye.

It was during his time at the institute that Visintin realized he wanted to be a goldsmith, and following graduation he first worked in Babetto's workshop before returning, at the age of twenty-one, to teach at the Institute. Visintin is now part of the third generation of teachers who maintain the ethos of the school: 'It is a challenge as young students today approach things differently and do not necessarily want to focus on learning the skills of working at the bench.' In the age of computer technology, the traditional route to becoming a master goldsmith and craftsperson is changing. Visintin teaches laboratory and workshop techniques, showing students the traditional goldsmithing skills – soldering, casting, piercing and how to alloy gold to get the characteristic reddish colour associated with the jewelry from the Institute: 'Gold has always fascinated me. It is a precious material, not for its value but for its malleability and ductility. It requires the utmost attention.'

brooches, 2007
enamel and 18-carat
yellow gold

While starting to teach at a young age, Visintin also established his own workshop which kept him abreast of the commercial world and its associated pressures. His studio is lined with art books, a collection of African masks and various rugby ephemera but also his own designs in watercolour, betraying his deep love of art. Whenever he has the chance, he visits museums and galleries; he particularly admires the artists Andrea Mantegna, Masaccio, Carpaccio, Giorgio Morandi, Alberto Burri and Joseph Beuys. He examines their works for composition and use of colour and tries to translate these elements into his jewelry, painting his free-flowing designs with watercolour first. As the shapes take on a geometric form, he then makes several models in paper and occasionally in silver. Only then does he use gold: 'Circles, squares and triangles seem simple elements, but I have long been fascinated by them and tried to understand the potential of primary shapes, which are always different when observed closely. Geometry, equilibrium and simplicity create the quality of shape in apparently simple objects.'

Some of Visintin's recent pieces are fashioned in gold, silver and niello (a black metallic alloy of sulphur, copper, silver and lead). Niello is

necklace, 2008
copper oxide, niello,
18-carat yellow gold
and silver

produced with a technique that was reintroduced by Visintin's mentor Pinton. The alloy is ground down and applied to the surface of the gold using a heated point made of pure gold. The niello covers the surface of the gold, and its darkness is lightened with delicately coloured enamels in Visintin's characteristic palette of green, yellow, blue and red. He uses enamels like paint to soften the geometric structure of three-dimensional gold pieces, and the results look like miniature works of art that can be worn as jewelry. Visintin applies the enamel by first hammering the gold to make recesses into which he places the glass enamel

dust. He then heats the metal beneath with a blowtorch, causing the enamel to melt and fuse to the gold. This technique gives his work a wonderful tactile equality, which is unique but carries echoes of Pinton's work.

Visintin's work conveys his sensitivity to his materials; in his marvellous combinations of curved or flexible gold surfaces with delicate enamels you can see the work of one of the great teachers of the Padua school; in the future he will surely inspire new artists to emulate his extraordinary jewelry designs.

brooch, 2008
copper oxide, niello,
18-carat yellow gold
and silver

leo de vroomen

born: 1941, warmond, netherlands

I was working as a diamond dealer in London's Hatton Garden when I first encountered the Dutch-born jeweller Leo de Vroomen. A larger-than-life character, De Vroomen is utterly devoted to designing and producing jewelry and *objets d'art*. Rightly lauded as one of the world's best jewellers, working with him recently I realized just how respected and influential he has become over the years.

He has received numerous awards, including the coveted De Beers Diamonds International Award (twice) and the Best in Design Award, Haute Couture, at the Town & Country Couture Design Awards in Las Vegas in 2001, considered

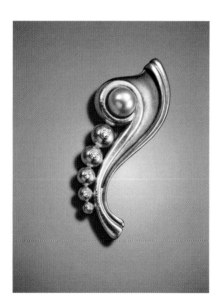

brooch, 2005
golden south sea pearl, diamonds, enamel, and 18-carat *repoussé* gold

the 'Oscars' of the jewelry industry. What strikes you first about his jewelry is the boldness of the design, which reveals not only his exceptional level of technical proficiency but also his love of colour. The latter is complemented by his skill in choosing gemstones: 'Colour and form are intrinsic elements of my jewelry.' Often seeking stones with natural flaws that recall abstract paintings, he also likes unusual and vibrant tones. As he says: 'My jewelry begins with the stone. I do not agree with the concept of precious and semi-precious stones, so the traditional hierarchy of diamond, ruby, sapphire and emerald does not affect me. In fact, tourmaline would be my favourite stone because of its almost limitless variation in colour.'

De Vroomen's interest in jewelrymaking started at an early age; he knew he wanted to create something with his hands, which led him to undertake an apprenticeship with a goldsmith in The Hague. He also wanted to travel, and having qualified as a master goldsmith, he went to work for a small jewelry atelier in Switzerland. At the time, in the early 1960s, jewelry in Switzerland was beautifully made but lacking in creativity. Wanting to discover more about design, De Vroomen moved to London in the mid-1960s, an experience that revolutionized his work. It was an exceptional moment to be in the city, and he got a job with David Thomas, one of the leading goldsmiths at the time. Self-taught and also a talented designer, Thomas had a workshop in Chelsea, which provided a hugely creative environment. In his three years there, De Vroomen recognized the importance of being a good craftsman as well as an inspired designer. It was at this time,

necklace, 2008
cabochon sapphires and
18-carat *repoussé* gold

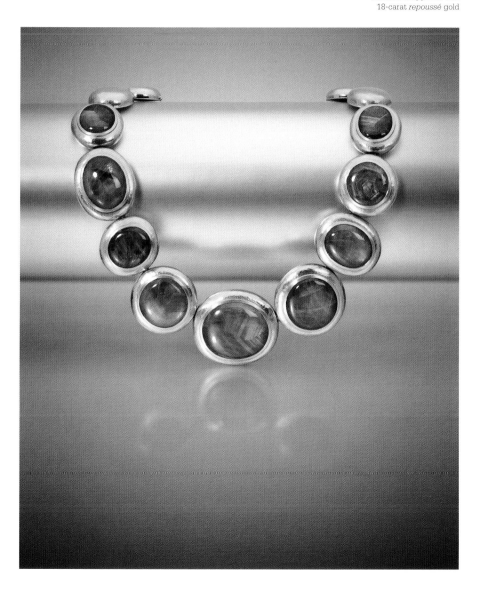

brooch and earclips, 2010
diamonds, enamel and
18-carat white gold

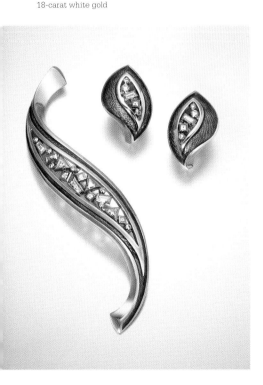

technically clever or symbolically intriguing, it has failed as jewelry.' With a third of his work coming from commissions, he gets great satisfaction from working with his clients, many of whom are from the United States. Getting to know a client's needs is paramount. Jewelry always looks better when worn, and De Vroomen insists his clients try items on, to give both wearer and designer an indication of what will suit them. He and his team have an instinct for what will suit a person, creating bold yet simple, smart and straightforward jewelry. 'The pieces in my collection are not just "products", they are the result of individual creativity and craftsmanship.'

This craftsmanship is coupled with invaluable experience, accumulated over nearly fifty years. It means De Vroomen has a profound knowledge of handling jewels. When a client shows De Vroomen an inherited jewel that is broken or out of fashion, he will, after detailed discussions, reinvent it and create a beautiful modern piece, as only a skilled jeweller of his standing could do. Close examination of De Vroomen's work reveals the highest level of technical proficiency. He is a master craftsman who refuses to compromise his standards. Having trained many goldsmiths in his workshop over the years, he has made a huge contribution to keeping technical skills alive. For example, he has revitalized the ancient craft of *repoussé*, a technique that involves the shaping of sheet metal with hammer and punch. The metal is held in place on a bed of pitch, which, being more yielding, allows the metal to be formed into the desired design. The technique gives the 18-carat gold,

while still working for Thomas, that De Vroomen began teaching at the Central School of Art and Design (now Central Saint Martins), where he met his future wife, Ginnie, with whom he founded the De Vroomen companies.

De Vroomen's design sensibility is profoundly influenced by his ultimate inspiration, the human form. He states that 'after all, jewelry is a means of enhancing a person. Its prime purpose is to be beautiful and wearable, and if it does not possess these two qualities, then, however

four band rings, 2000–11
tourmaline, sapphire,
diamonds and 18-carat gold

which De Vroomen normally uses, a beautifully soft and tactile surface texture. He does occasionally also use platinum, but only when enamelling is not involved, as this cannot be done on platinum.

When asked what the future holds for his industry, De Vroomen says that he feels that technology has changed the manufacture of jewelry: 'Computers can be useful with design development, or when using laser-cutting equipment or laser spot-welding equipment. The latter has come about in the last ten years or so and is the most important technological advance.' But for the artist-jeweller making individual pieces, today's technology tends to be either too expensive or impractical for limited-production numbers. It is clear to De Vroomen, however, that the future of jewelry is assured: 'It is hard to forecast, but jewelry will always be with us and continue to evolve as it has for thousands of years. A well-designed, handmade piece will always outlast mass production – one has to only look at ancient pieces in museums, many of which would not look out of place if worn today.' In the same way, a De Vroomen piece has a sense of permanence that means it would not look out of place in a museum. The quality and craftsmanship of his work is instantly recognizable for collectors.

brooch, 2002
cabochon tourmaline, south
sea pearl and 18-carat gold

david watkins

born: 1940, wolverhampton, uk

Like many of the jewellers profiled in this book, Watkins trained as an artist first, studying sculpture at Reading University before focusing on jewelry. In addition to working with wood, clay and plaster, he got an introduction to working with metal and an appreciation of the human form, which has become a constant theme in his jewelry. After graduation in 1965, Watkins joined the team of artists and technicians making models for the acclaimed film *2001: A Space Odyssey*. This proved to be an inspiring experience, as he learned to build space shuttles, landing vehicles and planetary rovers for the film. A downturn in the movie industry meant he had to change direction, but the skills garnered were absorbed into his creative vocabulary.

He turned to work with his other passion – music – playing and touring with a jazz group. It was also at this time that he began to experiment with jewelrymaking, using his wife's tools (jeweller Wendy Ramshaw, pages 136–41). They share the attitude that artists should work through their own ideas, meaning that they rarely offer each other advice or opinions until their work has reached the final stage. Watkins and Ramshaw also have a shared love and enthusiasm for technology, which they both use sucessfully in their art. Watkins was one of the first jewellers to use computers as a working tool, and he gains inspiration from new techniques. A recent series of bangles, for example, uses computer design and laser cutting to achieve great

RIGHT
**'in the gardens of arquà petrarca'
approaching/receding bangle, 2003**
layered, plasma-coated steel

OPPOSITE AND BELOW
four pins ('encounter'), 1997–8
gold

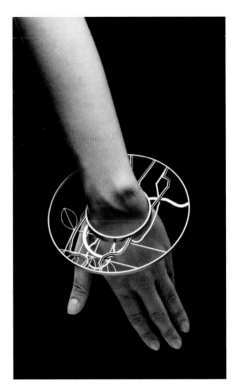

accuracy and delicacy in the combination of
acrylic and gold, while his 'Garden' brooch
series brings three-dimensional computer
modelling into the realm of goldsmithing. The
resulting simplicity of the brooches seems
effortless, but even with computer-aided design
there are still many experiments necessary in
model-making, jigging and tooling before the
desired results are achieved. Watkins has
experimented using acrylic that is lathe-turned,
machined and heat-formed to make wearable
sculptural pieces, in addition to dyeing the
surface and inlaying lathe-turned grooves with
gold. When discussing technical skills, Watkins
observes: 'It is difficult to define what "skills"
are. There are so many different tools, such as
computer technology and laser cutting. They

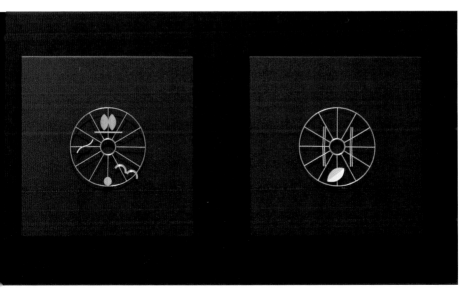

pendant/neckpiece, 1974
dyed acrylic and gold

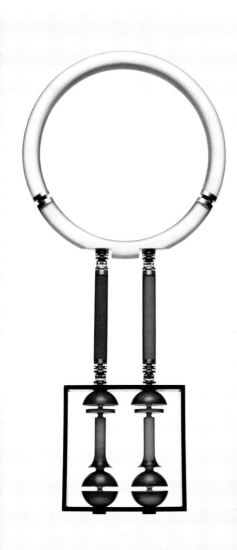

have extended our capabilities beyond the traditional skills of goldsmithing and jewelrymaking.'

Watkins alternates between computer design and drawings, relishing the spontaneity of the latter. Handfinishing and the human touch are important in his work, giving his pieces the authenticity he seeks, which is certainly an aspect of Watkins's work that attracts collectors. He is always intrigued to see how a piece will develop, and whether he is using a computer or not, he maintains that 'the one ingredient which is necessary is patience if you are to get anything out of a new process or material'.

One thing Watkins neglects to mention is the value of experience. He brings the fluidity of music to the craftsmanship of goldsmithing, while his pieces are sculptural in construction, drawing on the industrial techniques he learned as a film technician. Working in the United States in the 1970s had a huge impact on his work, as he met numerous collectors who appreciated bold jewelry. This demand fed through into his output, and his work increased in size.

Recently Watkins was the subject of a solo exhibition at the Victoria and Albert Museum in London, and I was struck by the quality of his pieces as I was able to try some of them on. The striking statement jewelry appears as if it might be uncomfortable, but it is in fact highly wearable. Watkins's distinctive style attracts commissions from those who want a piece in his signature style, and often clients are avid collectors seeking something new.

Another important aspect of Watkins's career is his role in nurturing the next generation of

BELOW
'veiled rays 2' bangle, 2009
acrylic and 18-carat gold

BOTTOM
**'diver' combination
neckpiece, 1984**
neoprene, wood and steel

jewelry talent. For more than two decades, from 1984, Watkins was head of the Goldsmithing, Silversmithing, Metalwork and Jewelry department at the Royal College of Art in London. During this time he taught Giovanni Corvaja (pages 52–57), Jacqueline Ryan (pages 150–55), Mah Rana, Christoph Zellweger, Manuel Vilhena, Lin Cheung, Kamilla Ruberg, Yoko Izawa, Malcolm Betts and Lara Bohinc, to name a few, inspiring and challenging the students to produce their best work. He explains: 'Artists in our field now have such a wide range of different skills, it is exciting. But they still need to follow their ideas and enthusiasm. It is not enough to master the technique itself: technique must be used to express ideas.'

Watkins continues to innovate, and his work will no doubt keep surprising his followers. He has designed the medals for the Olympic Games 2012, featuring the goddess Nike and the 'London 2012' emblem. What does the future hold? Watkins does not know for sure; the only certainty is that he will go wherever his art takes him: 'Once the contemporary jewelry world was a small community doing experimental work. Now it has really blossomed and seems to be an ever-expanding universe. My attitude has become "I do what I do" – I am quite happy to just carry on doing my thing.'

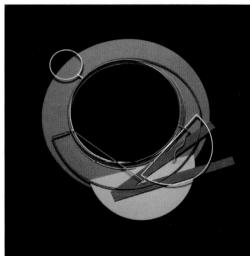

'bed' brooch, 2009
iron, ebony, enamel,
silver and gold

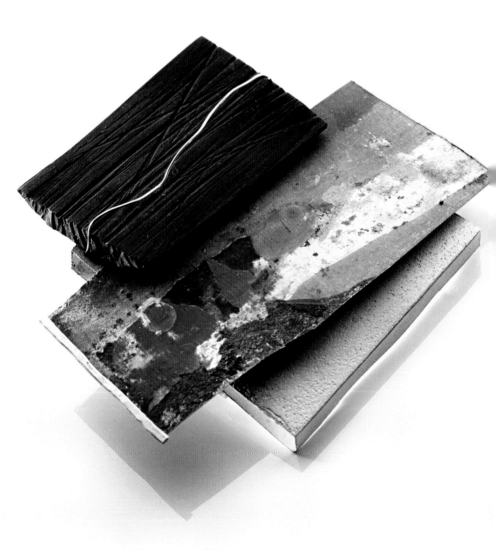

BELOW
'dress' bracelet, 2009
steel netting, magnet,
silver and gold

annamaria zanella

born: 1966, padua, italy

A student of the famous Pietro Selvatico State Institute of Art in Padua, Annamaria Zanella developed a love of jewelry at an early age. As a child she loved designing and making clothes and, aged fourteen, she went to the Institute in Padua with the intention of studying fashion design. However, when she visited the goldsmithing workshops and saw what the students were producing, she immediately fell in love with the craft and decided to study metals and jewelry design instead.

Zanella was very lucky to have such teachers as Francesco Pavan, Giampaolo Babetto and Graziano Visintin, who have been instrumental in turning goldsmithing into a contemporary art form without compromising on technical skills. When she graduated at the age of nineteen, Zanella was one of the first contemporary female jewellers in Italy: 'It was different in the 1980s. Today, there are more galleries and museums, and many means of showcasing work. It was incredibly difficult then to start out.' Following the explosion of the internet there are now more opportunities for new designers to communicate and be discovered and 'these factors have ensured that the world of contemporary jewelry is now much more widely understood and appreciated'.

From 1988 to 1992 Zanella studied sculpture at the Academy of Art in Venice and attended the Hochschule (School of Design) in Pforzheim, Germany, to learn more about enamelling, before returning to Padua to teach at the school where she had studied. She is a great believer in the importance of jewelry as an 'artistic movement' that brings practitioners from all over the world together: 'Every year students from contemporary jewelry schools and academies around the world come to study in Italy and bring new ideas and innovations. I believe one of the most important developments in recent years has been the impact of technology on design, materials and production. It is becoming ever more sophisticated and can achieve unimaginable results.' This open-minded and innovative attitude encapsulates Zanella's approach as both teacher and designer; her work has been exhibited in the most important museums and prestigious galleries all over the world, and she has received numerous awards.

Zanella's originality and boldness led her to experiment with unconventional ideas and materials. Her mantra is 'try, try, try' and she

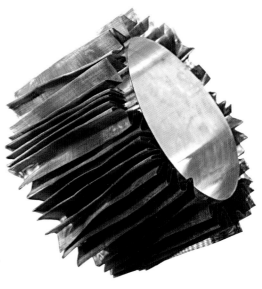

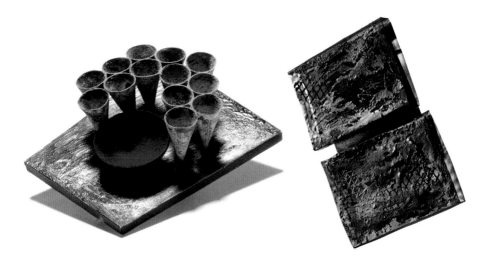

spends a great amount of time discovering new ways of using colour and working with metals. She uses glass and acrylic enamel, often combining two or three different enamelling techniques to achieve the desired effect. Zanella experiments with the properties of her materials: producing a velvety finish on metal, for example, or when working with gold, emphasizing not simply the brightness but also the softness and lightness. Another element she likes to explore is the various stages of rust on iron. This last example illustrates her characteristic approach of including apparent contradictions, combining 'inferior' materials such as rusting iron with gold and thereby challenging received wisdom about what jewelry should be.

Since she uses gold only sparingly, the focus is on base metals. Zanella favours iron and steel, often using waste products such as curled steel shavings. She likes the history of the materials she employs: 'Gold is magic, it is sensational, beautiful…but it does not really tarnish or discolour. I love it when you can trace time in metal, just as you can trace time in people's faces, bodies and souls. We must express that with metal.' In order to achieve this effect Zanella will go to great lengths, leaving metal out in the open air to speed up the ageing process. In using rust Zanella sees a means of expressing the passing of time; she also uses oxides and corrosive elements to actively change the surfaces of metals.

The ideas behind her work are as important as the beauty of a piece. One of her most famous pieces is a ring that explores the theme of destruction: it is fashioned from shards of glass from the windscreen of her car, which shattered in an accident. The monetary value of stones is not important to Zanella, and she might use broken glass just as she might precious stones: 'It is important for me to search for new materials because it is a way of creating a contemporary style in jewelry.'

Zanella's inspiration comes from diverse sources, drawing on travel, music and theatre in particular. She takes great pleasure in these activities: 'My jewelry is like a diary, with inspiration coming from my daily life, from architecture, travel, music, film and television. Going to the theatre or listening to classical music helps me to open my mind and release my thoughts. I transfer these images onto paper, then I turn them into jewelry.' She spent a month in India, a trip that left a deep impression and inspired her in many ways, especially colours and textures. The blue-painted Brahmin houses in

OPPOSITE LEFT
**'queen of the night'
brooch, 2010**
copper, niello, enamel,
acrylic paint, silver and gold

OPPOSITE RIGHT
'burqa' brooch, 2009
steel netting, niello, enamel,
titanium, silver and gold

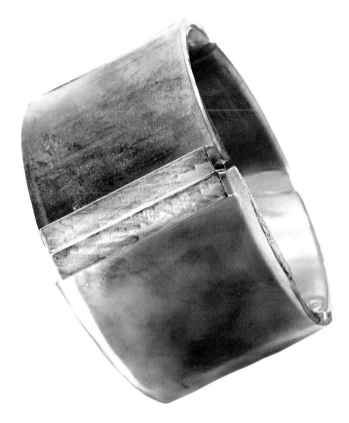

'blob' bracelet, 2008
silicone, acrylic and silver

Rajasthan in particular left a lasting impression, and that colour has come to have a spiritual meaning for her. This was reinforced when she saw Anish Kapoor's work, first in an installation while she was studying in Venice, and later at an exhibition in Milan. She says: 'I love colour, I put colour in every piece, and I was amazed by the blues and reds in his sculptures.' Having studied sculpture, this is a field she would love to explore further: 'If space and money were no object, I would always make a sculpture first before making a piece of jewelry. A piece of jewelry has a dialogue with the body, and a sculpture has a dialogue with space – the body is, in a sense, the space in which you wear jewelry, so you are a sculpture, a mobile sculpture.'

Zanella adapts her inspiration and initial designs as she takes additional ideas directly from the material she is working with. She delights in materials that are unusual in jewelry such as paper, cardboard and fabric, reworking scrap materials into pieces of symbolic importance. Zanella believes that 'every artist talks through their creation in the language of the time they are working in. The elements used in jewelrymaking – precious and non-precious materials, computer design, inspiration – all contribute to its enduring appeal.'

marcin zaremski

born: 1951, warsaw, poland

BELOW
necklace, 2004–5
matt and oxidized
silver, gold-plated
silver and copper

For collectors, jewelry fairs such as 'Schmuck' in Munich and the Goldsmiths' Hall Fair in London provide wonderful opportunities to explore new developments in the world of jewelry and, more importantly, to meet those who make the pieces. It was at one such fair in Germany that I first met Marcin Zaremski, attracted by the tactile nature of his highly flexible necklaces.

Zaremski was raised in Warsaw, the son of self-taught goldsmiths. His parents worked in Poland in the years immediately after the Second World War, when materials were in extremely short supply. It was difficult to find precious or indeed non-precious materials to make jewelry and other art objects, and until the collapse of the Communist regime, they were still required to apply to the Minister of Culture and Art to get hold of two or three kilograms of silver per year. Zaremski still lives and works in Warsaw, where his brothers, and now also his son, work as jewelrymakers and designers. He retains some 1,500 pieces of jewelry designed by his parents, dating from immediately after the war until the mid-1980s, which continue to provide a great source of inspiration, not least because his parents were working when isolated behind the Iron Curtain but translating their local influences into modern designs. As Zaremski's says: 'They were clearly ahead of their time, which makes me proud.'

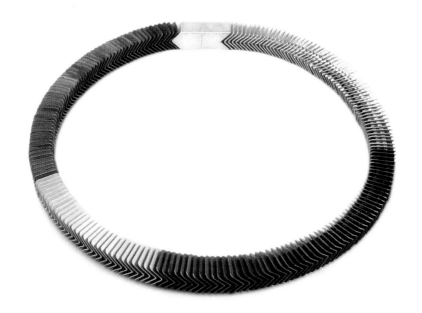

Always aiming to perfect his jewelry, Zaremski ensures that his pieces are worn before they are sold to establish that they are comfortable and that the bayonet fitting he uses for the clasps is secure. He does not use solid gold because of the expense, focusing instead on copper, oxidized silver and gold-plated silver. He avoids shiny surfaces – 'anyone can make highly polished jewelry' – and uses a chemical treatment to give his pieces a frosted, matt texture. He often makes pieces incorporating linked copper discs that have been coloured through heat treatment, employing a specific technique he has developed over many years. Zaremski also uses chemical reactions to develop different colours on the metal. Amber, a characteristically 'Polish material' (large amounts can be found on the shores of the Baltic Sea), features unpolished in large bracelets that show off the material's rough texture (above right).

Zaremski's work is characterized by its variety but unified by recurring themes such as geometric shapes. He is inspired by elements of the natural world – exotic leaves on trees in Thailand – and the mundane, for example in the shape of rooflines in Italy. He states: 'I want to introduce the world to simplicity, and my designs reflect the belief that less is more.' His jewelry is an ideal starting point for someone new to the field, allowing them to experiment with collecting while exploring individual design and production techniques. For hallmarks Zaremski uses three different marks: the standard '925' for silver, his maker's mark of an 'M' superimposed over his parents' 'zJz', and the mark of an eye, which is 'winking at you, telling you to love life'.

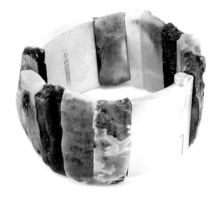

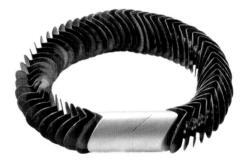

TOP
bracelet, 1997
amber and silver

ABOVE
bracelet, 2004–5
chemically browned silver
and tarnished matt silver

atelier zobel

michael zobel born: 1942, tangier, morocco
peter schmid born: 1971, ostrach, germany

The history of Atelier Zobel is a success story of an apprentice following his master to become a prominent jeweller in his own right. It began with Michael Zobel, whose natural talent as a goldsmith was immediately recognized when he was studying at the Hochschule (School of Design) in Pforzheim. During his studies he learned about painting and sculpture in addition to jewelry techniques, and his broad training ultimately enabled him to create the complex inlay and patterned works that have become an integral part of his work. Celebrated as one of the most innovative and exciting designer/makers, Zobel juxtaposes raw materials in unexpected and thought-provoking ways. The recipient of numerous awards for his highly influential work, he has consistently produced some of the boldest and most original contemporary jewelry.

In 2005, Zobel decided he would pass the business to his protégé Peter Schmid, who is now head designer and owner of Atelier Zobel and dedicated to carrying forward Zobel's work, building on the tradition but also working with his own, distinctive identity and sculptural approach. It was encountering Zobel's work that first convinced Schmid that he should take up jewelry design, and he trained at the School of Jewelry Design in Schwäbisch Gmünd before becoming Zobel's apprentice in 1995. Schmid travelled widely to develop his skills, undertaking a scholarship in Barcelona to learn Japanese lacquer technology, and when he returned to Zobel's workshop he quickly became

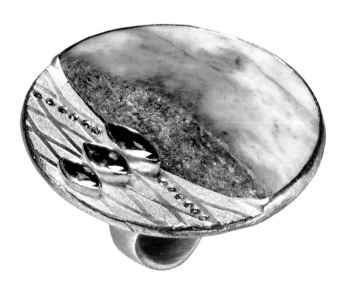

ring by peter schmid, 2009
jade, emeralds, green diamonds
and 18-carat gold

ring by peter schmid, 2010
tourmaline (becker cut), rough
diamonds, pink diamonds,
18-carat rose gold and platinum

his right-hand man. Zobel trained Schmid in all
aspects of the business, from presentations at
international fairs and exhibitions to working
in gold, before smoothly transferring the atelier
to Schmid.

Traditional jewelry-making skills of the
highest degree have been kept alive in the
workshop because of a deep-rooted respect,
knowledge and understanding of the craft.
At the same time, however, they maintain a
freedom of expression in their designs. This is
a magical combination not many are able to
accomplish. In the early 1980s, Zobel pioneered
new techniques allowing makers to work with
metals and stones almost as if they were painted
on canvas. Inspired by structure, colour and
flawed beauty, he built a tension between the
metal work and the stones. Zobel's signature
style was meticulous, with colourful patterned
and textured surfaces of pink and yellow gold,
silver, platinum and small diamonds of various
colours. Offering an array of colours, shapes and
textures and using backgrounds of precious
metals and diamonds to reflect and complement
the gemstones, another innovative design saw

him create the illusion that the settings and
small diamonds were an organic continuation
of the larger stone.

Schmid continues to explore stones in
relation to each other in his designs and looks
for material of unusual beauty. Atelier Zobel has
a long working relationship with the renowned
Munsteiner family of stonecutters (pages
128–31) enabling the atelier to acquire stones of
high quality; the platinum, pure gold and silver
they use are all alloyed in their workshop to
achieve specific colours and surface textures.
Schmid also buys stones from Andreas
Hochstrasser, a master stonecutter from
Switzerland, now based in Germany, and plays
with the polished and rough surfaces of the stone.

All pieces start with a drawing produced by
Schmid and accompanied by the specific stone
the design has been created for. The atelier
employs five highly skilled craftspeople, and
Schmid will share the designs with all of them.
The person who feels most inspired will make
the piece from start to finish. As Schmid says:
'I feel the piece will only have that extra special
magic if the craftsman making it really responds

brooch/pendant by peter schmid, 2010
water opal, diamonds, shells, 925-silver,
18-carat gold and platinum

ring by peter schmid, 2009
diamonds, platinum and 18-carat gold
with diamond surface

bracelet by peter schmid, 2007
diamonds, rose and orange diamonds,
925-silver, 22- and 24-carat gold

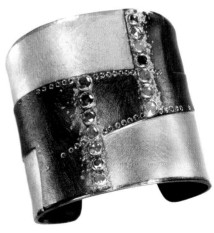

to it. I think this way of working makes our jewelry even more special.' It is indeed unusual, as craftspeople usually specialize in one discipline only, such as setting or polishing.

Schmid's own ideas come either from travelling, experiencing new peoples and cultures, or from a particular stone. The colour of the stone is important to him, and it is often the catalyst to what combinations of metals he will incorporate into the design. Schmid loves stones, although when he was starting out he disliked the idea that to be properly appreciated, traditional stones such as sapphires, rubies, diamonds and emeralds were expected to be cleanly cut and set. Schmid developed the view that beautiful gemstones are defined by their colour but also by their imperfections and inclusions. He sees their flaws as 'the fingerprint that makes that stone unique'.

The techniques and combinations of different metals used by the atelier have resulted in their becoming a role model for goldsmiths: the bravery and open-mindedness reflected in the jewelry is second to none. Schmid's passion sparks a dialogue between the designer and the wearer: 'Without that spark there is no magic.

My craftsmanship gives me the sculptural vocabulary to allow the form to convey this spark.' Their jewelry is meant to complement the human form, exploring tensions with the human figure: earrings set against the cheekbone to frame the face, or rings designed to extend the graceful lines of a woman's hands.

There is so much passion and care in Schmid's work and ideas, and one of the joys of buying contemporary jewelry is this opportunity to hear such enthusiasm directly from the maker. Schmid undertakes numerous commissions, his favourite being 'when someone comes in with a bag of old jewelry, which they have inherited or do not wear any more. They ask me if we can make something from it and I love to sit down with them and go through the old pieces and understand their needs.' Whether commissioned or not, each of the Atelier Zobel pieces is unique. The clients are not what Schmid would call typical collectors: 'They are entrepreneurs, doctors, scientists – people who are attracted by the unique nature of the pieces. I am glad that they feel comfortable wearing our work.'

ring by peter schmid, 2008
rubellite, diamonds, pink diamonds, 925-silver, 22- and 24-carat gold

taking care of your jewelry

It is important to care for your collection properly so that it is in good condition for you and for the generations to follow who might wear the jewels. It is a shame when jewelry has not been looked after properly, so below is some basic guidance to help preserve your pieces and keep them looking as good as when they were first bought.

storing jewelry

Jewelry pouches with compartments that allow you to keep your pieces of jewelry separate are a good investment. Choose one that will fit into your bag easily, so should you need to take any jewelry with you, it will not get scratched or lost. Keep any chains fastened when the piece is not worn to ensure that they do not get tangled.

tarnishing

Almost all jewelry will tarnish over time, and perfume, lotions, cosmetics, hair products and perspiration accelerate this process. Gold takes on a dark coloration through superficial corrosion, although the higher it is in carat the less likely it is to tarnish. In a completely natural process silver becomes oxidized over time and also tarnishes; such stains can be removed with a soft cloth and a specific metal polish. With iron or other types of metal any discoloration is often the intention of the craftsman so should be left as it is. The best way to prevent tarnishing is to store jewelry in a pouch or bag and polish it regularly with a soft cloth.

cleaning silver

While it can be convenient to clean your silver jewelry in a silver dip, be careful which jewels you put into it. Never dip jewelry with porous or fragile stones such as turquoise, coral, opals or pearls, or jewelry that is foil-backed or has closed settings. For example, if a silver bangle set with coral were placed into the solution, the coral would instantly turn grey. Always read the small print on the jar before immersing the jewelry.

cleaning jewels

By far the easiest and safest way to clean jewelry that is set with diamonds, rubies, sapphires or semi-precious stones such as amethysts, aquamarine and citrine, is to fill a bowl with warm soapy water, add common household ammonia and use a soft toothbrush to brush gently around and behind the settings. Make sure to rinse and dry thoroughly. Regular cleaning in this solution will get rid of any greasy build-up surrounding the stones. For emeralds, pearls, opals and turquoise, however, I would not recommend cleaning in this fashion because these are especially fragile gems.

taking care of pearls

Pearls are highly porous, and both natural and cultured pearls are believed to benefit from being worn regularly as the oils from the skin make them shine, but in fact when pearls are not wiped after wearing the residue from skin contact can actually damage them. Ensure that pearls are put on only after cosmetics, hairspray and perfume have been given time to dry, and wipe them clean when you take them off to remove any residue. Once they have been wiped, wrap them in chamois leather; but do not store them in tissue or cotton wool, as the acids from these materials will damage the lustre of the pearls. Always check that the stringing on pearls is secure.

plastics

Many contemporary jewellers use different types of plastic that require care to prevent damage. Store the pieces in a cool, dry place and in low light and do not use solvents or cleaners containing ammonia as they may react with the plastic and cause cracks. Brushing and dusting are the best

ways to remove surface dirt from plastic jewelry, while a solution of detergent and warm water or slightly damp cotton swabs should remove stubborn dirt without harming the acrylic.

hallmarks

Hallmarks are the marks applied to pieces that are made from precious metals such as platinum, gold, silver and, more recently, palladium. UK hallmarks provide information on who made or commissioned the piece, what it is made from, and where and when it was hallmarked. Hallmarks have been in use in England and France from the 14th century, and many countries have adopted a system of hallmarking of some kind, often in the shape of a letter or a specially designed maker's mark. A good reference book for European

hallmarks is *World Hallmarks Vol. I: Europe 19th to 21st Centuries* by William B. Whetstone, Danusia V. Niklewicz and Lindy L. Matula, (2010). For international marks refer to *Tardy's International Hallmarks on Silver*. These websites are also a useful resource:

www.assayofficelondon.co.uk
www.jewellers-online.org
www.hallmarkresearch.com
www.theiaao.com
www.hallmarkingconvention.org

alterations

Should you need any pieces altered for any reason, it is best to go back to the craftsman who made them as they will know best how to approach this.

precious metal alloys

millesimal fineness

The system of millesimal fineness is used to specify the purity of precious metal alloys (platinum, gold, silver and palladium); it categorizes the metal by parts per thousand of pure metal. A 750-gold alloy therefore contains 750 parts per thousand of gold. Hallmark stamps (585 for gold being very common) are used in most European countries, whereas in the United States the metal content is usually specified by the older carat system (14K, 18K, etc.) The carat system denotes the purity of gold by fractions of 24: for example, 18K gold contains 18 parts per 24, or 75% gold. Millesimal fineness is usually rounded to three figures. It is now possible to determine fineness with much greater accuracy than before.

The most common types are:

PLATINUM 999, 950, 900, 850

GOLD 999 (equivalent to 24 carat), 995, 990, 916 (22 carat), 750 (18 carat), 585 (14 carat), 375 (9 carat), 333 (8 carat; minimum standard)

SILVER 999, 958, 925 (equivalent to sterling silver), 800 (minimum standard)

If an item is sold in the UK and described as gold, silver, platinum or palladium, either in writing or verbally, and if it is above the minimum marking weight of that metal it has to bear a UK recognized hallmark. It is illegal to sell pieces above minimum marking weight without a hallmark.

biographies

The lists of exhibitions and awards below include mostly information from around 2000 onwards and are by no means exhaustive.

PRICES
$ $160–1,100/£100–700
$$ $1,100–3,300/£700–2,000
$$$ $3,300–8,000/£2,000–5,000
$$$$ $8,000–24,500/£5,000–15,000
$$$$$ $24,500–82,000/£15,000–50,000
$$$$$+ above $82,000/£50,000

zoe arnold

education
2001–3 Central Saint Martins College of Art and Design, London

exhibitions include
2006–7 'London Rocks', Sotheby's, London
2007 'Rising Stars at Goldsmiths' Hall', Goldsmiths' Fair, London
2010 'Collect', Victoria and Albert Museum, London
'Inner Voice', Contemporary Applied Arts, London

awards include
2007 First Prize: Best New Merchandise, Goldsmiths' Fair, London

www.zoearnold.com
$$–$$$$$

ark

rena krishtul:
education
1974–9 Lvov State Academy of Arts, Former Soviet Union/Ukraine

anatoly krishtul:
education
1974–7 Moscow State University of Civil Engineering, Moscow
1977–9 Lvov Polytechnic University, Former Soviet Union/Ukraine

collections include
Staatliche Porzellan-Manufaktur Meissen; Königliche Porzellan-Manufaktur (KPM), Berlin; State Museum of Ceramics, Kuskovo Estate, Moscow

www.arkjewelry.com
$$$$$–$$$$$+

michael becker

education
1982–7 Cologne University of Applied Sciences (Fachhochschule), Cologne

exhibitions include
2002 '20 European Artists', Patina Gallery, Santa Fe, N. Mex.
2005 'Collect', Victoria and Albert Museum, London
2007 Galerie Louise Smit, Amsterdam
2011 Solo show, Alternatives Gallery, Rome
2012 'Michael Becker and Annamaria Zanella', Deutsches Goldschmiedehaus Hanau Schmuckmuseum, Hanau

collections include
Museum of Decorative Arts, Berlin; Collection of Danner Foundation in Pinakothek der Moderne, Munich; German Blade Museum (Klingenmuseum), Solingen; Musée des Arts Décoratifs, Paris; Musée des Arts Décoratifs, Montreal; Schmuckmuseum, Pforzheim, Germany; Smithsonian Cooper-Hewitt National Design Museum, New York

www.beckermichael.de
$$$–$$$$$

sevan biçakçi

education
1984–90 Apprenticeship, Hovsep Catak Studio, Istanbul

exhibitions include
2007 'Nuruosmaniye Collection', Topkapi Palace, Istanbul
2009 Jameel Prize exhibition, Victoria and Albert Museum, London

awards include
2006–9 Couture Design Awards, Las Vegas, Nev.
2006 Best Independent Designer, Tanzanite Foundation Award, New York
2008 Turkish Patent Institute's Award for Design, Ankara

www.sevanbicakci.com
$$$$–$$$$$

luz camino

education
1973–7 Escuela Sindical de Joyería, Madrid

exhibitions include
2003 Bergdorf Goodman, New York

awards include
Joyero Sacador de Fuego, Escuela Sindical de Joyería, Madrid

collections include
2008 Permanent collection, Museum of Art and Design, New York
2009 Permanent collection, Musée des Arts Décoratifs, Paris

www.luzcamino.com
$$–$$$$$+

peter chang

education
1962 Liverpool College of Art, Liverpool
1967 Atelier 17, Paris
1971–87 Slade School of Fine Art, London

exhibitions include
2002–3 'It's only plastic…', Pforzheim, Berlin, Munich, Hanau and Idar-Oberstein, Germany
2007 'Unnatural Selection', Walker Art Gallery, Liverpool

awards include
1995 Jerwood Applied Arts Prize, London
2003 Herbert-Hofmann Preis, Munich
2005–7 Wingate Scholarship, London
2008 Neuer Schmuckpreis, Munich, Germany

www.peterchang.org
$$$$–$$$$$

kevin coates

education
1969–70 West Surrey College of Design, Farnham, UK
1970–73 Central School of Art, London
1973–6 Royal College of Art, London
1979 Royal College of Art, London (PhD)

exhibitions include
1999–2000 'Fragments: Pages Stolen from a Book of Time', Museo Correr, Venice (also shown in Scotland and New York 2000–1)
2005 'Kevin Coates – an Alphabet of Rings', Mobilia Gallery, Cambridge, Mass.
2006 'The "Mozart" Jewels, Mobilia Gallery, Cambridge, UK
2007–9 'A Notebook of Pins', Mobilia Gallery, Cambridge, USA; The Wallace Collection, London; Ruthin Craft Centre, Denbighshire, UK; Harley Gallery, Welbeck Abbey, Nottinghamshire
2011 'Time Regained', The Wallace Collection, London

public collections and commissions include
St George centrepiece for 10 Downing Street, Silver Trust, London; St Chad Cup, Litchfield Cathedral, Litchfield, UK; Charter Bell and Amity Cup, Goldsmiths' Company, London; Carrington Cup, Victoria and Albert Museum, London; 'Athene Noctua', Victoria and Albert Museum; 'The Entry of the Queen of the Night' Tiara, Royal Museum, Edinburgh; 'Pan' Ring, Museum of Fine Arts, Boston, Mass.; 'Frog Labyrinth' Brooch, Spencer Museum of Art, Lawrence, Kansas

awards include
2007 Appointed Associate Artist, The Wallace Collection, London

$$$$–$$$$$

giovanni corvaja

education
1985 Pietro Selvatico Art Institute, Padua
1990 Royal College of Art, London

public collections
2004 Victoria and Albert Museum, London
2006 Schmuckmuseum Pforzheim, Germany

2007 Museo degli Argenti e delle Porcellane, Palazzo Pitti, Florence
2008 The National Gallery of Australia, Canberra
Museum of Arts and Design, New York
2009 Middlesbrough Institute of Modern Art (MIMA), Middlesbrough, UK

exhibitions include
2007 'Giovanni Corvaja', Gallery Katherine Kalaf, Perth
2008 'Giovanni Corvaja', Gallery Anna Schmid, Basel
'TEFAF', Maastricht
'Just Must', Estonian History Museum, Tallinn
2009 'Giovanni Corvaja: Alchimia', MIMA, Middlesbrough, UK, 'The Golden Fleece' Collection, Meister der Moderne, Munich
2010 'Masterpiece London', Royal Hospital Chelsea, London
'Collect', Saatchi Gallery, London
'TEFAF', Maastricht
2011 'Masterpiece London', The Royal Hospital Chelsea, London

www.giovanni-corvaja.com
prices on request

jaclyn davidson

education
1968–70 Kent State University, Kent, Ohio
1970–72 Kent State University, Kent, Ohio (MA)

collections and exhibitions include
2003–11 Craft Boston, Boston, Mass.
Smithsonian Permanent Collection '20th-Century Crafts', Washington, D.C.

awards include
2007 Best in Metals Verdera Prize, Philadelphia Museum of Art Craft Show, Philadelphia
2009 Excellence in Jewelry,
& 2011 Spring Boston Arts Fair, Society of Arts and Crafts, Boston, Mass.

www.jaclyndavidson.com
$–$$$$

tomasz donocik

education
2000–4 Central Saint Martins College of Art and Design, London
2004–6 Royal College of Art, London

exhibitions include
2006 'Hero of Our Time', Royal College of Art, London

awards include
2006 Designer of the Year, New Designers, Goldsmiths' Company (Jewelry), London
2007 Gold Award for Best Design in Fine Jewelry, Goldsmiths' Company, (Jewelry), London
Gold Award for Best Junior, Goldsmiths' Company (Jewelry), London
Silver Award for Fashion Jewelry, Goldsmiths' Company, London

www.tomaszdonocik.com
$–$$$$$

nora fok

education
1973–5 Hong Kong Polytechnic, Hong Kong (Design)
1975–7 Hong Kong Polytechnic, Hong Kong (Three-dimensional design)
1978–81 Brighton Polytechnic, Brighton

exhibitions include
2007 Jerwood Prize for Applied Arts, Jewelry, London
2010 Jerwood Contemporary Makers, London
2011 'Cloud Nylon, The Jewellery of Nora Fok', Harley Gallery, Welbeck Abbey, Nottinghamshire

collections include
Victoria and Albert Museum, London
Crafts Council, London; Fitzwilliam Museum, Cambridge, UK

www.norafok.com
$–$$$$$

maria rosa franzin

education
1967–70 Pietro Selvatico Art Institute, Padua
1970–77 Academy of Fine Arts, Venice

exhibitions include
2008 'Earrings', Ornamentum Gallery, New York

'Maria Rosa Franzin and
Melanie Kolsch', Galerie
Isabella Hund, Munich
'Gioielli d'Autore Padova e la
Scuola dell'Oro', Palazzo della
Ragione, Padua
'Gioiello Italiano
Contemporaneo',
Kunstgewerbemuseum,
Berlin
'Italienische Schmuckkunst',
Galerie Slavik, Vienna
'Sguardi Sonori', Museo
dell'Audiovisivo, Rome
2009 'Gioielli d'Autore', Galerie
Handwerk, Munich
'Collect', Saatchi Gallery
London
'Contemporary Jewellery from
Italy', Oratorio di San Rocco,
Padua
'Moon Jewellery', Ridotto
Teatro Verdi, Padua
'Schmuck', Galeria Isabella
Hund, Munich
'Omaggio a Palladio',
Studio GR20, Padua
2010 'Collect', Saatchi Gallery
London
'Minimum', Galeria Sztuki,
Legnica, Warsaw
'Schmuck Zauber Kraft',
Slavik Gallery, Vienna

collections include
Museo delle Arti Applicate e
Decorative, Padua; Museo degli
Argenti, Palazzo Pitti, Florence

prices on request

gimel (kaoru kay akihara)
education
1973 Gemological Institute of
America, Los Angeles,
California

exhibitions include
2000 'Baselworld', Basel

www.gimel.co.jp
$$$–$$$$$+

michael good
education
1969 Apprenticeship, Robert
Peerless (Sculptor),
New York
1978 Metalsmithing with Heikki
Seppa, Haystack, Deer Isle,
Maine

exhibitions and collections include
1997–2005; 2007–11
American Crafts Council,
Baltimore, Md.
2005–6 Couture Salon, Las Vegas, Nev.
2006–7 Salon: 100 Percent Design,
New York

awards include
1986 Diamonds International
Worldwide Competition
Finalist
1996 Contemporary Design Group
Annual CDG High
Achievement Award
'Designer MVP'

www.michaelgood.com
$–$$$$ / sculptures $$–$$$$$

mary lee hu
education
1965 Academy of Art,
Bloomfield Hills, Mich.
1967 Southern Illinois University-
Carbondale, Carbondale, Ill.

awards include
2002 Donald E. Peterson Endowed
Fellowship for Excellence,
College of Arts & Sciences,
University of Washington,
Seattle
2006 Lifetime Achievement Award,
Seattle Metals Guild
2008 Metalsmiths' Hall of Fame
Award, St Petersburg, Fl.
2008 Twining Humber Award
for Lifetime Artistic
Achievement, Artist Trust,
Washington State

public collections include
Columbus Museum of Fine Arts,
Columbus, Ohio; Goldsmiths' Hall,
London; Illinois State University;
Museum of Art & Design (formerly
Museum of American Crafts), New York;
Renwick Gallery, National Museum of
American Art, Washington, D.C.; Art
Institute of Chicago; Metropolitan
Museum of Art, New York; Museum of
Fine Arts, Boston, Mass.; Museum of
Fine Arts, Houston, Tex.; Newark
Museum, Newark, N.J.; Victoria and
Albert Museum, London; Charles A.
Wustum Museum of Fine Arts, Racine,
Wis.; University of Indiana,
Bloomington, Ind.; Yale University Art
Gallery, New Haven, Conn.

exhibitions include
2007 'Jewelry By Artists: The

Daphne Farago Collection',
Museum of Fine Arts,
Boston, Mass.
2007 'Craft in America: Expanding
Traditions' (touring for three
years)
2012 'Retrospective', Bellevue Arts
Museum, Bellevue, Wash.
'SOFA', New York, Chicago

maryleehu.com
$$$–$$$$$

martin and ulla kaufmann
education/apprenticeships
Martin Kaufmann at Carl van Dornick;
Ulla Kaufmann at Theodor Blume,
Hildesheim

awards include
2002 'Aus dem Kreis', Design
Zentrum Nordrhein
Westfalen, Essen
2003 Bavarian State Prize, Munich
Grassi Prize, Grassi Museum,
Leipzig
2005 'In dem Kreis', iF Design
Award, Germany
2006 Hessian State Prize, Frankfurt
Justus Brinckmann Prize,
Hamburg

www.ulla-martin-kaufmann.de
$$–$$$$

helfried kodré
education
1961–5 Vienna University, Vienna
1984 Vienna University, Vienna (PhD)

exhibitions include
2006 'Attraversamenti', Galleria
Civica, Desenzano del
Garda, Italy
2007 Klimt02 Gallery, Barcelona
2009 'Collect', Saatchi Gallery,
London
2010 'Marvel: Selected Works
from Austria/Germany:
1970–2010', Philadelphia Art
Alliance, Philadelphia, Pa.
'20 Years of Galerie Slavik',
Galerie Slavik, Vienna

collections include
Austrian Museum of Applied Arts,
Vienna; Landesmuseum Joanneum,
Graz, Austria; Artothek des Bundes,
Vienna, Austria; Cultural Department
of the City of Vienna, Vienna;
Schmuckmuseum, Pforzheim, Germany;
Museum of Applied Arts, Cologne;

National Museum of Applied Arts,
Munich; Design in der Pinakothek der
Moderne, Munich; Danner Foundation,
Munich; Museum of Decorative Arts,
Jablonec, Czech Republic

awards include
2007 'Eligius' Jewelry Prize, Salzburg

www.galerie-slavik.com
$$$–$$$$

constantinos kyriacou
education
1991–3 Le Arti Orafe, Florence

exhibitions include
2005 Inhorgenta, Munich
2005–6 'SOFA', Chicago, Ill.

commissions include
1999 Yves Saint Laurent, Haute
 Couture Spring/Summer
 Millennium Collection, Paris

www.constantinoskyriacou.com
$$

andrew lamb
education
1996–2000 Edinburgh College of Art,
 Edinburgh
2002–4 Royal College of Art, London

commissions and collections include
2002–10 Worshipful Company of
 Goldsmiths, London
2004 Galerie Marzee Collection,
 Nijmegen, Netherlands
 Royal College of Art
 Collection, London
 Medal Collection, Royal Mint,
 Pontyclun, UK
2005 De Beers Brooch, Royal Ascot,
 Berkshire, UK
2006 Birmingham Museum and Art
 Gallery, Birmingham

awards include
2004 Marzee Graduate Prize,
 Goldsmiths' Company
 Award, London
2007 Crafts Council Development
 Award, London
2009 Association for Contemporary
 Jewelry Prize, London
2010 Arts Foundation
 Fellowship Award for
 Jewellery, Brighton

www.andrewlamb.co.uk
$–$$$$$

shaun leane
education
1984 Kingsway Princeton College,
 Middlesex, UK
 Apprenticeship with English
 Traditional Jewellery Co.,
 Hatton Garden, London
1991 Sir John Cass College, London

awards include
2004, 2005, 2006, 2009 and 2010
 UK Jewelry Designer of the
 Year, Industry Award
2007 Winner, Tanzanite Celebration
 of Life Award, New York
 Winner (Best of Bridal), Town
 and Country Couture Design
 Award, Las Vegas, Nev.
 Walpole Awards for British
 Excellence, London
2008 Winner of Tahitian Pearl
 Design Award (brooches),
 London
2009 Professorship, University
 of the Arts, London
2010 Winner, Luxury and Creation
 Awards, Paris

exhibitions include
2006 'Anglomania Exhibition',
 The New York Metropolitan
 Museum, New York
 'Love and War', Museum at
 FIT, New York
 'Runway Rocks', Paris Haute
 Couture Week, Paris
2007 'Love and Money' Touring:
 South East Asia
 'Design and Architecture',
 Touring: Middle East
 'Silver Glove', Dover Street
 Market: Comme des
 Garçons, London
 'The London Cut: Savile Row
 Tokyo', Isetan department
 store, Tokyo
 'Gothic: Dark Glamour
 Exhibition', Museum at
 FIT, New York
 'Shaun Leane and Boucheron',
 Paris
 'White Light', Forevermark
 Precious Collection, London
2010 A Unique Emerald Collection,
 Selfridges, London

collections include
Victoria and Albert Museum, London

www.shaunleane.com
$–$$$$$

myungjoo lee
education
1978–82 Hongik University, Seoul
1982–4 Hongik University, Seoul,
 (graduate school)
1986–8 University of Georgia,
 Athens, Georgia

exhibitions include
2004 Gallery Sun, Seoul
2007 Korean Craft Promotion
 Foundation, Seoul
2009 Gallery Only, Seoul

www.leemyungjoo.com
prices on request

fritz maierhofer
education
1955 Apprenticeship with Anton
 Heldwein, Vienna
1967 Workshop with Andrew Grima,
 London

exhibitions include
2003 'Aspects of Austrian Jewellery
 Art', Tokyo
2006 'Fritz Maierhofer',
 Künstlerhaus, Vienna

awards include
1986–7 Research Fellowship Sir John
 Cass College of Art, London

collections include
Schmuckmuseum, Pforzheim,
Germany; Victoria and Albert Museum,
London; Goldsmiths' Hall, London;
National Museum of Scotland,
Edinburgh; Art Gallery of Western
Australia, Perth; Helen Williams Drutt
Collection, Museum of Fine Arts,
Houston, Tex.

www.fritz-maierhofer.com
$$–$$$$

catherine martin
education
1989–92 Sir John Cass College,
 London
1992–4 Royal College of Art, London

exhibitions include
2006 Solo show, Scottish Gallery,
 Edinburgh
2007 'Collect', Scottish Gallery,
 Edinburgh; Victoria
 and Albert Museum, London
2009 'Creation II', Goldsmiths' Hall,
 London
2010 'Collect', Saatchi Gallery,
 London

public collections include
Victoria and Albert Museum, London;
The Goldsmiths' Collection, London;
National Museums of Scotland,
Edinburgh; Birmingham Museums and
Art Galleries, Birmingham, UK; Ipswich
Museum, Ipswich, UK; Stafford Art
Gallery, Stafford, UK; Museum of Fine
Arts, Boston, Mass.

awards include
Darwin Scholarship, Royal College
of Art, London
Great Britain Sasakawa Foundation
Research Grant, London
Crafts Council Setting-up grant, Crafts
Council of Great Britain, London
First Prize (four times), Goldsmiths'
Crafts Council Awards,
Goldsmiths' Hall, London

www.thegoldsmiths.co.uk
S–SSSSS

märta mattsson
education
2003–5 Silversmithing and Jewelry
Design, Nääs Fabriker,
Lerum, Sweden
2005–8 School of Design and Crafts,
Gothenburg, Sweden
2008–10 Royal College of Art, London

exhibitions include
2010 'Last Orders', Gallery S O,
London
'Menagerie', Gill Wing Jewelry,
London
'Show 1', Royal College of Art,
London
Selected Graduates from the
Royal College of Art,
Electrum Gallery, London
'HomeWorks', Mint, London
Pavilion of Art and Design,
London
Graduation show, Galerie
Marzee, Nijmegen,
Netherlands
'When Heroes Shiver',
Pinakothek der Moderne,
Munich
'Konstslöjdsalong',
Arkitekturmuseet, Stockholm
'In Stock', Taiwan's Designer's
Week, Huashan Creative
Park, Taipei, Taiwan
'SOFA' Chicago, Sienna
Gallery, Chicago, Ill.

www.martamattsson.com
S–SS

jacqueline mina
education
1957–62 Hornsey College of Art, London
1962–5 Royal College of Art, London

exhibitions include
2002 Solo Shows, Lesley Craze
Gallery, London;
Scottish Gallery, Edinburgh
2008 Kath Libbert Jewellery Gallery,
Bradford, UK
2011 Goldsmiths' Hall, London

awards include
2000 Winner, Jerwood Prize for
Applied Art, London
2001 Trustee of Bishopsland
Educational Trust, Oxford

collections include
Victoria and Albert Museum, London;
Crafts Council, London; Worshipful
Company of Goldsmiths, London;
National Museums of Scotland,
Edinburgh; Cleveland Collection of
Contemporary Jewelry, Middlesbrough;
Cooper-Hewitt Museum of Design,
New York

www.thegoldsmiths.co.uk
S–SSSSS

atelier tom munsteiner
bernd munsteiner
education
1962–6 Pforzheim School of Design,
Germany

jutta munsteiner
education
1985–9 Schmuckatelier Heinz
1993–5 School of Gemstone and
Jewelry Design,
Idar-Oberstein, Germany
1995 Master Goldsmith, Germany

awards include
2001 Winner of the European
Jewelry Award, Germany
2008 First Prize Mineral Art, Germany

tom munsteiner
education
1991 German Gemmological
Association, Idar-Oberstein,
Germany
1993–5 School of Gemstone and
Jewelry Design, Idar-
Oberstein, Germany
1995 Master of Gemstone Cutting,
Idar-Oberstein, Germany

www.munsteiner-cut.de
SS–SSSSS+

adam paxon
education
1990–91 Cumbria College of Art and
Design, Carlisle, UK
1991–5 Middlesex University, London
1998 Edinburgh College of Art,
Edinburgh

exhibitions include
2008 'Modern Masters',
Handwerkskammer für
München und Oberbayern,
Munich
2009 'Interior', Scottish Gallery,
Edinburgh
'Cheongju International Craft
Biennale', Cheongju,
South Korea
2010 'Collect', Saatchi Gallery,
London

collections include
Victoria and Albert Museum, London;
National Museum of Scotland,
Edinburgh; Crafts Council, London

awards include
2002 Herbert-Hofmann Preis,
Schmuck International
Jewelry Exhibition, Munich
2007 Winner: Jewellery,
Jerwood Applied Arts Prize,
London

www.adriansassoon.com
S–SSSSS

wendy ramshaw
education
1956–60 College of Art and Industrial
Design, Newcastle-upon-
Tyne, UK
1961 Reading University,
Reading, UK
1970 Central School of Art and
Design, London
(postgraduate)

exhibitions include
2000 Design for the millennium gold
medal presented to H.M.
Queen Elizabeth II,
Electrum Gallery, London
2001 'Picasso Ladies', Victoria and
Albert Museum, London;
American Craft Museum,
New York
2007 'A Journey Through Glass',
Scottish Gallery, Edinburgh
2008 'Drawings in Gold',
Lesley Craze Gallery, London
2012 'Rooms of Dreams',
Somerset House, London

awards include
1993 OBE for services to the arts
2003 CBE for services to the arts
2006 Royal College of Art,
 Senior Fellow

collections include
British Museum, London; Museum
of Art and Design, New York;
Metropolitan Museum of Art, New
York; Musée des Arts Décoratifs, Paris;
Museum of Modern Art, Kyoto;
National Gallery of Victoria, Melbourne

www.ramshaw-watkins.com
prices on request

todd reed
education
Self-taught

exhibitions include
2007 'Essentials for Men', Aaron
 Faber Gallery, New York
2008 'SOFA' Chicago, Ill.
2011 Todd Reed & Peter Schmid
 of Atelier Zobel 'Rock the
 House', Patina Gallery,
 Santa Fe, N. Mex.

awards include
2006 American Vision Award,
 Manufacturing Jewelers &
 Suppliers of America,
 New York
2008 Town and Country Couture
 Design Award Couture,
 Las Vegas, Nev.
2009 Veranda Design Award,
 New York
2010 AGTA Spectrum Award, AGTA
 Gem Fair, Tucson, Ariz.

www.toddreed.com
S–SSSSS+

fred rich
education
1977–81 Central School of Art, London
1982–5 Sir John Cass College, London

awards include
1988 De Beers Diamonds
 International Award, London
2003 Jacques Cartier Memorial
 Award, Goldsmiths'
 Craftsmanship and Design
 Awards, London
2009 First Prize, Enamelling Award;
 Goldsmiths' Company
 Award, Goldsmiths'
 Craftsmanship and Design
 Awards, London

exhibitions include
2003 'Love Story' Exhibition,
 Goldsmiths' Hall, London
2005 'On The Cuff', Goldsmiths' Hall,
 London
2009 'Silver with a Pinch of Salt',
 Goldsmiths' Hall, London

collections include
Worshipful Company of Goldsmiths,
London; Victoria and Albert Museum,
London; Lambeth Palace, London;
British Museum, London; DeBeers,
London; Worshipful Company of
Ironmongers, London; Lichfield
Cathedral, Lichfield, UK

www.fredrichenameldesign.com
SS–SSSSS

jacqueline ryan
education
1985 Harlow Technical College, UK
1986 West Surrey College of Art,
 Farnham, UK
1988 College of Art and Design,
 Düsseldorf
1989–9 Royal College of Art, London

exhibitions include
2007 'Die Blume', Galerie Handwerk,
 Munich
2008 'Fired up! Modern Enamel
 Jewellery', Scottish Gallery,
 Edinburgh
 'Gioiello Italiano
 Contemporaneo 2008 –
 Tecniche e Materiali tra Arte
 e Design', Museo di Arti
 Decorative Pietro Accorsi,
 Turin
2010 'Vittime di una folle gelosia',
 Mies Gallery, Modena
 TEFAF, Maastricht
 'Beauty in Repetition –
 Metalwork and Jewellery by
 Junko Mori and Jacqueline
 Ryan', Bowness-on-
 Windermere, Cumbria, UK

awards include
2005 Grassi Prize, Museum für
 Kunsthandwerk, Leipzig

collections include
Museum für Kunst und Gewerbe,
Hamburg; Victoria and Albert Museum,
London; Aberdeen Art Gallery &
Museums, Aberdeen, Scotland;
National Gallery of Australia, Canberra

www.jacqueline-ryan.com
SS–SSSSS

robert smit
education
1963–6 School of Design (Kunst- und
 Werkschule), Pforzheim,
 Germany

exhibitions include
2001 'Empty House', Musei Civici
 di Padova, Padua
2004 'Metallic Yellow, Gold for
 Robert Smit', Stedelijk
 Museum, Amsterdam

awards include
2004 Françoise van den Bosch
 Award, Amsterdam
2010 Bavarian State Award
 (Bayerischer Staatspreis),
 Munich

collections include
Rijksmuseum, Amsterdam;
Stedelijk Museum, Amsterdam;
Centraal Museum, Utrecht;
Museum 'Het Kruithuis', Den Bosch,
Netherlands; Rijksdienst Beeldende
Kunst, The Hague; Haags Gemeente
Museum, The Hague, Netherlands;
Schmuckmuseum Reuchlinhaus,
Pforzheim, Germany; Neue
Sammlung, Munich; Helen Willams
Drutt Collection, Museum of Fine
Art Houston, Houston, Tex.; Royal
College of Art, London; Hiko Mizuno
College of Jewelry, Tokyo; National
Gallery of Australia, Canberra

www.louisesmit.nl
SSS–SSSSS

georg spreng
education
1967–71 Industrial Design
 Werkkunstschule,
 Schwäbisch Gmünd,
 Germany

exhibitions include
2000–3 JCK Show, Las Vegas, Nev.
2003 'Einzelausstellung Georg
 Spreng', Kleve,
 Schmidthausen, Germany
 'Eight Jewelry Artists',
 Nuria Ruiz, Barcelona
2010 'Bezaubernd', Oliver Hofmann,
 Berlin
 'Platinum with Georg Spreng',
 Sönnichsen, Hamburg
 'Georg Spreng', Reinhold
 Jewelers, San Juan,
 Puerto Rico

awards include
1996 State Prize, Arts and Crafts,
 Baden-Württemberg,
 Germany

www.georgspreng.de
$$–$$$$$+

charlotte de syllas
education
1963–6 Hornsey College of Art, London

exhibitions include
2005–6 'Collect', Victoria and Albert
 Museum, London
2009 'Collect', Saatchi Gallery,
 London
 'Creation I', Goldsmiths' Hall,
 London

awards include
1995 Jerwood Prize, Jewelry (joint
 with Peter Chang), London
2007 Goldsmiths' Award at the
 Goldsmiths' Craft and
 Design Awards, London

www.charlottedesyllas.com
$$$–$$$$$

graziano visintin
education
1968–73 Pietro Selvatico Art Institute,
 Padua

exhibitions include
2004 Galerie Marzee, Nijmegen,
 Netherlands

awards include
2010 'Masterprize', European Prize
 for Applied Art, Ministry of
 Culture, Belgium

museums and collections include
Collection Marzee, Nijmegen,
Netherlands; Die Neue Sammlung,
Staatliches Museum für Angewandte
Kunst, Design in der Pinakothek
der Moderne, Danner-Stiftung,
Munich; Hiko Mizuno College, Tokyo;
Landesmuseum Joanneum, Graz,
Austria; Musée des Arts Décoratifs,
Paris, Royal College of Art, London;
Schmuckmuseum, Pforzheim,
Germany; Studio GR 20, Padua;
Victoria and Albert Museum, London;
Museo degli Argenti, Palazzo Pitti,
Florence

www.alternatives.it
prices on request

leo de vroomen
education
1958 Apprenticeship in The Hague
1963 Master Goldsmith diploma

exhibitions include
1991 Solo exhibition, De Vroomen
 Retrospective, Goldsmiths'
 Hall, London
2002 Opening of the De Vroomen
 Gallery, London

public collections include
Goldsmiths' Company Collection,
London; Lichfield Cathedral Silver
Collection, Lichfield, UK

awards include
1974 De Beers Diamonds
& 1986 International Award, London
2000 Tahitian Pearl Trophy,
 London
2001 Haute Couture Design Award,
 Phoenix, Ariz.

www.devroomen.co.uk
$$–$$$$$+

david watkins
education
1963 Reading University, Reading,
 UK
1965 MGM, Elstree, Borehamwood,
 UK

awards include
1989 Liveryman, Goldsmiths'
 Company, London
1994 Research award, Royal College
 of Art, London
 Royal Society of Arts, Art for
 Architecture award,
 London
2010 Royal Designer for Industry
 (RDI), Royal Society of Arts,
 London

exhibitions include
2003 'Encounters', Arts and
 Crafts House, Cumbria, UK
2008 'David Watkins: Artist in
 Jewellery', Deutsches
 Goldschmiedehaus, Hanau,
 Germany
2009 'Schmuck von David Watkins:
 A Retrospective',
 Schmuckmuseum,
 Pforzheim, Germany
2010 'David Watkins: Artist in
 Jewellery, a Retrospective
 View 1972–2010', Victoria
 and Albert Museum,
 London

collections include
Victoria and Albert Museum, London;
Worshipful Company of Goldsmiths,
London; Musée des Arts Décoratifs,
Paris; Schmuckmuseum, Pforzheim,
Germany; Stedelijk Museum,
Amsterdam; Museum of Arts and
Design, New York; Metropolitan
Museum of Art, New York; National
Museum of Modern Art, Tokyo

www.ramshaw-watkins.com
prices on request

annamaria zanella
education
1980–85 Pietro Selvatico Art Institute,
 Padua
1987 School of Design
 (Fachhochschule für
 Gestaltung), Pforzheim,
 Germany
1988–92 Academy of Fine Arts,
 Venice

exhibitions include
2007 'Parures, bijoux insolites',
 Musée de Cagnes sur Mer,
 France
2008 'Challenging the Chatelaine!',
 Hertogenbosch Stedelijk
 Museum, Hertogenbosch,
 Netherlands
2009 'Dialog, Annamaria Zanella e
 Renzo Pasquale', Galerie
 Birò, Munich, Germany
2010 'Falten-Pleats-Plissee',
 Galerie Handwerk, Munich
 'Gioiello Contemporaneo Due',
 Museo degli Argenti Palazzo
 Pitti, Florence
 'Collect 10', Saatchi Gallery,
 London
2012 'Michael Becker and
 Annamaria Zanella'
 Deutsches
 Goldschmiedehaus Hanau,
 Schmuckmuseum, Hanau

awards include
1997 Herbert-Hofmann Prize,
& 2006 Munich
2002 Bayerischer Staatspreis,
 Munich

collections include
Musée des Arts Décoratifs, Paris;
Museum of Arts and Design, New
York; Schmuckmuseum, Pforzheim,
Germany

www.galerie-slavik.com
prices on request

marcin zaremski
education
1969–74 Academy of Fine Arts
(Interior Design), Warsaw

exhibitions include
1989 Galeria Kordegarda, Warsaw

www.zaremski.pl
S–SS

atelier zobel
education
1992–5 School for Design, Jewelry and
Instruments, Schwäbisch
Gmünd, Germany
1995–7 Apprenticeship, Michael Zobel,
Konstanz, Germany
2000–1 'Japanese Lacquer Technology
on Precious Metals', Escola
Massana, Barcelona

awards include
2007 Honorable Mention, Friedrich
Becker Prize, Germany
2008 First Prize, Couture Design
Awards, Las Vegas, Nev.
Honorable Mention, New
Traditional Jewellery,
Amsterdam
2009 Guest Curator of the Modern
Jeweller Academy, Germany
2010 Designpodium der Inhorgenta
Europe, Munich

exhibitions include
2008 'Gemstones', Electrum Gallery,
London
2009 'What is it: Art?', Galerie
Kurzendörfer, Pilsach,
Germany
2010 'Masters and Apprentices',
Aaron Faber Gallery,
New York and Chicago, Ill.
'Cocktail Rings', Greenvurcel
Gallery, Jerusalem
2011 Todd Reed and Peter Schmid
of Atelier Zobel 'Rock the
House', Patina Gallery,
Santa Fe, N. Mex.

www.atelierzobel.com
SS–SSSSS

museums & galleries

The list below is by no means exhaustive but will serve as a useful introduction to the breadth of international museums and galleries featuring jewelry designs.

australia
Gallery Funaki
4 Crossley Street
Melbourne VIC 3000
www.galleryfunaki.com.au

Established in 1995, Gallery Funaki represents both local and international jewellers. The gallery is well regarded for promoting contemporary jewelry design in Australia and beyond and organizes six solo and group exhibitions per year.

e.g. etal
167 Flinders Lane
Melbourne VIC 3000
www.egetal.com.au

Opened in 1998 to support Australia's flourishing contemporary jewelry scene, e.g. etal represents innovative works by artists from Australia and New Zealand.

austria
Galerie Slavik
Himmelpfortgasse 17
A-1010 Vienna
www.galerie-slavik.com

Renate Slavik showcases unique works by contemporary jewelry designers who define their work as wearable art. The gallery also publishes books on influential jeweller-makers.

belgium
Galerie Sofie Lachaert
St Jozefstaat 30
B-9140 Tielrode

Zwartezustersstraat 20
B-9000 Ghent
www.sofielachaert.be

Galerie Sofie Lachaert offers a great opportunity for jewellers who are just starting out, giving them a platform to obtain the experience needed to establish their career. The gallery researches contemporary jewelry and explores the function of objects as jewelry, design or craft.

france
Galerie Hélène Porée
1 rue de l'Odéon
Paris 75006
www.galerie-helene-poree.com

Situated in the heart of Paris, Galerie Hélène Porée was established in 1992 and features applied arts, in particular jewelry, glass and ceramics, by designers from all over Europe.

Musée des arts décoratifs
107, rue de Rivoli
75001 Paris
www.lesartsdecoratifs.fr

The museum boasts a vast collection of 150,000 objects from the Middle Ages to the present day, including contemporary jewelry by innovative artists.

germany
Deutsches Goldschmiedehaus
(German Goldsmiths' House)
Altstädter Markt 6
63450 Hanau
www.museen-hanau.de

The German Goldsmiths' House was founded in 1942 as an exhibition space for goldsmiths' and silversmiths' art. The regularly changing exhibitions showcase major national and international jewellers.

Schmuckmuseum Pforzheim
(Jewelry Museum)
Jahnstrasse 42
75173 Pforzheim
www.schmuckmuseum.de

Dedicated to the history of jewelry, the Schmuckmuseum Pforzheim displays some 2,000 items showing the vast diversity of jewelry from the past 5,000 years. The modern collection is one of the largest of its kind, containing pieces by German and international makers.

Hilde Leiss Galerie für Schmuck
Grosser Burstah 38
20457 - Hamburg
www.hilde-leiss.de

Hilde Leiss is a master goldsmith based in Hamburg. Her gallery is both a working studio and a centre for displaying works of international and German jewellers, which lends the space a lively atmosphere.

Galerie Rosemarie Jäger
Wintergasse 13
65239 - Hochheim
www.rosemarie-jaeger.de

Founded in 1989, Galerie Rosemarie Jäger focuses on extraordinary works of contemporary applied arts and organizes four to six thematically linked exhibitions per year.

Galerie BIRÓ
Zieblandstrasse 19
80799 Munich
www.galerie-biro.de

This gallery is unique in that it specializes in acrylic jewelry only, looking beyond tradition to this modern and versatile material that can be worked into countless innovative designs. Galerie BIRÓ also puts together publications in conjunction with exhibitions.

italy

Alternatives Gallery
Via d'Ascanio 19
00186 Rome
www.alternatives.it

Specializing in contemporary jewelry, Alternatives Gallery focuses on new work from internationally established jewellers as well as talented newcomers.

Ab Ovo Gallery
Via del Forno 4
06059 Todi
www.abovogallery.com

Emphasizing the gallery's aim to 'translate thoughts into contemporary craft objects', Ab Ovo Gallery (the name means 'from the beginning') presents wearable and collectable jewelry.

Studio Gr. 20
Graziella Folchini Grassetto
Via dei Soncin, 27
35122 Padua

Founded in 1980 by Graziella Folchini Grassetto, this gallery puts together regular exhibitions exploring different materials and the connection between jewelry design and painting

Studio Marijke
Via A. Gabelli, 7
35121 Padua
www.marijkestudio.com

This privately owned gallery is located in Padua, the home of the famous Pietro Selvatico Art Institute. Visits by appointment only.

japan

Gallery Deux Poissons
2-3-6 B1F Ebisu
Shibuya-Ku
Tokyo 150-0013
www.deuxpoissons.com

The mission of Deux Poissons is to introduce international contemporary jewellers to a Japanese audience and to promote Japanese artist-jewellers on an international level. The gallery showcases pieces that strike a successful balance between artistic expression and wearability.

luxembourg

Galerie Orfèo
28, rue des Capucins
L-1313 Luxembourg
www.galerie-orfeo.com

Founded in 1992, this gallery focuses on innovative contemporary jewelry design as well as sculpture, ceramics and photography.

netherlands

Rijksmuseum
Jan Luijkenstraat 1
1071 CJ Amsterdam
www.rijksmuseum.nl

The Rijksmuseum has one of the largest collections of jewelry in the Netherlands. It gives an overview of Dutch jewelry from the 8th century to the present day in about 800 objects. The majority are from the collection of art historian Marjan Unger and will be displayed in a purpose-built gallery from 2013.

Stedelijk Museum
Paulus Potterstraat 13
1071 CX Amsterdam
www.stedelijk.nl

The Stedelijk Museum's collection goes back to the early 1970s and covers jewelry up to the present day with an emphasis on innovative Dutch design. The works of British, Swiss, Austrian and German jewellers are also included.

Galerie Ra
Nes 120
1012 KE
Amsterdam
www.galerie-ra.nl

Since its opening in 1976, Galerie Ra has become an international centre for contemporary jewelry, specializing in innovative contemporary jewelry design and promoting it as an art form in its own right. There is a permanent collection in addition to changing exhibitions.

Galerie Louise Smit
Prinsengracht 615
1016 HT
Amsterdam
www.louisesmit.nl

Founded in 1986, this is one of the first galleries in Amsterdam to specialize in 'art jewelry', and it carefully selects pieces of high quality. Owners Louise Smit and Monika Zampa exhibit and support emerging Dutch and international jewellers.

Galerie Marzee
Lage Markt 3/Waalkade 4
6511 VK Nijmegen
www.marzee.nl

Galerie Marzee was founded in 1978 and supports contemporary jewelry and silverware design. The gallery hosts four or five exhibitions a year and has a large collection of jewelry in stock.

portugal

Galeria Reverso
Rua da Esperança 59/61
1200-655
Lisbon
www.reversodasbernardas.com

Galeria Reverso is a gallery/workshop that was set up in 1998 to celebrate contemporary jewelry as a means of artistic expression. Creativity and innovation in design are central elements in the gallery displays, which include works by established and emerging artists from Portugal and all over the world.

south africa

Veronica Anderson Jewellery
The Firs
Rosebank
www.veronicaandersonjewellery.co.za

Veronica Anderson Jewellery is dedicated to showcasing the work of South Africa's leading goldsmiths and jewelry designers. They offer a complete design service, giving customers the unique opportunity to work with the artist-jewellers directly.

spain

Klimt02 Gallery
Carrer de la Riera de Sant Miquel, 65
08006 Barcelona
www.klimt02.net

Klimt02 offers information and debate
about contemporary jewelry (see also
their dedicated website) and provides
a useful resource to discover new
design ideas.

Alea Galeria
Argenteria 66
08003 Barcelona
www.aleagaleria.com

Alea is dedicated to promoting
innovative contemporary jewelry;
its accessible space makes
contemporary jewelry design more
widely available to the public.

sweden

Platina
Odengatan 68
Stockholm
www.platina.se

Platina was founded in 1999 and
showcases jewelry chosen for its
particular, unusual qualities and
designs that confound expectations,
tell stories and fascinate.

switzerland

Galerie SO Schmuck Objekt
Riedholzplatz 18
CH–4500 Solothurn
www.galerieso.com

The main focus of Gallery SO is on
contemporary design as it aims
to stimulate public interest in art
objects and jewelry, exploring how
contemporary objects can convey
diverse meanings through form
and material. A second space is
located in London (Brick Lane).

united kingdom

Victoria and Albert Museum (V&A)
Cromwell Road
South Kensington
London SW7 2RL
www.vam.ac.uk

The prestigious V&A Museum has
collected jewelry and fashion since
its founding in 1852. The William and
Judith Bollinger Jewellery Gallery
opened in 2008 and displays some
3,000 pieces, showing jewelry from
ancient times to the present and
featuring more than 140 living jewellers
and goldsmiths.

Talisman Gallery
Harvey Nichols
109-125 Knightsbridge
London SW1X 7RJ

23 Cale Street
London SW3 3QR
www.talismangallery.co.uk

A retail gallery based at
Knightsbridge's Harvey Nichols
department store and at a dedicated
shop in Chelsea. Founder and curator
Lesley Schiff carefully selects jewellers
and designers from across the world.

Electrum Gallery
21 South Molton Street
London W1K 5QZ
www.electrumgallery.co.uk

Electrum was established in 1971
and shows a selection of handmade
jewelry from some of the best-known
international jewelry artists as well
as emerging talent. Exhibitions
reflect the latest trends, and there is
a constantly changing programme
featuring more than a hundred
jewelry artists.

Louisa Guinness Gallery
21 Cork Street
London W1S 3LZ
www.louisaguinnessgallery.com

Louisa Guinness set up her gallery
in 2003 and invites key contemporary
artists, painters and sculptors to
create jewelry pieces. She believes
that jewelry can be seen both as a
form of adornment and as sculpture
on its own. Featured artists include
Anish Kapoor, Marc Quinn, Antony
Gormley and Rob Wynn.

Contemporary Applied Arts
2 Percy Street
London W1T 1DD
www.caa.org.uk

Founded in 1948, the CAA is a
charity that was set up to promote
and champion British craftsmanship.
It has an exhibition and retail space
for contemporary design and organizes
a varied programme of shows and
associated events.

Lesley Craze Gallery
35 Clerkenwell Green
London EC1R 0DU
www.lesleycrazegallery.co.uk

The Lesley Craze Gallery showcases
a range of innovative works that make
use of different materials, from paper
to precious stones, and explore various
trends. The gallery represents more
than a hundred established and
emerging designers from all over the
world and hosts four major exhibitions
every year.

Flow Gallery
1–5 Needham Road
London W11 2RP
www.flowgallery.co.uk

Flow Gallery is based in London's
Notting Hill and specializes in
contemporary crafts and applied arts,
in particular jewelry. It was established
to showcase the best of international
contemporary crafts and currently
represents more than fifty jewellers
working in a variety of materials
including precious metals, wood,
paper, glass and textiles.

Kath Libbert Jewellery Gallery
Salts Mill
Saltaire
Bradford BD18 3LA
www.kathlibbertjewellery.co.uk

This contemporary jewelry gallery was
founded in 1996 in Saltaire, a World
Heritage Site, and is set in a former
mill that has been converted into an
art gallery complex and also displays
works by David Hockney. The gallery
specializes in contemporary jewelry
and metalsmithing, showcasing
diverse collections by over seventy
renowned designers and emerging
talents from Britain and abroad.

Harley Foundation and Gallery
Welbeck
Worksop
Nottinghamshire S80 3LW
www.harleygallery.co.uk

The Harley Gallery features changing displays of contemporary crafts with a particular focus on jewelry and includes work by recent graduates as well as established designers.

Ruthin Craft Centre
Park Road
Ruthin
Denbighshire LL15 1BB
www.ruthincraftcentre.org.uk

The Ruthin Craft Centre has become a major venue for contemporary applied arts and gained a national and international reputation for excellence. There is a continually changing display of jewelry designs in the retail gallery and exhibitions feature well-known international names.

The Scottish Gallery
16 Dundas Street
Edinburgh EH3 6HZ
www.scottish-gallery.co.uk

The Scottish Gallery has specialized in contemporary art and decorative objects since 1842. Showcasing contemporary jewelry design is an essential element of the gallery's dynamic programme.

Sprovieri Gallery
23 Heddon Street
London W1B 4BQ
www.sprovieri.com

Sprovieri believes that jewelry is 'wearable art', showcasing jewels alongside contemporary art. The gallery aims to continue the tradition of jewelry designed by artists from other disciplines, which began at the beginning of the 20th century with Jean Arp, George Braque, Alexander Calder, Salvador Dalí, Pablo Picasso, Man Ray and Dorothea Tanning.

united states

Museum of Arts and Design
2 Columbus Circle
New York
NY 10019
www.madmuseum.org

The Museum of Arts and Design (MAD) is the leading American institution dedicated to art, craft and design. It aims to look beyond the traditional hierarchies of art, craft and design, and helps to promote and raise the profiles of contemporary jewellers.

Ornamentum
506 Warren Street
Hudson
NY 12534
www.ornamentumgallery.com

Ornamentum Gallery represents some of the world's most fascinating jewelry artists, selected for the individuality of their designs. Through the gallery space and various exhibitions, Ornamentum aims to promote the evolving field of contemporary jewelry design in new markets.

Mobilia Gallery
358 Huron Avenue
Cambridge, MA 02138
www.mobilia-gallery.com

Established in 1978, Mobilia specializes in modern and contemporary jewelry, sculpture, installation and painting. The gallery runs a varied programme of lectures and travelling exhibitions with works by American and international artists.

Patina Gallery
131 West Palace Avenue
Santa Fe
NM 87501
www.patina-gallery.com

The gallery was founded in 1999 by Ivan and Allison Barnett and focuses on contemporary handmade jewelry, textiles and sculptural objects in metal, clay and wood by leading American and European artists.

De Novo
Fine Contemporary Jewelry
250 University Avenue
Palo Alto
CA 94301
www.denovo.com

De Novo was opened in 1990 and represents some of the finest contemporary jewelry artists from around the world.

Gallery Loupe
50 Church Street
Montclair,
NJ 07042
www.galleryloupe.com

Gallery Loupe was established in 2006 and represents an international group of artists. Its proclaimed mission is 'to challenge the boundaries of traditional jewelry and to explore the unlimited possibilities of self-adornment'.

fairs

goldsmiths' fair

The Goldsmiths' Company
Goldsmiths' Hall
Foster Lane
London, UK
www.thegoldsmiths.co.uk

The Goldsmiths' Company has been promoting craftsmanship in jewelry, goldsmithing and silversmithing for the past 700 years. The Goldsmiths' Fair is held annually, usually in autumn; it offers the public the chance to meet carefully selected jewellers and purchase or commission exquisite jewels. It is *the* place to see the finest craftsmanship and is considered the leading selling exhibition of highly sought-after contemporary jewelry in the UK.

new designers

Business Design Centre
52 Upper St
London, UK
www.newdesigners.com

Every year, New Designers aims to showcase the best in UK graduate design. More than 3,500 graduates from all major disciplines are featured; the event is an excellent opportunity to meet the next generation of contemporary jewelry designers.

origin

Old Spitalfields Market
London, UK
www.originuk.org

Origin is an annual exhibition held in October, showing works by more than two hundred of the most innovative international jewellers and designers chosen by a panel of judges to showcase the ultimate in craft and design.

collect

Saatchi Gallery
Duke of York's HQ
King's Road
London, UK
www.craftscouncil.org.uk/collect

Collect is an annual fair for contemporary craftsmanship from some of the most important and prestigious international galleries. An important event in the contemporary art calendar, it is supported by numerous private collectors and curators, showcasing the best in international design.

american craft exposition

The Henry Crown Sports Pavilion
Northwestern University
2311 N. Campus Drive
Evanston, IL, USA
www.americancraftexpo.org

This exhibition features unique pieces and collections of the highest quality by some 150 of the finest craftspeople in the United States.

the philadelphia museum of art craft show

Pennsylvania Convention Center
1101 Arch Street
Philadelphia, PA, USA
www.pmacraftshow.org

The Philadelphia Museum of Art presented its first craft show in the late 1970s. It was an entirely new forum for exhibiting handmade functional art, and the annual event now features work by the top 195 contemporary craft artists in the United States.

international expositions of sculpture objects & functional art (SOFA)

Chicago; New York; Santa Fe,
NM, USA
www.sofaexpo.com

SOFA is an annual exhibition held in Chicago, New York and Sante Fe, where prominent international galleries and dealers present works that bridge the worlds of design, decorative arts and fine arts, showcasing new, innovative expressions. Pieces span various historical periods, art movements and cultures, from Asian arts and mid-20th-century modern to the cutting edge of contemporary design. The show also features a lecture series and special educational exhibits.

schmuck

International Trade Fair for the Skilled Trades
Munich Trade Fair Centre,
Munich, Germany
www.hwk-muenchen.de

A high-profile annual fair held in Munich in March. Sixty international jewelry artists are featured for their innovative approach and works that stand out as contemporary or unique, or make a social or political statement.

kunst und handwerk messe (art and craft fair)

Museum für Kunst und
Gewerbe Hamburg
Steintorplatz 1
Hamburg, Germany
www.kunstundhandwerkmesse.de

For more than a century this annual fair has promoted contemporary arts and crafts, and kept traditional skills and techniques alive.

jewelry schools

central saint martins college of art and design
King's Cross Centre
Eastern Goods Yard
York Way
London, UK
www.csm.arts.ac.uk

Recently opened in a new, state-of-the-art facility in London, Central Saint Martins is both an art college and a cultural centre. It educates foundation, undergraduate, postgraduate and research students, and has wide-ranging links to the creative industries.

royal college of art
Kensington Gore
London, UK
www.rca.ac.uk

A postgraduate college for art and design at the forefront of high-level research, this well-regarded institution offers courses taught by internationally renowned artists, practitioners and theorists, preparing students for careers in art, design and the creative sector.

the goldsmiths' centre
Britton Street
London, UK
www.goldsmiths-centre.org

The Goldsmiths' Centre has been created by the Goldsmiths' Company to serve as a hub for members of the jewelry, silversmithing and allied trades, as well as the general public. It is a charitable enterprise with the purpose of advancing, maintaining and developing art, craft, design and artisan skills, particularly goldsmithing.

staatliche zeichenakademie hanau (state academy of drawing hanau)
Akademiestr. 52
Hanau, Germany
www.zeichenakademie.de

The State Academy of Drawing Hanau is a vocational school and has offered apprenticeships in goldsmithing, silversmithing, stonesetting and engraving since 1772.

alchimia
Piazza Piattellina 3/r
Florence, Italy
www.alchimia.it

Alchimia is a private school for contemporary jewelry design that runs courses ranging from two weeks to three years, and accommodates all levels of experience.

le arti orafe
Via dei Serragli, 104/124
Florence, Italy

Via Sant'Andrea, 33
Lucca, Italy
www.artiorafe.it

With academies in Florence and Lucca, Le Arti Orafe is one of the best places in Italy to learn about jewelry-design techniques and concepts. Courses in jewelrymaking, jewelry design, stonesetting, computer design and hand-engraving are offered at all levels.

edinburgh college of art (ECA)
Lauriston Place
Edinburgh EH3 9DF, UK
www.eca.ac.uk

The Silversmithing and Jewelry Department at Edinburgh College of Art is managed by a dedicated team of staff who encourage creativity in design and ensure that students have a good understanding of materials.

rhode island school of design
2 College Street
Providence, RI, USA
www.risd.edu

The RISD jewelry and metalsmithing curriculum offers courses at different levels, both introducing traditional goldsmithing skills and encouraging the pursuit of unique contemporary work.

new paltz state university of new york
1 Hawk Drive
New Paltz
NY, USA
www.newpaltz.edu

The metal course at New Paltz gives students the opportunity to explore the technical, aesthetic and conceptual aspects of contemporary jewelrymaking and metalsmithing in a state-of-the-art facility.

hizo mizuno college of jewelry
5-29-2 Jingo-mea Shibuya
Tokyo, Japan
www.hiko-mizuno.com

The only jewelry school in Tokyo, Hiko Mizuno College is a non-profit organization for students from both Japan and abroad. It regularly holds joint exhibitions and workshops with its sister campus in Osaka.

USEFUL WEBSITES
www.thejewelleryeditor.com
www.allaboutgemstones.com
www.metalcyberspace.com
www.tygerglyn.com
www.craftcouncil.org
www.ajdc.org
www.acj.org.uk
www.chihapaura.com

picture credits

ARK: pages 24, 26, 27 © the artist; page 25 © SquareMoose

Zoe Arnold © courtesy the artist

Michael Becker: pages 32–33 © Walther Haberland; page 34 (top) © Conny Stein; page 35 (bottom) © Georg Meister

Sevan Biçakçi © Levent Yucel and Kemal Olca

Luz Camino © Luz Camino

Peter Chang © courtesy the artist

Kevin Coates © Clarissa Bruce

Giovanni Corvaja © Giovanni Corvaja, courtesy Adrian Sassoon

Jaclyn Davidson: pages 58, 59, 60 (left), 61 © Allen Bryan; page 60 (right) © Michael Heeney; page 62 © Michael Heeney; page 63 (top) © Michael Heeney; page 63 (bottom) © Ralph Gabriner

Tomasz Donocik: pages 64, 65 (top), 66 (left), 67 © Mowat and Martner; pages 65 (bottom); page 66 (right) © Tomasz Donocik

Nora Fok © Frank Hills

Maria Rosa Franzin © Lorenzo Trento

Gimel © Naruyasu Nabeshima

Michael Good © Michael Good

Mary Lee Hu © Doug Yaple

Martin and Ulla Kaufmann: page 14 © Matthias Hoffmann; pages 90–93 © H. Hansen

Helfried Kodré © Helfried Kodré Constantinos Kyriacou © courtesy the artist

Andrew Lamb: page 104 (bottom) © Andrea Nelki; page 105 (bottom) © Graham Clarke; pages 102–103, 104 (top), 105 (top) © Keith Leighton

Shaun Leane: page 106 © Guy Lucas de Peslouan; pages 107–109 © Tim Brightmore

Myungjoo Lee © courtesy the artist

Fritz Maierhofer © courtesy the artist

Catherine Martin © Heini Schneebeli

Märta Mattsson © courtesy the artist

Jacqueline Mina: pages 124–125 © Joel Degen; pages 126–127 © Neil Mason

Atelier Tom Munsteiner © courtesy the artist

Adam Paxon: pages 132, 134, 135 (top) © Shadi Vossough; pages 133, 135 (bottom) © Matthew Hollow, courtesy Adrian Sassoon

Fred Rich © Todd White

Jacqueline Ryan © Jacqueline Ryan

Robert Smit © Robert Smit

Wendy Ramshaw: page 136 © Mike Hallson; page 137 © Mike Hallson; pages 138–140 © David Watkins; page 141 © Graham Pym

Todd Reed © Craig Pratt

Georg Spreng © Gerd Spreng Studios; H.P. Hoffmann Studios; Platinum Guild International

Charlotte de Syllas © David Cripps

Graziano Visintin © Lorenzo Trento

Leo de Vroomen © courtesy the artist

David Watkins © David Watkins

Annamaria Zanella © Giulio Rustichelli

Marcin Zaremski © Mateusz Zaremski

Atelier Zobel © Fred Thomas

acknowledgments

Thanks to Scott and Chloe, for putting up with me being locked away in the office for months on end.

Jessica Rowles Nicholson for her help and support.

Malcolm Cossons for his patience and ability to put my words into proper English; without him this would never have happened.

Stephen Kennedy for his help on gemstone definitions.

Daniela Mascetti for introducing me to Gimel and Luz Camino, and for her encouragement in getting me to write this book.

Ute Decker for her explanations of ethical issues.

All the artists for being so accommodating, supportive and helpful.

Editor's acknowledgments:
Thanks to Jenny, Harland and Ariadne for all the time it took.

index